Masters of Starlight

Ted Allan
Self-portrait with Eleanor Powell
1936

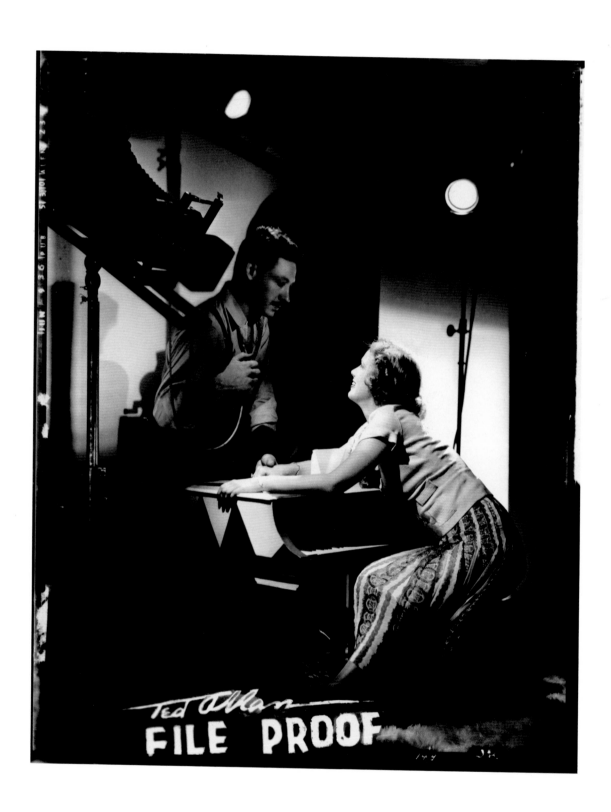

Masters of Starlight

P H O T O G R A P H E R S

I N

H O L L Y W O O D

.

D A V I D F A H E Y

L I N D A R I C H

.

Los Angeles County Museum of Art

.

Published by the
Los Angeles County Museum of Art
5905 Wilshire Boulevard
Los Angeles, California 90036

Editor: Mitch Tuchman
Designers: Renée Cossutta and Judith Lausten
Type set by Continental Typographics, Inc.,
Chatsworth, California
Printed by Gardner Lithograph,
Buena Park, California

Library of Congress
Cataloging-in-Publication Data
is available.

Library of Congress number:
87–29900

ISBN:
0–87587–141–0 (pbk.)
0–87587–141–2

Masters of Starlight
Photographers in Hollywood
was made possible
through a collaboration between the
Los Angeles County Museum of Art
and the
Hollywood Photographers Archives.

cover:
Anonymous
Robert Coburn
about 1950

■

Robert Coburn
Kim Novak
1955

Contents

FOREWORD

FOR EIGHTY OF ITS ONE HUNDRED YEARS Hollywood has been practically synonymous with the motion picture industry. Throughout the world *Hollywood* means the films produced here as well as the people who produce them: not only the talent in front of the cameras and the directors, screenwriters, and producers, many of whom have become well known, but the carpenters and the painters, the cinematographers and the editors, the designers and the costumers, and the many, many other men and women working more or less anonymously behind the scenes. No major motion picture can be made without them. Together they constitute a collaborative team.

Yet one artist, working as anonymously as the rest, often does work alone. The Hollywood still photographer, whether on the studio lot or on some remote location, in the portrait gallery or out "on the town," in the palatial mansions of Beverly Hills or the beachfront villas of Malibu, creates a work that is certifiably that of an individual. Some of these images are as well or better known today than the movies they were made to promote. Marilyn Monroe, her pleated skirt set sailing by an upward gust of wind, has become an icon of the 1950s, but the photographer behind that image re-created from *The Seven-Year Itch* is for all intents and purposes unsung.

Between 1910 and 1970 more than three hundred still photographers worked in Hollywood. Some were under contract to one of the studios. Some were on staff at a magazine or newspaper. Some were working freelance on special assignments or "on spec." Artifice, not art, was uppermost in their minds, yet somehow many created works of enduring distinction; and all—whether a record shot of a costume or a set, a behind-the-scenes glimpse of the movies as they are made, a portrait of improbable perfection and exotic appeal—a record of their day. Some indeed are the only records that remain of films now lost or irreparably damaged. In restoring *Queen Kelly, Lost Horizon,* and *A Star Is Born*, preservationists overlaid surviving stills with long-lost dialogue to replace scenes permanently missing from the films themselves.

Masters of Starlight: Photographers in Hollywood brings together the work of forty-four such photographers. Some have attained recognition commensurate with their achievements; many more are relatively unknown even though their work could hardly seem more familiar. Our goal is to proclaim them, to attach names to their images, and to acknowledge their contributions to the art of photography, to the history of film, and to the glory of Hollywood in its one hundredth year.

In bringing *Masters of Starlight* to the public, the Los Angeles County Museum of Art is indebted to the tireless efforts of Sid Avery, himself a still photographer in Hollywood and longtime friend of the museum, Linda Rich, and David Fahey in collecting and preserving our photographic heritage. A friendship having grown out of exhibitions that included Avery's work, they went on to cofound the Hollywood Photographers Archives, dedicated to the preservation, study, and exhibition of outstanding still photography pertaining to the history of Hollywood, the motion picture industry, and California's influence on photography.

Earl A. Powell III
Director
Los Angeles County Museum of Art

ACKNOWLEDGMENTS

LITTLE DID WE KNOW in 1981, when the idea of the Hollywood Photographers Archives was born, that six years would pass before these acknowledgments would be written. Locating, collecting, and preserving the work of these photographers was an enormously time-consuming and complicated endeavor. Originally *Masters of Starlight: Photographers in Hollywood* was to have been an exhibition of the work of about a dozen photographers each of whom spent most of his career in Hollywood. As we continued to rediscover photographers and uncover ever-higher mountains of stills, our concept broadened to include forty-four photographers who worked in Hollywood from the 1910s through the early 1970s.

Our desire to emphasize unexhibited or unpublished photographs required that trust be established. Eventually many photographers or their estates allowed us access to their entire archives. We conducted audio- or videotaped interviews with as many photographers as possible. Because an exhibition can only be so big, most of the photographs and much of the results of our research are not included here. We are hopeful of the opportunity to continue this work.

The enthusiasm, support, consultation, and continued assistance of many individuals and organizations have made this project possible. We are grateful to each of the participating photographers, their families or estates, and the other lenders to this exhibition too numerous to name here.

Since its inception our cofounder, Sid Avery, has dedicated his time wholeheartedly to the establishment and growth of the Hollywood Photographers Archives. For his dedication to this exhibition and the accompanying book, financial assistance during the research phase of the project, purchase of several of the photographs included, donation of numerous services, and introduction to a number of the photographers, we are deeply appreciative.

We are indebted to the other members of the founding board of trustees of the archives: Shirley Burden for his commitment to the preservation of still photography, magnanimous financial support, and extraordinary

confidence; Phil Tremonti for his astute guidance, valuable suggestions, and sense of humor; and Earl Witscher for his spirited debate and for providing funds supporting a portion of the exhibition and preparation of this book. We also thank recently appointed board members Diana Avery, Ernest Borgnine, and Robert E. Duffy. The archives have benefited from the support of many others in the Hollywood community, and we acknowledge their generosity here too.

We are especially grateful to Stan Cornyn and Randee Klein for their thoughtful opinions, encouragement, friendship, patience, and confidence that work on this project would one day be complete. For her diligent curatorial assistance throughout this project we thank Leslie Bogart.

For recognizing the project's significance, enthusiastically supporting the exhibition, and persisting in overcoming numerous obstacles in bringing it to the museum, we are grateful to Earl A. Powell III, director of the Los Angeles County Museum of Art. Other members of the museum staff who have been extremely supportive include Kathleen McCarthy Gauss, curator of photography, and Sheryl Conkelton, assistant curator; Elizabeth Huntley, chief of the exhibitions division, and John Passi, exhibitions coordinator; Peter Brenner, head of Photographic Services; Ron Haver, head of Film Programs; Renee Montgomery, registrar, and assistant registrars Lisa Kalem and Sharon Slanovec; Jim Peoples and his operations staff, responsible for the exhibition installation; Deenie Yudell, head graphic designer; Marlene Kristoff, general manager of the Museum Shop; and museum press officer Pam Jenkinson and assistant press officer Vivian Mayer, who coordinated publicity for the exhibition and book.

Never underestimate the contribution of a good editor. Mitch Tuchman, managing editor at the Los Angeles County Museum of Art, offered creative inspiration, editorial expertise, and critical direction. His contributions have been instrumental in the preparation of the book. We would like to thank Renée Cossutta and Judith Lausten, who created the elegant design for this book. Risa Kessler, vice-president, Ballantine Books, never waivered in her faith in the project, and for that we thank her as well.

For their foresight in collecting and preserving the work of Hollywood portrait photographers over the past fifteen years and providing valuable information on many of them to supplement the text of this book, we are appreciative of the efforts of John Kobal, Bob Costenza, and Simon Crocker. Mark Johnstone's knowledge of photographic history was invaluable in the completion of the essay and chronologies.

We are thankful to Kimberly Schock, Fatima Andrade, Thea Piegdon, John Dennis, and Vicki Toy for their research assistance, attention to detail, and accuracy. For attending to countless details in the preparation of the checklist and loan forms, we thank Cezanne Hitchcock. Christina Craddock's and Julie Harris's work in preparing the manuscript is appreciated.

We would like to acknowledge the motion picture studios for their cooperation: Columbia Pictures, Metro-Goldwyn-Mayer, Paramount Pictures, Republic Studios, RKO, Samuel Goldwyn Studios, Turner Entertainment, Twentieth Century Fox (especially Bette Einbinder and Pat Miller), United Artists, Universal Studios, and Warner Bros.

We appreciate the generosity of the following suppliers of photographic services: Don Weinstein at Photo Impact, Los Angeles, for making silver gelatin prints and Mark Allen and Boris Color Lab, Boston, for making Cibachrome prints for the exhibition; Ilford for providing Cibachrome materials and supplies; A & I, Los Angeles, for making reproduction-quality duplicate transparencies for this book; Sam Mackenna and Joseph Kennedy for volunteering their restoration and retouching services; and Modernage Photo Services, Los Angeles, for preparing research prints.

The following people and institutions supplied guidance: Robert Cushman and Doug Edwards of the Academy of Motion Picture Arts and Sciences; Michael Friend, American Film Institute; Weston Naef, J. Paul Getty Museum; Richard De Nuet, Globe Photo; Robert Sobieszek, International Museum of Photography at the George Eastman House; and the Radio, TV, and Film Archive and Department of Special Collections of the University of California, Los Angeles.

Numerous friends and acquaintances provided valuable suggestions, insights, and assistance of various kinds. They include Ron Avery, Dan Belin, G. Ray Hawkins, John and Susan Edwards Harvith, Paul Hertzman, Deborah Irmas, Larry Israel, John Livzey, Suzanne McCafferty, Monty Montgomery, Allan Rich, Jean Sapin, Richard Stern, Mary Virginia Swanson, Mark Swope, Gene Trindl, and Stephen White.

For their encouragement, support, and the many evenings and weekends they spent alone, we are grateful to our spouses, Anne Fahey and George Jadowski. Without their love and patience this lengthy project could never have been completed.

David Fahey and Linda Rich

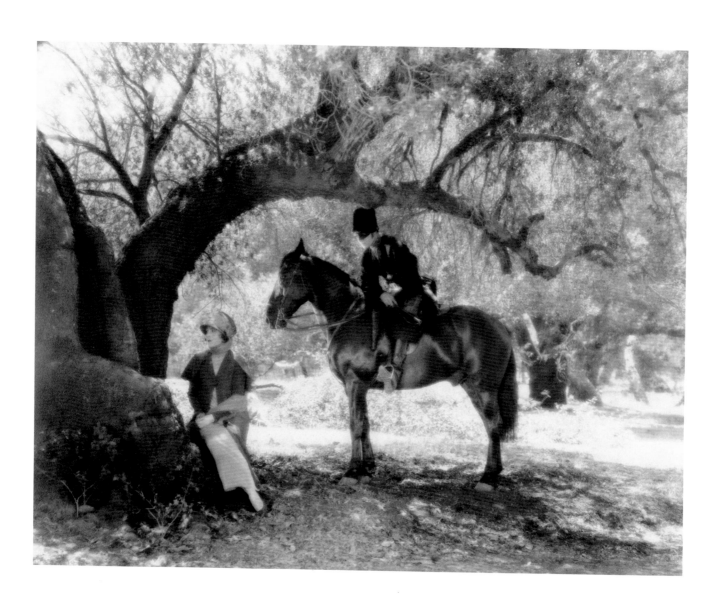

Masters of Starlight

As early as the 1890s motion picture directors used still photographs to study sets and costumes, to record each scene and player, and to promote their completed films with illustrated posters and lobby cards. Motion picture camera operators doubled as motion picture still photographers, although they received no credit for doing so. Stills shot prior to 1915 are largely unattributed.

Producers concealed the names of their players, fearing their popularity would open the doors to temperament and outrageous salary demands. "It was enough to be known as 'The Biograph Girl,' or 'The Girls with the Curls,' or 'A Mack Sennett Bathing Beauty.' "[1] By the time audiences had discovered that one Biograph Girl had the somewhat unlikely name of Florence Lawrence, they were already in love with another, "Little Mary." They loved her as no audience had ever loved before. They flocked to her films. They mobbed any place she was scheduled to appear. They wanted desperately to know her name and everything else about her. When they learned she was Mary Pickford, the first star and first fans were born.[2]

Biograph was deluged with requests for her photos, and the lesson was not lost on her. During the 1920s Mary Pickford is reputed to have spent as much as $50,000 a year on photographs. Briefly encountered in a Hollywood restaurant, her mother had one word of advice for Rodolfo Alfonzo Raffaele Pierre Philibert Guglielmi: photographs. "Get the very finest. . . . Spend plenty of money on them. . . . Profile, full face, bust, and full figure."[3]

The young man took her advice, and later as Rudolph Valentino he continued to have his portraits made by the most renowned photographers of his day. When times were lean, he sold autographed copies for twenty-five cents apiece.

The first Los Angeles photographers to make portraits of the stars were "main street" photographers with commercial storefront studios. Nelson Evans and Witzel (he worked with no first name, and none is recorded) are among the first who can be identified as Hollywood portraitists. Though little is known of their early careers, each appears to have been working in a

Mary Pickford
in portraits by Baron deMeyer
(France, active in the United States, 1868–1946), 1920;
by White (birthplace and life dates unknown), about 1922; and
by Edwin Bower Hesser, about 1922.

·

studio of his own even before motion picture production in Los Angeles began in 1908. The players, knowing of the many portraits they had made of prominent business and society figures, commissioned them as well.

By comparison with later portrait photographers bound by contract to particular studios, Evans and Witzel had tremendous freedom. They chose their own clients. Their portraits were collaborative endeavors between photographer and sitter. Because the actors paid for these portraits, their employers, the producers, could not dictate matters of style.

At first Evans and Witzel followed the conventions of their day. Celebrities were formally dressed but informally posed. Occasionally they were costumed for a role. Backgrounds were invisibly neutral. Props reminiscent of nineteenth-century carte-de-visite photographs were frequently incorporated; a book or vase of flowers completed the composition, though greater attention to background, even complicated settings were gradually added. The photographs capture a romantic, ethereal look in the sitter's expression. It is apparent that a feeling of mutual trust existed.

Evans was one of the first to photograph film personalities at home: on the grass, in their gardens, by their cars, or glancing through copies of *Photoplay*.

The fan magazines—*Motion Picture*, appearing in 1911, was the first—began publication about the time that movie "fanatics" were clamoring for the identities of their favorite performers. Imitators—*Movie Life, Movie Star Parade, Photoplay, Picture Play, Screenland, Screen Stars, Screen Stories*—soon flooded the market. Throughout the 1910s Evans's and Witzel's photographs were published frequently there as well as being sent autographed by celebrities directly to their fans. In the 1920s, when film studios expanded and established their own portrait galleries, they obligated their contract players to patronize them exclusively, and demand for the work of Evans and Witzel declined.

The introduction of the fan magazines and other picture magazines, such as *Vanity Fair* in 1914, stimulated the public's voracious appetite for still photographs. Producers received thousands of letters weekly requesting pictures and details of the stars' lives. The heads of studios recognized the need to document their productions, promote them with still photographs, and make portraits of their growing rosters of players. Motion picture camera operators fulfilled these needs initially, but unlike the private commercial photographers, they made little effort to create psychologically penetrating portraits.

The picture magazines contributed significantly to the way audiences perceived Hollywood style and glamour. Fan magazines published facts and fabrications. They printed "exclusive" firsthand accounts of the principal events of a star's life. It was from the fan magazines that the public learned how their idols were discovered, if they were in love or lonely, the price they paid for fame—indiscretions were delicately revealed—all lavishly illustrated with pictures, pictures, pictures created by photographers who

later became masters of their art. The editors of the fan magazines referred to these articles as "photographic essays." Some fans bought the magazines just for the portraits, which they could cut out and hang on their walls, as though the stars were old friends or relatives.[4]

Film studios attempted to create their own fan magazines. The first were hardly more than official press releases, which purposefully omitted the personal stories that fans wanted to read most. Biographical sketches were invented; human interest stories, created; gossip, leaked. Studio publicity blended real life with movie plots. If the facts were boring, they were "improved."

To promote these "mythological" figures, thousands of publicity photographs were needed. Most often they were shot by studio gallery photographers and provided to newspapers, magazines, and others who might request them free; the photographers, largely uncredited. At least, as glamour photographer Laszlo Willinger recalls, there was this compensation: "A lot more people have seen our stills than [have seen] the movies."[5]

THE FIRST STUDIO to set up a still photography gallery was Famous Players-Lasky about 1920. It was used mainly to make camera studies of players in costume and to photograph stars for poster art. These photographs were unimaginatively composed with players shot before plain backdrops. At other studios stills were shot in makeshift galleries or on the lot or location near the actual filming. Still photographers tried to shoot outdoors as often as possible for technical reasons relating to available film stocks and artificial lighting.

By 1925 formal portrait galleries had been established at MGM, Paramount-Famous Players-Lasky, and several smaller studios. At first the stars resented giving up their favorite commercial photographers, but the terms of their contracts left them no choice. One benefit of the new system was that they no longer were expected to pay for their own publicity portraits.

By the end of the decade nearly every studio had built some kind of formal portrait gallery, employing a photographer full time to run it. These galleries were attached to the publicity departments, which made extensive use of them. Alone or with an assistant the photographer was to convey the essence of every movie and leading role with the same sense of quality that the production attained with weeks of preparation.

As portraitists, studio photographers did not aim to express their subjects' characters but rather to create icons that the public could worship. The purpose of their portraits, they knew, was to entice people to attend movies.

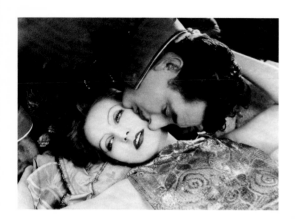

Ruth Harriet Louise
Greta Garbo and John Gilbert
Flesh and the Devil
1927

■

Attributed to Edwin S. Porter
The Count of Monte Cristo
1913

■

Eugene Robert Richee came to Paramount in 1923. For the next two decades, he produced an enormous catalogue of negatives. Seldom would he finish a sitting with fewer than a hundred exposures.[6] Willinger recalls MGM's expectations of him: "two or three pounds of negatives per sitting."[7]

Situations in which more than one photographer worked with a star on a film occurred often, explaining why it is sometimes difficult to identify definitively the work of particular photographers on unstamped or unsigned prints. Bert Longworth shot production stills of the now-famous Greta Garbo-John Gilbert kiss from the film *Flesh and the Devil* during production at MGM in 1926. Ruth Harriet Louise recreated it in the studio portrait gallery. One of Longworth's images from the sequence is reproduced in his book *Hold Still . . . Hollywood!*, while a series of Louise's sensuous gallery portraits was published in *Photoplay* in January 1927 in an article entitled "The Evolution of a Kiss." Louise's contract guaranteed her credit on each of her portraits, thus her authorship is documented as well.

POSSIBLY THE FIRST identifiable still photographer in Hollywood was Alfred Gondolfi, a motion picture camera operator hired by Cecil B. DeMille to photograph *The Squaw Man* in 1913. It is likely Gondolfi also shot the production stills, all of which survive. Together DeMille and Gondolfi experimented with lighting techniques, modulating light and shade to create a sense of drama, rather than relying on conventional flat light. These experiments similarly affected the look of the production stills.

That year, when Adolph Zukor's Famous Players Film Company produced *The Count of Monte Cristo*, Edwin S. Porter, traditionally credited with the idea of making narrative motion pictures, was chosen as director and cameraman. The still photographs for the film have long been considered to have been created anonymously. Arguably Porter made these stills along with his other responsibilities during production.

DeMille maintained an avid interest in still photography throughout his career. He was an early collector of the work of Edwin Bower Hesser. Photographer, then cinematographer Karl Struss (along with cameraman Alvin Wyckoff) most certainly contributed to DeMille's understanding of lighting and composition. DeMille, who justified the extraordinarily high expense of his films by claiming the money spent was apparent on the screen, had equivalent concerns about the quality of still photographs, hiring the most creative photographers for his motion pictures. On *The Ten Commandments* (1923) and *The King of Kings* (1927) he hired the widely acclaimed photographers Edward S. Curtis and William Mortensen to make production stills.

As Struss recalls, "The majority of what we then called cameramen were not photographers. They knew nothing of lighting. They knew nothing of photography. It was all guesswork. They came from all kinds of fields and they got in. They tinkered around the camera and they were called cameramen."[8]

Unlike most other cameramen and still photographers working in Hollywood in the 1910s, Struss himself was trained as an artist-photographer. The soft focus of the Struss Pictorial Lens, an invention of the pre-World War I years, created a romanticized, soft-focused picture that was conducive to idealized portraiture. With his aesthetic orientation and technical ability, Struss produced some of the first highly stylized portraits and production stills in Hollywood, documenting DeMille productions, including *Male and Female* (1919), *Why Change Your Wife* (1920), and *The Affairs of Anatol* (1921), later sharing with Charles Rosher the first Academy Award given for cinematography (for *Sunrise*, 1927–28).

Karl Struss
Sunrise, *1927*
▪

It WAS JOHN BARRYMORE who inadvertently brought new prominence to theatrical photography when in 1919 he refused to sit for his portrait in James Abbe's studio, insisting that Abbe photograph him onstage instead. In so doing, Abbe created a new genre of stage photography. Newspapers, magazines, and celebrities themselves loved the originality of these pictures. Now Abbe could make portraits in his subjects' environments rather than waiting for them to come to his studio.

D.W. Griffith, Mary Pickford, and Rudolph and Natacha Valentino—all frequent subjects—urged Abbe to go to Hollywood to work. He found portrait and stills work soon after his arrival, photographing Pickford in *Suds* (1920) and taking stills of Mack Sennett's bathing beauties.

The key elements that set Abbe's work apart from that of most of his contemporaries were his lighting techniques and the distance he set his camera from his subjects. He used mirrors to reflect shimmering light into shadowy areas. In many of his portraits his subjects appear to glow. While head-and-shoulder portraiture dominated the field throughout the 1920s—Abbe himself continued to do some—he often distanced himself from his subjects, revealing larger areas of their environments. The architecture of the studio itself often served as the setting for his photographs.

Abbe's stylistic and technical innovations influenced the work of Ruth Harriet Louise and Bert Longworth later in the 1920s. Longworth utilized reflective surfaces to amplify light and create three-dimensional space. He placed his camera extremely high or extremely low, creating distorting angles. His production stills reveal his appreciation for modernist styles.

James Abbe
D.W. Griffith, *about 1919*
▪

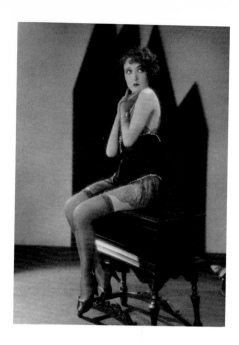

Ruth Harriet Louise
Dorothy Sebastian
about 1927

■

Louise's photography was also moving away from the portrait styles popular earlier in the 1920s. Full-length portraits were her forte. Greater distance helped put her subjects at ease, facilitating the collaboration between photographer and sitter, sitters that included Garbo, who had selected Louise as her exclusive gallery portraitist in 1925. A looser composition allowed for more information to be contained in her photographs. She introduced background shapes to frame her subjects. At times those shapes were merely shadows artfully cast.

The photographs of Eugene Robert Richee are similar stylistically to those of Louise, but while her portraits incorporate elements of simple sets, Richee placed his subjects in environments that were more textural. The clothing worn in these photographs emphasizes popular designs of the day. The conventions of art nouveau and art deco clearly influenced his vision as well.

Many of Richee's subjects seem inaccessibly detached from the viewer. Whether this was his intention or a projection of his subjects' moods is difficult to determine. Nevertheless, it distinguishes his work from that of his contemporaries at Paramount. He and director Josef von Sternberg often collaborated on portraits of the director's protegee, Marlene Dietrich. Von Sternberg supervised the sittings—the lighting and the "action"—though Richee's aesthetic sensibility and technical expertise made him an ideal collaborator for von Sternberg.

T HE STYLE OF HOLLYWOOD photography was developing from the romanticized pictorial ideal to highly stylized, sharply focused portraits, glorifying beauty. Evidence of dramatic lighting filled the frame in numerous variations. Portrait photographers manipulated light to create forms and shapes accenting or highlighting facial features. Background shapes were often arranged to throw the star presence into high relief. A perfectly placed light source could emphasize or minimize the contours of the face and body. Props were readily available on the lot. A replica of a set could be created in the photographer's gallery. The choice of background multiplied dramatically once the photographers began regularly working outside the studio's portrait gallery.

Dramatic "Rembrandt" lighting, highly contrasted areas of light and shadow that seem to sculpt what they reflect, is one of the most identifiable characteristics of Hollywood glamour photography of the 1930s. The manipulation of light permitted photographers to re-create faces. The proper placement of a shadow altered facial structures. Blemishes and other imperfections were obscured. Working with expert retouchers, the Hollywood still men produced living legends, all in the name of glamour.

The creature in a George Hurrell portrait epitomizes perfection of face and form as his photographs themselves epitomize Hollywood allure. Hurrell's inventive lighting style is immediately identifiable: his dramatic use of light allows the shadow areas to play an important design element within the picture's frame. His use of Rembrandt and butterfly lighting (the latter using a spotlight to produce a butterfly-shaped shadow under the subject's nose) in coordination with his own invention, the portable boom light, produced "the Hurrell style."

I always had an understanding about lighting….That's all I thought about when I was working with a person… until I was ready to shoot. My style was somewhat different because I didn't light up the shadows. Publicity was on [the photographers'] necks all the time because [newspaper and magazine] editors would holler about shadows…and in my manner I would say, "To hell with the editors!" I wouldn't say it to their faces, but I would go on doing my same old thing…black backgrounds. If they didn't like the black backgrounds, they could throw them in the trash cans. They had to wait till I was in the mood for a white background. That's the way it worked, because I was just an arrogant, egotistical bastard![9]

In the gallery Hurrell's creative process followed a distinctive pattern. After the lights were set and the film holders in place, he began developing rapport with his subject. "All the portraits that I've ever done had [the subject's] personal expression, and that expression had to come from inside: you didn't just tell a person to laugh, you made them laugh.…I would stand on my head, fall on my face, do anything just to keep things from looking like they were getting dull or that the excitement was falling apart."[10] Hurrell sometimes played jazz recordings during his sessions, rendering a tempo for the action in the shoot.

"There is a great difference between Hurrell's work and that of his predecessors like Ruth Harriet Louise or Edwin Bower Hesser, whose work in the late twenties tended to be as soft as the pictorialists. Hurrell is at once more sensitive and ruthless. In his mature work he had an instinct for the central climactic event of a sitting. His watchfulness, the activity of his perception, remind us of the shrewdness of Edward Weston's portraits."[11]

Hurrell had the ability to manifest a star's sex appeal, communicating that magic and visual electricity, that "star quality." This unique ability prompted *Esquire* magazine to comment in 1936, "A Hurrell portrait is to the ordinary publicity still about what a Rolls Royce is to a roller skate." [12]

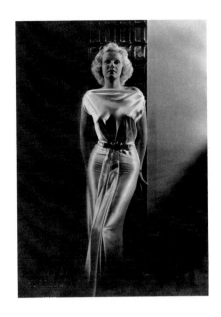

George Hurrell
Jean Harlow
1934

▪

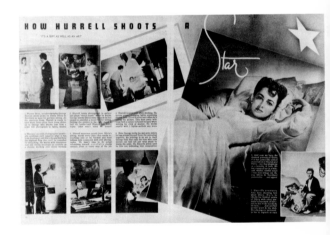

According to this article in Motion Picture
(November 1940),
Hurrell's goal was the evocation of his subject's personality.
He selected her gown,
set the mood with music,
moved around the studio constantly,
squeezing the shutter bulb.
"Olivia's never sure
when he's taking the picture.
This does away with [the] tense look
a subject is bound to have
when waiting for [the] click
of [a] shutter."

▪

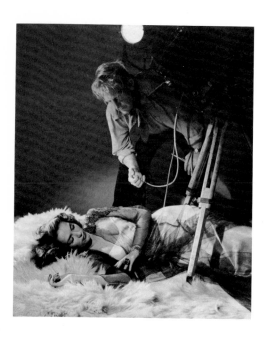

Peter Stackpole
A.L. ("Whitey") Schaefer and Jinx Falkenberg
about 1943

■

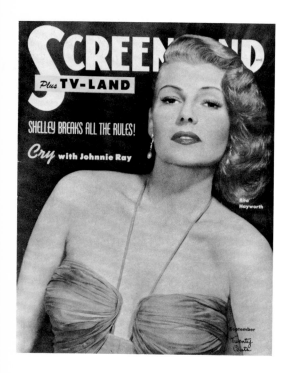

Robert Coburn
Rita Hayworth, Affair in Trinidad
Note the reflection of the times
in the title of the magazine:
Screenland Plus TV-Land
(September 1952).

■

THE FIFTEEN YEARS between 1925 and 1940 have been called the "Golden Age of Movies." "In 1938, there were some eighty million movie admissions every week, a figure representing 65 percent of the population of the United States." (This dropped to "less than 10 percent of the population in 1978.")[13]

In 1934 Metro-Goldwyn-Mayer boasted twenty-three modern sound stages on a lot of 117 acres. The world's largest film laboratory, four thousand studio employees, sixty-one feature stars, seventeen directors, and fifty-one writers. It was true what the sign over the studio said: "More stars than there are in heaven." It was L. B. Mayer's idea to have the tops in everything—in writers, in cameramen, in directors, in photographers. It was no mystery why they did the best and the most.[14]

MGM retained some of the most innovative and original photographers: Clarence Sinclair Bull (1924–58), Louise (1925–30), Longworth (1926–28), Virgil Apger (1930–67), Hurrell (1930–33), Ted Allan (1933–37), Eric Carpenter (1933–46, 1950–about 1962), and Willinger (1937–41).

"The studios…treated their stars with enormous respect, because they were their income.…Everybody was under contract. The publicity went on whether you were in a movie or not, all year long."[15]

Indeed film stars often achieved greater public recognition from their portraits and publicity photographs than from the movies themselves. Seventeen hundred different photographs of Carole Lombard were disseminated by Paramount in an eight-year period alone. On one occasion Robert Coburn shot color portraits of Rita Hayworth for nineteen different magazine covers in a single day.

The other studios also employed talented still men throughout the thirties, forties, and fifties. William E. Cronenweth, Irving Lippman, and A. L. ("Whitey") Schaefer in addition to Coburn at Columbia, Max Munn Autry, Alex Kahle, and Frank Powolny at Fox, Otto Dyar, Donald Biddle Keyes, Eugene Robert Richee, and William Walling, Jr., at Paramount, Roman Freulich at Republic, Ernest Bachrach at RKO, and Elmer Fryer, Madison Lacy, Bert Six, and Scotty Welbourne at Warners were studio still men for most of their careers. For each of them comparisons of their work of the thirties with that of the fifties point out major stylistic developments. In the 1930s, for example, when glamour portraiture was at its peak, the subject was the principal design element of the photograph. Photographers individualized the stars by placing them on elaborate sets, distinguishing them by their costumes and makeup. The development of smaller, hand-held cameras and faster, grainier films affected the work of the studio gallery photographers and reoriented the portrait from an icon to a study of personality with all its earthly qualities.

SOMETHING OTHER THAN STYLE accounted for the quality of images, moving and still, in this period as well. In 1930 the Production Code, the motion picture industry's declaration of moral principles in the movies, was formally adopted. No "two-shot" could be composed in such a way that, if cropped, it would suggest the male was on top of the female even though they were fully clothed. Cleavage had to be removed by retouching, and women's navels were anathema; perhaps film stars really were mythological. Actors could not kiss each other on the ears, and if a man stood behind a woman and put his arms around her, his hands had to be absolutely clear of her bosom.

The office of Will Hays, one in a series of Hollywood morality czars, was the arbiter in determining the moral codes of photographic stills as well as motion pictures. Every photographer from every studio required the Hays Office stamp of approval on the back of each keyset.

"The Hays office was still very strong. There was a lot of self-censorship because we [photographers] knew that certain things could not be done [such as showing] the inside of thighs. How do you photograph a dancer without showing the inside of her thighs? You couldn't show cleavage. They had a slew of retouchers at MGM whose only job was to fill in the shadows between the breasts."[16]

Willinger described one memorable encounter with the Hays Office: "I remember once when they really went too far. I shot a portrait of Joan Crawford, which I filled full frame. I got it back from the Hays Office desk, and they'd said no. I called them and asked them what the problem was. Nothing showed except her face. The Hays Office said, 'That's precisely it. You might imagine that she was nude.'"[17]

Photographs rejected by the censor:
Robert Coburn
Cornel Wilde and Ginger Rogers, It Had to Be You
1947
Irving Lippman
Joan Caulfield, The Petty Girl
1950
•

IN 1933 HURRELL LEFT MGM to open a commercial studio of his own on the Sunset Strip. Ted Allan replaced him. In an industry where artifice was the rule, where a director could state bluntly: "I don't care whether the girl looks like a crow....In Hollywood, there are ways to manufacture beauty; you can't manufacture talent,"[18] Allan adhered to the portrait photographers' mandate: "[to] make mere men and women into objects of fantasy...with poses and dramatic lighting and with that breakthrough...the close-up."[19] His controlled lighting, his experience as a part-time actor with makeup, and his retouching skills enabled him quite literally to shape the stars as MGM imagined they should look.

By using as many as a dozen spots, controlling his lights with "barndoors" and chutes, he would start with black and build.

If you want lights to hit over the top of the breasts to make the gals look more voluptuous, that light comes from the side and skims over the top and throws a shadow in between. It's simple. If you want to straighten a nose, you [throw] the light from a certain side, and it straightens a crooked nose out. I learned this from my art background....

I knew if I put a "clown-white" makeup down the nose, it would narrow the nose. If I put "clown-white" on the cheekbones, it would lift the cheekbones. Dietrich had this same thing done to her by Josef von Sternberg. He would light her "high key." He told the still photographer what to do. She had her back teeth removed to get that "gaunt look" on her cheeks.[20]

Frank Powolny worked as a still photographer for Fox most of his career, alternating among production stills on the lot and location, photographs to be reproduced on posters, and gallery portraits. Though he was Shirley Temple's photographer in the 1930s and Marilyn Monroe's in the 1950s and '60s, when they were under contract to Fox, Powolny is best remembered as a photographer of "leg art." His most famous photograph is the Betty Grable pinup; his most notorious, an altogether too revealing image of Carmen Miranda, which nearly cost the comedienne her career and the photographer his job.

The secret of taking good portraits was not to let them get confused. You didn't say, "What do we do next?" Not with the stars. You kept right on going as if you knew what you were doing. You had to gamble because if they guessed you were out of ideas, they'd say, "That's it." They were getting tired and bored. You had to keep ahead of them, make them feel secure at all times and beautiful.

Except for Loretta Young, I didn't have a special one whom I preferred or who preferred me. One day I'd shoot Alice Faye, the next it would be Gene Tierney. Some might ask for one or the other of us because they had a preference, but that didn't bother me one way or the other because I was more interested in taking good photographs.[21]

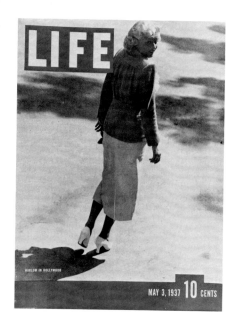

Martin Munkacsi's portrait of Jean Harlow was published on the cover of Life *May 3, 1937. It was* Life's *first Hollywood cover.*

Lᴵꜰᴇ ᴍᴀɢᴀᴢɪɴᴇ debuted in 1936. Its concept—the combination of photographs and text to relate news and feature stories to a massive audience—was an Americanization of a plethora of European picture weeklies. *Life, Look,* and the other photojournalistic magazines that followed came about only after the development of small-format cameras, faster films, and the invention of the electronic strobe, all of which facilitated the advance of available-light photography. Candid moments, small but evocative details, and scenes of action could be woven together by the editors in a form that was much more powerful than a simple collection of individual images.

The introduction of *Life* and the other picture story magazines caused significant changes in Hollywood still photography. The magazines hired their own staff photographers to make new kinds of pictures expressing new points of view. This was a major departure in editorial policy from earlier magazines, which used primarily photographs provided by the studio publicity departments.

Life devoted more space to the motion picture industry than any of its competitors. In its second issue it introduced a "Movie of the Week" feature, using stills provided by the studios to report on new releases. Before long, however, *Life* staff photographers were exploring the film community itself: the stars at work and play. At first these photo essays were shot in Los Angeles. Later *Life*'s photographers traveled wherever motion pictures were being made.

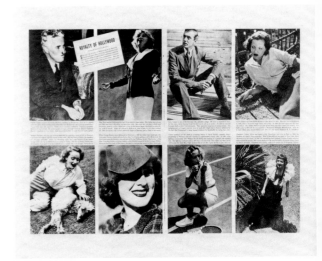

When *Life*'s photographers began invading the sound stages, they were not particularly welcomed by the studios. But seeing how intensely they worked, shooting over the director's shoulder, creating still photographs in new, updated styles with vigor and candor, producers realized how valuable they could be in publicizing their films. Additionally the magazine's readership was far greater than that of any of the fan magazines. Eventually the producers made deals with the photographers' union to pay its members to stay home while *Life*'s photographers shot publicity photographs. The magazine had the first option of publishing those photographs exclusively.

John Florea recalls those years fondly, if wryly, "In Hollywood as a *Life* photographer, the question was, Who was the bigger star: the *Life* photographer or Ingrid Bergman? And believe it or not, it worked because we needed each other."[22]

Life reigned in Hollywood from 1936 until 1970, when the general demise of picture magazines was brought on by the popularity of television and the resulting decline in print media advertising revenues. *Life*'s West Coast bureau office was located in Los Angeles. Among the photographers assigned to it, Peter Stackpole, Florea, J R Eyerman, and Eliot Elisofon created many of the photo essays published on Hollywood.

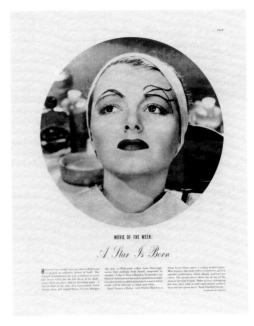

Stackpole covered the film capital from 1938 until 1951 and remembers the Hollywood of those days as "a crazy place with young hopefuls all over, people that never made it—and you knew damn well they'd never make it. You got to know what star material was and what it wasn't just by the people you'd see. I used to feel awful for the hopefuls in Central Casting, hopeful for any kind of publicity and notice. It was a publicity-run place, and you had to learn it that way. Everybody called you honey."[23] During those years Stackpole's photographs were an integral part of many *Life* stories.

"I used to dislike the way the fan magazine photographers handled a star. They would do anything to get an attractive picture. They'd say,

The May 3, 1937, issue of Life
*featured eight more Munkacsi portraits
of the "royalty of Hollywood":
(top) Charlie Chaplin, Mae West, Gary Cooper, Sylvia Sidney,
(bottom) Marlene Dietrich, Norma Shearer,
Carole Lombard, and Claudette Colbert.*
A Star Is Born *was the
"Movie of the Week."*

∎

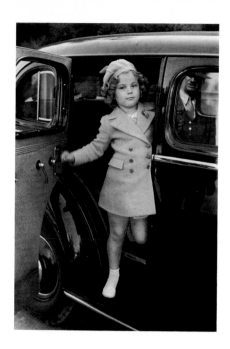

Peter Stackpole
Shirley Temple
1936
■

'Cheat a little this way, honey.' The stars didn't know the difference between showing themselves as real people and doing whatever the photographer dictated."[24]

Frequent use of 35mm made Stackpole a maverick, but it was precisely his mastery of this format that imbued all his photographs with a straightforward look of casual intimacy that is commonly found throughout modern photojournalism. Overlooked moments in the life of a star, such as Shirley Temple alighting from a car, were transformed into photographic statements as trenchant as most news images. That combination of spontaneity, incisiveness, and strong composition raises many of Stackpole's photographs to an emblematic level, for they reveal a movie personality as someone unique.

Florea recalls that watching the magazine's picture editors work "shook the living hell out of me": "A successful picture essay had to have a 'key picture.' The editors would get your pictures—fifty or sixty or a hundred pictures—and go through them—bing, bing, bing—as fast as they could go. If one jumped out at them, that was the key picture. Then they would build the story around it. Out of the one million pictures a year that the *Life* editors looked at, ten thousand got into the magazine. That shows you what a rare thing it was: 1 percent got in."[25]

John Engstead
Barbara Stanwyck
1942
■

I N 1948 AN EVENT OCCURRED that ultimately had an effect on Hollywood photographers, if not photography, more penetrating than the introduction of *Life*. "Until that year film finance was wondrously straightforward. The studio produced pictures and distributed them to theaters it owned. Proceeds from the box office paid for more pictures.

"A...Supreme Court decree of 1948 put a stop to that by splitting the studio from its theaters; production and distribution, from exhibition. The studios [began releasing] their contract players and technical personnel [including still photographers] and reduced their production schedules."[26] In the span of twenty years a contract labor force all but became a freelance labor force, and in terms of still photographers a curious, but steady return to the days of independents ensued.

Paul Hesse and John Engstead were two such independents, best known in the 1940s and 1950s for shooting commissioned portraits, celebrity product endorsements, and fashion layouts. Many of the stars remaining under contract during those years had greater freedom to work with the portraitists of their choice. What is more, the studios encouraged celebrities to pose for product endorsements as added publicity for their films.

Engstead opened his studio after leaving Paramount in 1941. Within months he was shooting fashion assignments for *Harper's Bazaar*. By

the 1950s he had acquired numerous advertising accounts as well. Well liked by the celebrities he photographed, they commissioned him to shoot intimate family portraits.

Engstead clearly worked well with strong lighting and powerful elements of environmental design. His photographs are boldly dramatic. Women are portrayed with an uncompromising sense of bewitching allure, and men are bestowed with uncommon grace. These unusual qualities in his work suited it for the worlds of fashion and film.

Color photography has only been a viable product in the marketplace for the last forty years. Even until the 1960s it was little used by many professional photographers because of the costs and time-consuming intricacies of lighting and processing compared with black-and-white. The majority of photographers investigating color during the 1930s and '40s worked with it on commercial assignments, for the added expenses could be charged to the client.

Product endorsements shot in color were Hesse's specialty. In the 1940s and 1950s he was on retainer for Chesterfield, Jergens, Lipton, Rheingold, Royal Crown Cola, and Studebaker, by whom he was richly rewarded, earning a "six-figure" salary. His Sunset Strip studio became a gathering place for the best-known talents of advertising and motion pictures. Robert Cummings modeled his character in the *Love That Bob* television series on Hesse.

Greer Garson wrote that Hesse was "greatly in demand by the leading national magazines to create cover-portraits to delight the eye.... The result would be a true-to-life likeness but idealized, or glamorized if you will, by his superb technique in producing only delectable color values."[27]

Not all freelance photographers specialized in the way Hesse did. Sid Avery recalls that "in order to make a living as a print photographer in Los Angeles, it was imperative to do more than one thing. In New York...you could be a tabletop photographer, a people photographer or a fashion photographer. [In Los Angeles] you [had] to do it all. It was essential that I learn to do cars, fashion, people—because there simply weren't enough accounts to specialize."[28]

The freelance or special assignment photographers worked toward finding the unusually imaginative picture. Not always working within a distinctive style, the end product, an honest pictorial representation of people and life was the objective. As a contributing photographer for the *Saturday Evening Post*, Avery was often required to produce photographs illustrating a written piece. The *Saturday Evening Post*, which was not, like *Life*, a picture magazine, favored writers over photographers. This offered a photographer less opportunity but more of a challenge to create the quintessential "picture worth a thousand words." In the course of his career as a still photographer in the forties, fifties, and sixties Avery shot some one hundred fifty thousand photographs of stars in Hollywood.

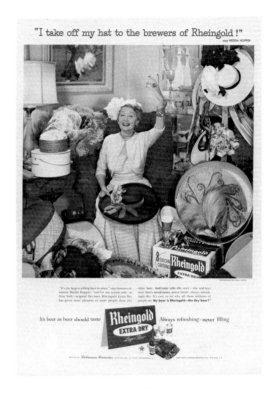

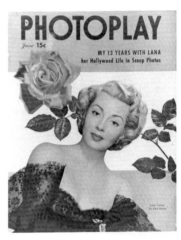

Paul Hesse
Hedda Hopper for Rheingold Beer
about 1957
Lana Turner for the cover of Photoplay
June 1948

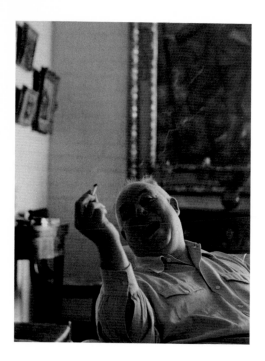

Sanford Roth
Jean Renoir
1951

∎

John Swope
Loretta Young, about 1942

∎

Sanford Roth shot stars on location in Los Angeles, New York, and Europe. His realistic style was particularly well suited to picture magazines, which continued to dominate the newsstands throughout the 1950s. He photographed stars on the set, between scenes, or at home in their private worlds. His unobtrusive approach made entry into those private worlds, albeit for short periods, a possibility. His portraits, which were published in *Harper's Bazaar, Life, Vogue,* and numerous European magazines, present a penetrating view backstage that suggests that glamour is just another nine-to-five job.

Another freelance photographer John Swope recalled:

It's very easy taking a picture of a wonderful actor because even though they're always conscious of the camera and of being photographed, they become so used to it that they don't pay any attention.

The main thing is to get a photograph that looks natural, whether the subject matter is someone you just happen upon, a well-known personality, or a landscape. I think for the most part [success depends on] a long experience of getting close to people without being shy. It's like when you approach an animal, if you're afraid, the animal will sense it right away. If you approach someone with trepidation, they become conscious of you, especially if you're holding a camera. The trick is to get an unposed picture. I don't think I'm very good at posing people. If I have to pose anyone and say, "Now do this," I become totally uncomfortable and it shows up in the photograph.[29]

Ruth Orkin's portraits of celebrities often place them outside the Hollywood context, making them less the star and more the individual captured in an expressive moment. "If a picture doesn't look assigned, it's because I was always looking and waiting for those moments that are 'true to life.'" But what looks spontaneous is, in fact, the result of dogged persistence and watchfulness. "I tried to get permission to hang around people long enough so that the proper lighting, situations, expression—and overall composition—would occur naturally."[30]

The freelancer on the set was an entrepreneurial sort. As Bob Willoughby remembers, "I was literally a one-man publicity department. I created the stories, organized the people, got the approval, and edited the material. My agent or I placed the stories. I knew what the various magazine editors were looking for. I was in touch with the editorial styles of the different American magazines. I knew who their audiences were."[31]

During the making of *A Star Is Born* (1954), he had assignments from six different magazines to supply photographs. Because of his success in placing his work, the studios themselves employed him as a "special," knowing the likelihood of his being prominently reproduced. During his twenty years in Hollywood, Willoughby was seldom out of print.

Unlike the preconceived, movie-related, newspaper-oriented stories that studio publicity departments "planted," Willoughby's photo layouts, not always predicated on specific motion picture projects, represented genuine human interest stories about Hollywood and the stars. "I tried to capture the reality of the way actors were working, of the life they were leading on the set."[32] During a film production, however, he originated publicity appealing to various magazine departments: fashion, beauty, or human interest.

Though both were freelancing, the work of the special photographers and the "street photographers" was significantly different. *Los Angeles Times* staff photographer Leigh Wiener began photographing premieres and Hollywood parties in the late 1940s along with photographers Nate Cutler, Nat Dallinger, and Hymie Fink. Their style was the precursor of today's paparazzi. Their photographs were reproduced in newspapers and fan magazines.

"The most important thing the paparazzi experience can teach anyone," according to Wiener, "is how to run with the mob and compete successfully against it at the same time. One learns how to locate the best vantage point from which to shoot, how to find a better angle, and even when and how to use available light—all to keep the photograph exciting, yet make it different."[33]

Bob Willoughby
Judy Garland, A Star Is Born,
1954
∎

WITH THE ADVENT of color television, magazine readers demanded more color photography. High-quality, fast color film stocks offered greater flexibility in producing subtle tonal nuances. Color film responds to the whole spectrum of visible light, extending the range of choices photographers have in creating their imagery, but a new generation of color photographers was required to see in terms of color. *Life*, due weekly on newsstands, operated on a three-day photography deadline. This limited the amount of color that could be reproduced. Given the immediacy expected of a newsweekly, *Life* continued to use more black-and-white than color photography. *Look*, a biweekly, offered an alternative.

In 1960 Douglas Kirkland was part of that new generation of photojournalists using primarily 35mm color. "Design became the priority [at *Look*]. They countered *Life* with more refined art direction and use of photography. With a [longer] deadline the photographers worked with the art director, getting involved in the design and layout of the pages. The extra time enabled

the photographers to come back from an assignment and edit their own work. *Life*, with its greater sense of urgency, required immediately sending your film in and letting the picture editors decide what were the best pictures."[34]

Color photography in 35mm best reflected the tenor of the 1960s. Dramatic color contrasts were evident in clothing, automobiles, art, and architecture. Experimentation in every aspect of life was encouraged. Kirkland responded by creating montage portraits as well as continuing to explore the limits of color photography.

THE MAJOR CHANGE in the structure of the Hollywood studio system, begun with the Supreme Court's so-called Paramount decree in the late 1940s and fully consolidated by the end of the 1960s, had completely changed the character of Hollywood still photography by 1970. The major studios were no longer grooming stars or signing long-term contracts. Most of the studio portrait galleries were closed. Actors assumed responsibility for their own portraiture, much as Pickford and Valentino had in the 1910s and 1920s.

Television offered advertisers access to larger audiences. Picture magazines and newspapers were declining. Those that remained devoted fewer pages to Hollywood. Many photographers retired or by 1970 changed careers as it became increasingly difficult to earn a living solely from still photography.

But in the aura of their golden years the still photographers of Hollywood assume a role somehow more exalted than their colleagues in the movie-making business because their accomplishments are more clearly the product of their own abilities, less evidently the result of collaboration. Regardless of background, training, or innate ability, there came a moment when even the least remembered of them made an image that perfectly synthesized the time, the place, and the people, even though produced under circumstances identical to the thousands or tens of thousands that preceded it.

Notes

1. Zelda Cini and Bob Crane with Peter H. Brown, *Hollywood: Land and Legend* (Westport, Conn.: Arlington House, 1980), 67.

2. Barbara Gelman, *Photoplay Treasury* (New York: Bonanza, 1972), *vii*.

3. John Kobal, *Hollywood: The Years of Innocence* (New York: Abbeville, 1985), 132.

4. Gelman, *Photoplay, viii.*

5. Laszlo Willinger, interview with the authors, Van Nuys, California, 25 August 1986.

6. John Kobal, *The Art of the Great Hollywood Portrait Photographers* (New York: Knopf, 1980), 279.

7. Willinger, interview with the authors.

8. John and Susan Edwards Harvith, *Karl Struss: Man with a Camera* (Bloomfield Hills, Mich.: Cranbrook Academy of Art Museum, 1976), 11.

9. David Fahey, *PhotoBulletin* 3 (June 1980): 4.

10. Ibid., 2.

11. Ben Maddow, "Hurrell of Hollywood," *American Photographer* 6 (April 1981): 48.

12. Quoted in Hurrell promotional brochure, 1980.

13. Gerald Mast, *A Short History of the Movies* (Chicago: University of Chicago Press, 1981), 218.

14. John Douglas Eames, *The MGM Story* (New York: Crown, 1982), 8.

15. Willinger, interview with the authors.

16. Ibid.

17. Ibid.

18. Richard Griffith, *The Movie Stars* (New York: Doubleday, 1970), 40.

19. Amei Wallach, "Publicity Finds a Museum Niche," *Newsday*, 11 January 1981.

20. Ted Allan, interview with the authors, Los Angeles, California, 28 February 1987.

21. Frank Powolny, interview with John Kobal, Newberry Park, California, April 1977.

22. John Florea, interview with the authors, Los Angeles, California, 4 September 1986.

23. Peter Stackpole, interview with the authors, Oakland, Caifornia, 11 February 1987.

24. Ibid.

25. Florea, interview with the authors.

26. Mitch Tuchman, "Post-Tax-Shelter Hollywood Has a New Mogul: Uncle Sam," *Film Comment* 14 (November/December 1978): 70.

27. Greer Garson to Don Hesse, 25 March 1980.

28. Julie Fretzin, "A Director for All Seasons," *Commercials Monthly* 6 (June 1981): 1.

29. John Swope, manuscript, 1978.

30. Ruth Orkin, *A Photo Journal* (New York: Viking, 1981), 49.

31. Bob Willoughby, interview with the authors, Los Angeles, California, 31 May 1987.

32. Ibid.

33. Leigh Wiener, *How Do You Photograph People?* (New York: Viking, 1982), 20.

34. Douglas Kirkland, telephone interview with the authors, 30 April 1987.

Frank Powolny
Betty Grable, 1943
Silver gelatin photograph
19⅞ x 15⅞ in.

PLATES & CHRONOLOGIES

ALTHOUGH 5 MILLION PRINTS of Frank Powolny's pinup portrait of Betty Grable were distributed to GIs during World War II, in the six years of gathering photographs for *Masters of Starlight* we were able to find only one print made from the original negative; that was hanging, uncelebrated, in Frank Powolny's home.

Every photograph in *Masters of Starlight* is an original print made from the original negative or transparency shot by the photographer. The majority are vintage prints, those made by the photographer or under the photographer's supervision within three years of the original shoot. Where acceptable vintage prints were not to be found but original negatives or transparencies exist, modern prints were made especially for the exhibition. Whenever possible, the photographer made or supervised the making of these prints. In the remaining cases the intent of the photographer was considered in determining cropping and overall tonality. Each such print was approved by the photographer's estate.

Betty Compson, George Fitzmaurice

The Barker, *1928*

Silver gelatin photograph

7³/₁₆ x 9⁵/₁₆ in.

∎

NELSON EVANS

Birthplace and life dates unknown.

Very little is known about the life and career of Nelson Evans. He was among the first commercial portrait photographers in Los Angeles. His studio was located on Hollywood Boulevard within walking distance of several of the early motion picture lots. In the period when motion picture performers arranged for their own publicity portraits, Evans photographed many of the pioneers, including Lon Chaney, Tom Mix, Mary Pickford, Gloria Swanson, Rudolph Valentino, and Anna May Wong. He photographed for the Triangle studio and worked briefly as Mack Sennett's still photographer.

As early as 1914 Evans was commissioned by *Photoplay* to do a picture story on actor Hal Cooley at home. Thereafter his photographs of stars at home–or "contributing to the cause" during World War I–appeared in numerous magazines, including *Harper's Bazaar, Motion Picture,* and *Picture Play.* By 1921, however, his photographs had ceased to appear.

Mary Pickford

Mistress Nell, 1915

Silver gelatin photograph

9 ³⁄₈ x 7 ⁷⁄₁₆ in.

■

Mary Pickford was one of the first film stars to recognize the value of stills for nurturing a screen image. Even past the age of thirty she commissioned portraits projecting the good-hearted, golden-tressed little girl of her films. She was about twenty-two when she posed for this Nelson Evans portrait. In 1929 she hired Karl Struss to help alter her image to that of a sophisticate to keep abreast of American values and styles.

WITZEL

Birthplace and life dates unknown.

Very little is known about the life and career of Witzel. Like Nelson Evans he was a Los Angeles commercial portrait photographer in the 1910s and 1920s. His images of motion picture celebrities appeared regularly in early fan magazines, including *Motion Picture* and *Photoplay*. He worked on assignment periodically for the William Fox studio. In 1917 for Fox he photographed Theda Bara in her roles as Cleopatra, Salome, and Madame du Barry.

Theda Bara

Cleopatra, 1917

Silver gelatin photograph

9 ¹⁄₁₆ x 7 ⁵⁄₁₆ in.

■

Anonymous
Karl Struss, 1927
Silver gelatin photograph
9⅜ x 7⁵⁄₁₆ in.

■

KARL STRUSS

United States, 1886–1983

Born in New York City.

1908–12 Takes night classes in photography with Clarence White at Teachers College, Columbia University.

1909 Travels ten weeks in Europe, photographing with his patented Struss Pictorial Lens, a soft-focus lens devised for still photography. Resulting prints included in the Albright Art Gallery exhibition of Photo-Secessionist work and published as gravures in *Camera Work*.

1912–17 Member of Alfred Stieglitz's Photo-Secession group.

1914 Takes over White's New York City studio, specializing in portraiture and advertising as well as shooting illustrations for numerous periodicals, including *Harper's Bazaar, New York Evening Post Saturday Magazine, New York Tribune, Photo-Era, Vanity Fair,* and *Vogue*. Manufactures his Pictorial Lens for sale; John Leezer, a D. W. Griffith cameraman, among the purchasers.

1917–18 Experiments with infrared photography while in U.S. Army.

1919–22 Still photographer and soon assistant cameraman on numerous Cecil B. DeMille/Famous Players-Lasky productions, including *Male and Female* (1919),* *Why Change Your Wife* (1920), *Something To Think About* (1920), *Forbidden Fruit* (1921), *The Affairs of Anatol* (1921), *Fool's Paradise* (1922), and *Saturday Night* (1922). (As his cinematography responsibilities grew, his still photography duties became somewhat more informal.) While working for DeMille experiments with panchromatic film and filters. First sole cinematography credit: *The Law and the Woman* (1922).

1922–24 As cinematographer and still photographer for B. P. Schulberg's Preferred Pictures—films include *Minnie* (1922), *Fools First* (1922), *Maytime* (1923), and *Poisoned Paradise* (1923)—making occasional films for other production companies. Between cinematography assignments, takes stills for films, including *Barbara Frietchie* (1924).

About 1923–24 Devises the Lupe light, an automobile headlight reflector and a 1000-watt tungsten bulb, for use as a catch light in actors' eyes.

1924–25 In Rome assumes direction of cinematography on *Ben-Hur*. (More than half the finished film is his, though he was not among the forty-two cameramen who photographed the chariot race.)

1927 Founding member of the Academy of Motion Picture Arts and Sciences. For their work on *Sunrise* Struss and Charles Rosher share first Academy Award given for cinematography (1927–28).

1928–55 Cinematographer on more than 110 films, specializing after 1953 in Italian 3-D productions.

1950–75 Takes stereoscopic slides, though ceasing to exhibit them after 1967.

1970 Retires.

Exhibition
Shows photographs in competitive salons and other exhibitions in Europe and North America (1918–39). San Francisco Museum of Modern Art, *California Pictorialism,* 1977.

Chronology adapted in part from John and Susan Edwards Harvith, *Karl Struss: Man with a Camera* (Bloomfield Hills, Mich.: Cranbrook Academy of Art Museum, 1976).

*Dates in parentheses following film titles indicate year of release.

Richard Dix

Not Guilty, *1921*

Platinum photograph

7 9/16 x 9 1/2 in.

■

"Ben-Hur, Rome, 1924," 1924

Silver gelatin photograph

7 ¼ x 9 ¼ in.

■

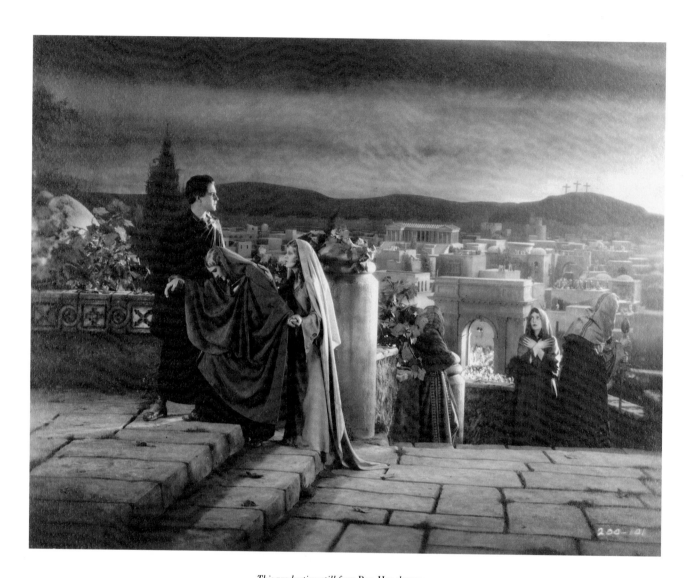

This production still from Ben-Hur *demonstrates Karl Struss's ability to compose complicated scenes. Lighting the background of his tableaulike arrangement of figures makes them appear three-dimensional. In addition to taking production stills for the film, Struss was one of several credited cinematographers during the shooting that took place in Rome in 1924. Much of the film was reshot in Hollywood before its eventual release in 1926.*

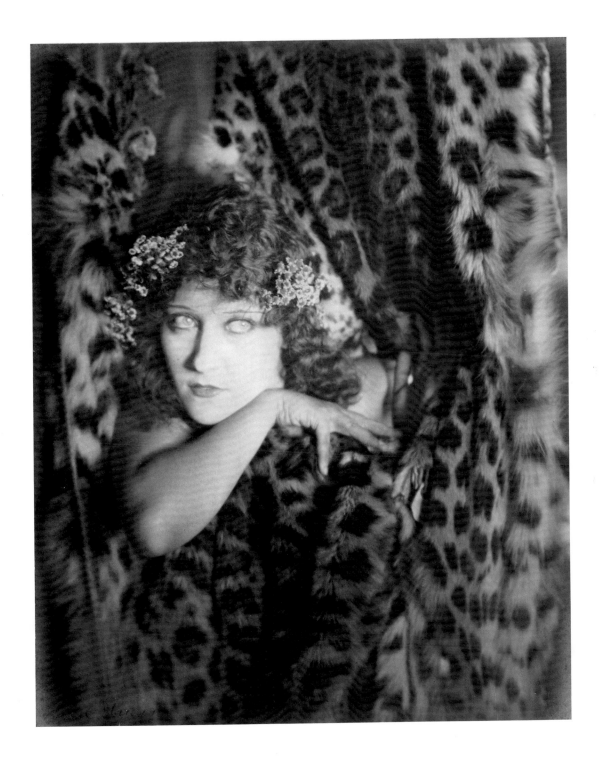

ARTHUR RICE

United States, life dates unknown

Born near the East Coast.

Apart from a brief period, 1921–22,
spent working in Hollywood, very little
is known about the life of Arthur Rice.
During those years he made production
stills of Nazimova and Rudolph
Valentino on *Camille* (1921), *The Con-
quering Power* (1921), *The Four Horse-
men of the Apocalypse* (1921), and *Sa-
lome* (1922). In 1922 he left Hollywood
and returned to either the East Coast or
Toronto.

The Four Horsemen of the Apocalypse, *1921*

Silver gelatin photograph

7 9/16 x 9 3/8 in.

■

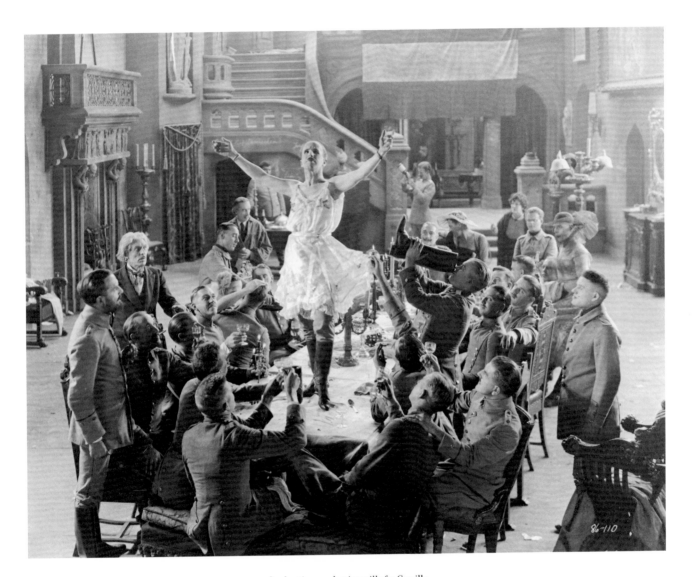

In shooting production stills for Camille
and The Four Horsemen of the Apocalypse
*(both 1921), Arthur Rice captured a sense
of exoticism, extravagance, and romance.
Set against opulent backgrounds, the pho-
tographs celebrate sophisticated sexuality.
Nevertheless Rice's photographic style itself
can be described as straightforward: his
subjects most often viewed from eye level,
his studio scenes evenly lit. In the still from*
Camille *this dispassionate style permits
viewers the pleasure of projecting their own
erotic fantasies onto the image of Alla
Nazimova and Rudolph Valentino.*

Alla Nazimova, Rudolph Valentino

Camille, *1921*

Silver gelatin photograph

9 ¹/₂ x 7 ⁵/₈ in.

■

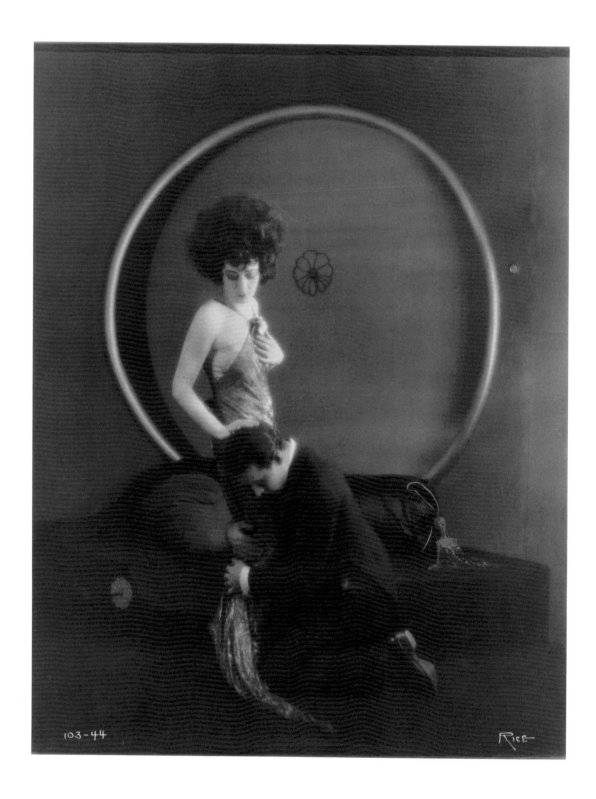

103-44

Rice

Alla Nazimova

Camille, *1921*

Silver gelatin photograph

7 ⅝ x 9 ⅝ in.

■

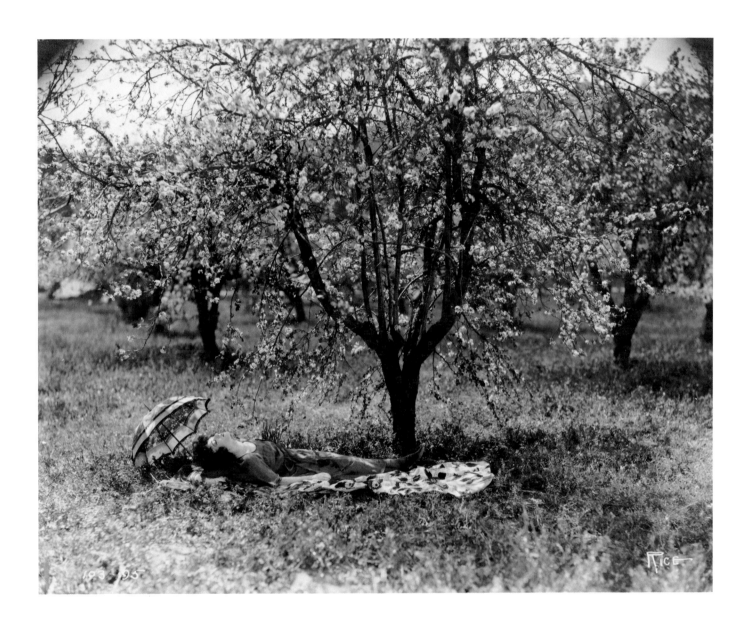

Anonymous
James Abbe, about 1920
Modern silver gelatin photograph
7³/₁₆ x 8½ in.

■

JAMES ABBE

United States, 1883–1973

Born in Alfred, Maine

1895 Receives first camera.

1898 Sells photographs to sailors aboard the battleship *Maine*.

1913 First photography assignment, a college annual, leads to requests for individual portraits, allowing Abbe greater artistic freedom.

1917 In New York sells photos of coed/models at five dollars apiece as magazine illustrations.

1918–19 As freelance photographer makes publicity photographs for stage and screen celebrities. His portrait of Jeanne Eagels becomes first *Saturday Evening Post* photographic cover (1919). John Barrymore's insistence on being photographed on the theater stage instead of in Abbe's studio forces Abbe to create on-location theatrical photography genre (1919). Makes portraits of Theda Bara, Billie Burke, Eagels, Lillian Gish, Pola Negri, Mabel Normand, Rudolph Valentino, and Mae West for *New York Times*.

1920 Still photographer on *Suds* with Mary Pickford in Hollywood. Hired by D. W. Griffith to shoot scenes as well as portraits for *Way Down East*.

1921 Takes stills of Mack Sennett's bathing beauties. Invited by Sennett to direct two-reelers in Hollywood.

1922 Shoots publicity stills for Griffith's Mamaroneck, New York, studio. At Lillian Gish's suggestion photographs *The White Sister* in Italy.

1922–34 Travels throughout Europe as a photojournalist (based in Paris, 1923–32), intermittently photographing celebrities, including the Dolly Sisters, Bessie Love, Fred and Adele Astaire, Noel Coward, and Gertrude Lawrence.

1924 Assignments for *Tatler*. Photographs frequently published in French (*L'Illustration, Vogue, Vu*), German (*Berliner Illustrierte, Dame*), British (*Harper's Bazaar*), and American (*Vanity Fair, Vogue*) periodicals.

1928–29 News photographer in Soviet Union for *Berliner Illustrierte*; then asked by government to leave the country. To Cuba on assignment for *Berliner Illustrierte, London* magazine, and *Vu* (a French newsweekly); then to Mexico to photograph an army rebellion. In Mexico photographs Diego Rivera and the dance and theater arts scene.

1932 On return to Soviet Union becomes first foreign correspondent to photograph Stalin. Documents Russian theater and ballet.

1933 On assignment for London *Times* travels to Germany and photographs high-level Nazi officials: Hitler, von Hindenburg, Goring, and Goebbels.

1934 Returns with family to the United States, settling (1936) in Larkspur, Colorado.

1936–37 As photographer/correspondent for *Alliance* covers the Spanish civil war from the royalist point of view, opposing Ernest Hemingway's loyalist coverage. Ceases photographing and becomes increasingly involved in journalism.

1937 Wife, Polly, returns to Germany with children to write about the Nazi movement; separation becomes permanent.

1945–61 Radio news commentator for Pacific Coast Network. On his own *James Abbe Observes* covers newsworthy events, such as founding of the United Nations (1945).

1950–61 Television critic for *Oakland Tribune*.

1961 Retires.

Publications
I Photograph Russia (New York: Stokes, 1934). With Patience and Richard Abbe, *Around the World in Eleven Years* (New York: Stokes, 1936).

Lillian Gish
Broken Blossoms, *1919*
Modern silver gelatin photograph
9 ¾ x 7 ¹¹⁄₁₆ in.

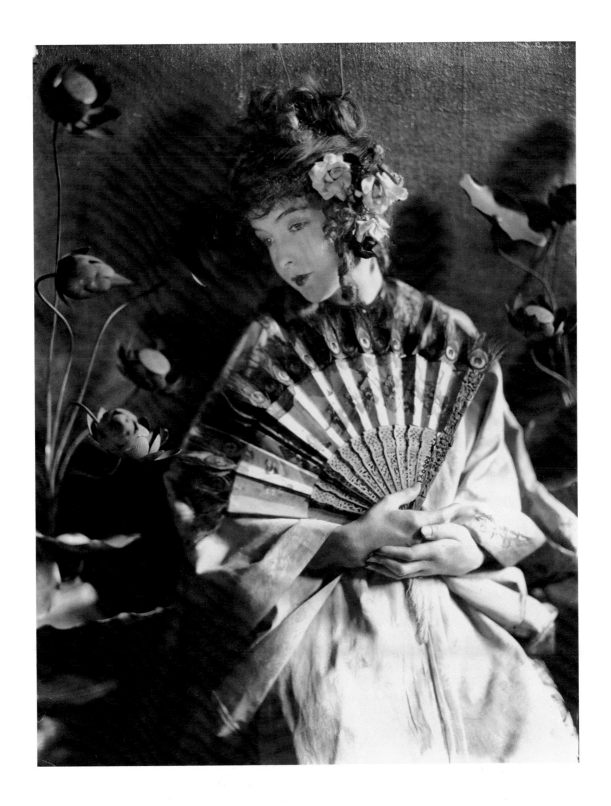

Betty Blythe

Chu, Chin, Chow, *1925*

Silver gelatin photograph

$8 \frac{5}{8} \times 5 \frac{1}{2}$ *in.*

■

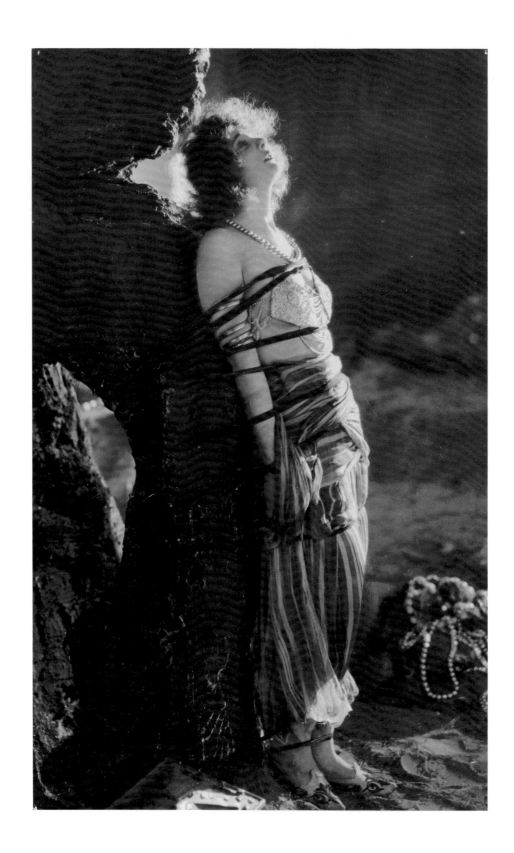

Francis X. Bushman, 1921

Silver gelatin photograph

13 ⅛ x 10 ¼ in.

■

Jackie Coogan

The Kid, *1921*

Silver gelatin photograph

9 ¹¹⁄₁₆ x 7 ⁵⁄₈ in.

∎

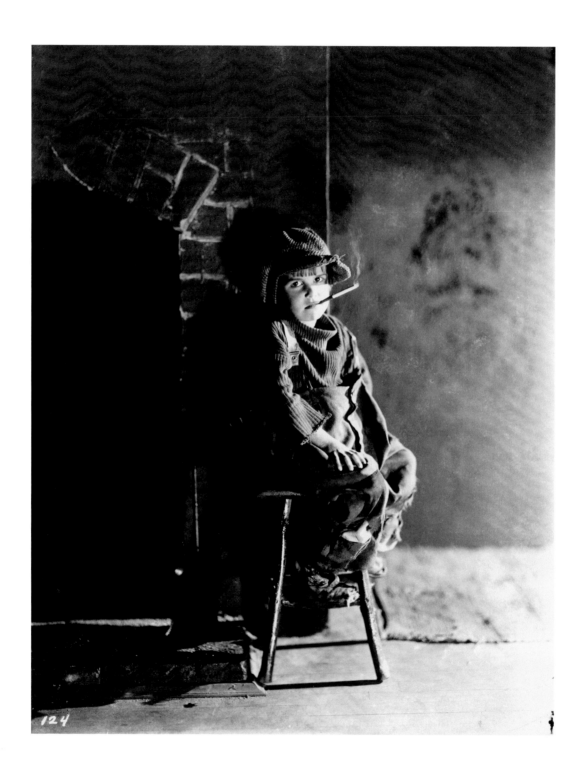

Louise Brooks

Le Prix de beauté, 1930

Silver gelatin photograph

14 ⅛ x 10 ⅞ in.

■

Lillian Gish, Ronald Colman

The White Sister, 1923

Silver gelatin photograph

13⅜ x 10⅞ in.

∎

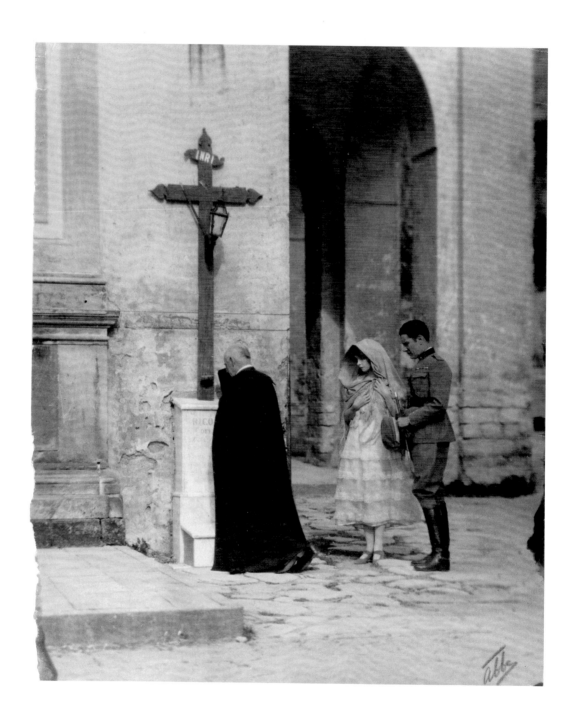

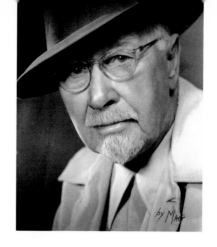

Manford E. Magnuson (United States, 1895–)
Edward Sheriff Curtis, 1951
Modern silver gelatin photograph
9 7/16 x 7 1/2 in.

∎

EDWARD SHERIFF CURTIS

United States, 1868–1952

Born in Whitewater, Wisconsin.

1896–1919 Establishes substantial renown as a photographer principally through his documentation of the lives and cultures of North American Indians. Makes more than 40,000 negatives, using initially a 14 x 17 view camera, later an 11 x 14 view camera, and finally a 6 x 8 reflex camera. In 1907 the first two volumes of *The North American Indians* were published. The twenty-volume set, containing more than 2,000 photographs of eighty Western tribes, was completed in 1930. A chronicle of these years appears in Barbara A. Davis, *Edward S. Curtis: The Life and Times of a Shadow Catcher* (San Francisco: Chronicle, 1985).

1919–25 Daughter, Beth Curtis Magnuson, and son-in-law, Manford Magnuson, form E. S. Curtis Studio, a commercial portrait studio, at the Biltmore Hotel, Los Angeles; film stars among their clients. Shoots special portrait assignments. Makes photographic stills for DeMille films, including *Adam's Rib* and *The Ten Commandments* (both 1923).

1925 Leaves studio work to complete *The North American Indians*.

1932 Photographs Johnny Weismuller in *Tarzan the Ape Man*.

1936 Photographs Gary Cooper in DeMille's *The Plainsman*.

Publications
The North American Indian vols. 1–5 (Cambridge, Mass: The University Press, 1907–9), vols. 6–20 (Norwood, Conn.: Plimpton, 1911–30). *The Flute of the Gods* (New York: Stokes, 1909). *Indian Days of Long Ago* (Yonkers: World, 1914). *In the Land of the Head Hunters* (Yonkers: World, 1915). Christopher Lyman, *The Vanishing Race and Other Illusions: Photographs of Indians by Edward S. Curtis* (New York: Pantheon, 1982).

Rudolph Valentino

The Sheik, *1921*

Silver gelatin photograph

3 ¼ x 2 ½ in.

■

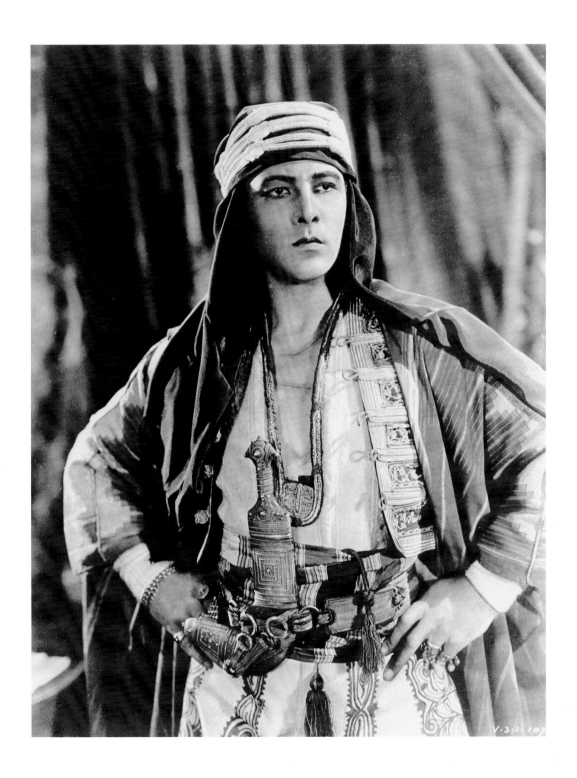

Theodore Roberts, Nigel de Brulier

The Ten Commandments, 1923

Blue-toned silver gelatin photograph

10⁹/₁₆ x 13⁹/₁₆ in.

■

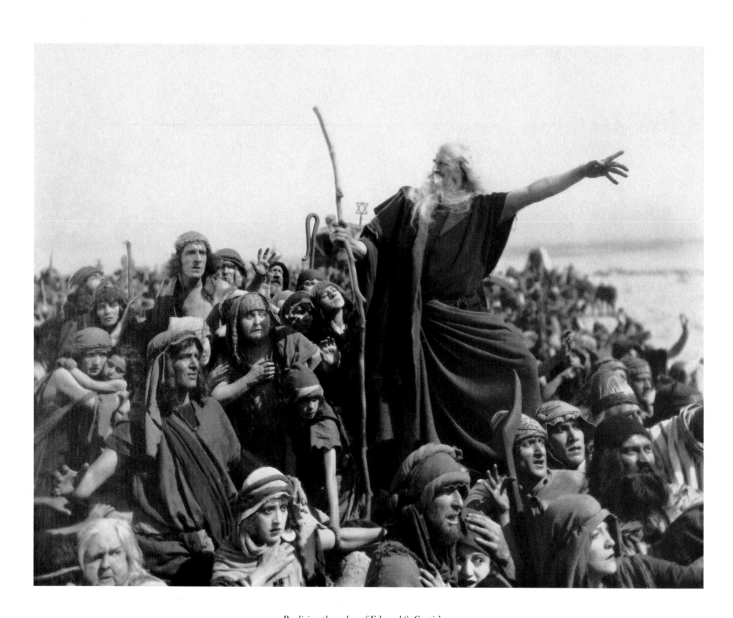

Realizing the value of Edward S. Curtis's seventeen years of experience photographing the Indians of the American West, Cecil B. DeMille, a close friend, hired him to shoot stills on The Ten Commandments *(1923). For the film Curtis created portraits and complicated, tableaulike camera studies like those he had made of Indians.*

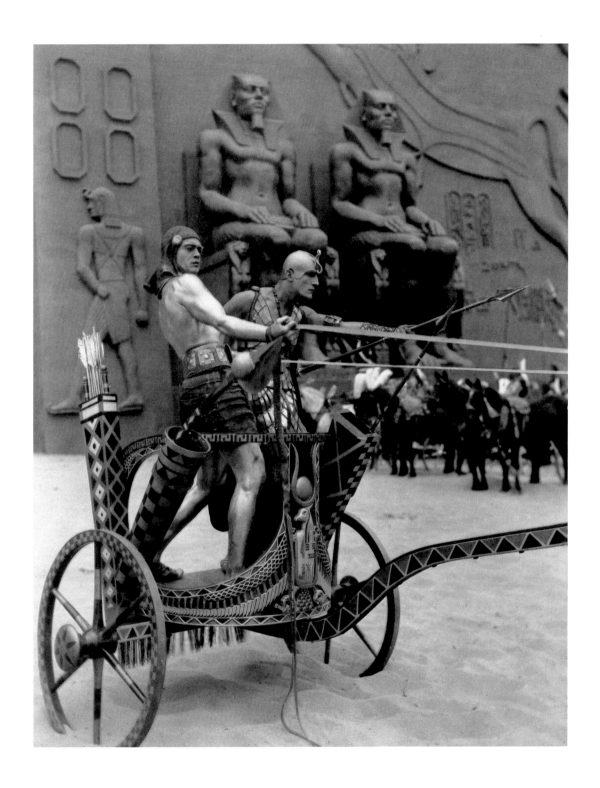

Theodore Roberts

The Ten Commandments, 1923

Hand-colored silver gelatin photograph on ivory

5¾ x 4³⁄₁₆ in.

■

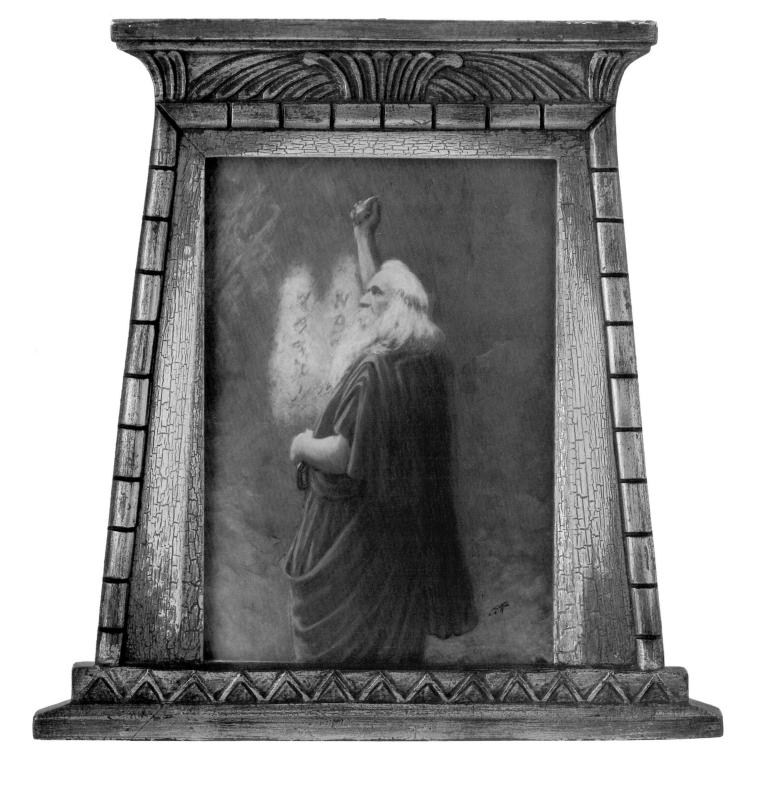

Anna May Wong, about 1925

Hand-colored silver gelatin photograph

15 x 9½ in.

■

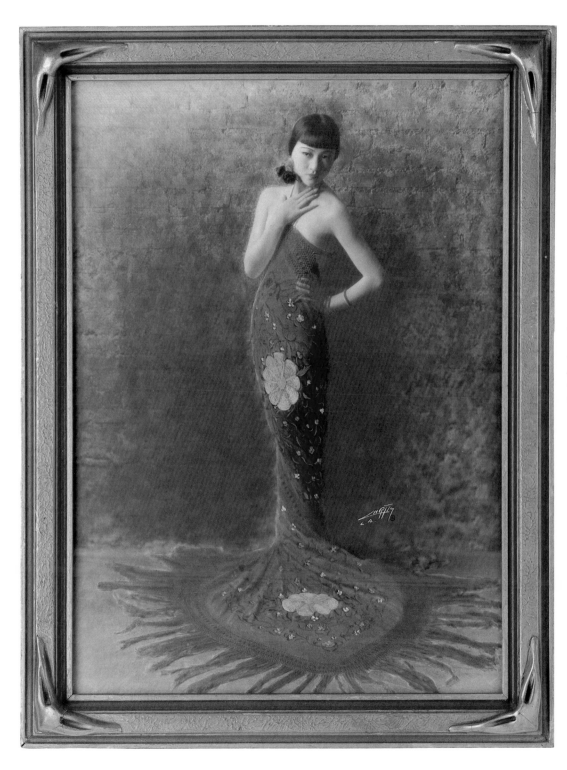

*Curtis rarely worked out of his Los Angeles
studio in the Biltmore Hotel. Many studio
photographs that bear his stamp were actu-
ally shot by his son-in-law, Manford
Magnuson. Curtis did come to the studio
for special sittings, however, and personally
signed the resulting prints. This hand-
colored photograph of Anna May Wong
is thought to be a unique print.*

William Mortensen
Arthur F. Kales
Silver gelatin photograph
13⅜ x 10³⁄₁₆ in.

■

ARTHUR F. KALES

United States, 1882–1936

Born in Arizona Territory.

1915–20 As oil company executive
becomes avocational photographer in
pictorial style, experimenting with gum,
carbon, and platinum printing.

1919–24 In Hollywood photographs
Ruth St. Denis dance company, includ-
ing Martha Graham and Doris Hum-
phrey, and other celebrities, including
Juliette Johnson, Marguerite De La
Motte, and Gloria Swanson.

1920 Makes portrait of Thomas
Meighan for DeMille's *Why Change
Your Wife*. Introduced to complex
bromoil transfer photographic printing
technique, which he teaches in turn to
William Mortensen.

Publications
1916–28 Writes and contributes photo-
graphs to *Photograms of the Year* (Lon-
don). 1920s Work published in *Camera
Craft* and *Photo Era* magazines.

Exhibitions Participates in fifty-five
exhibitions, including six solo exhibi-
tions. Works included in annual Lon-
don Salon of Photography (1916–34).
San Francisco Museum of Modern Art,
California Pictorialism, 1977.

Chronology based in part on research by
Paul Hertzman.

Thomas Meighan

Why Change Your Wife, *1920*

Silver gelatin photograph

13^{7}/$_{16}$ x 10^{7}/$_{16}$ in.

■

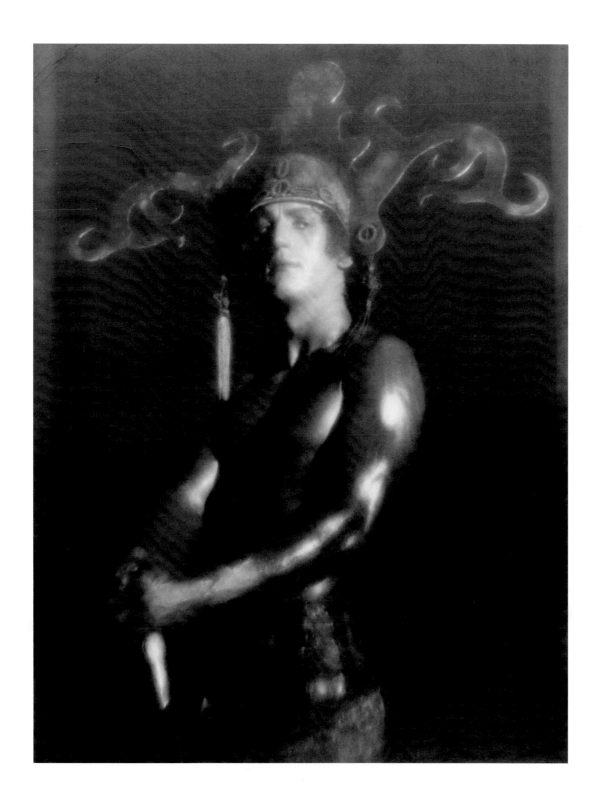

*Self-portrait with electric bromide tool
and portrait of Jean Harlow,
about 1930
Silver gelatin photograph
12¾ x 10⅛ in.*

■

WILLIAM HERBERT MORTENSEN

United States, 1897–1965

Born in Park City, Utah.

1907 Receives a simple Brownie camera.

1918–20 Attends classes at Art Students League, New York City.

1919 Supplements allowance from home by painting portraits on commission.

1920 Teaches art at East Side High School, Salt Lake City.

1921 In Los Angeles designing sets and costumes for *The Rubaiyat of Omar Khayyam*.

1922 Begins a career in commercial photography, making portraits of Hollywood performers. Befriended by Arthur Kales, who teaches him the bromoil transfer photographic printing process.

1925 Opens portrait studio in Hollywood, specializing in photographing performers in costume.

1926 Photograph entitled "Salome" shown at London Photography Salon. Several images published in photography periodicals, including *American Photography* and *American Annual*.

1926–30 Still photographer on most DeMille productions beginning with *The King of Kings* (1927).

1930 Moves to Laguna Beach. Subjects photographed there include Clara Bow, Jean Harlow, Rudolph Valentino, and Fay Wray.

1932 Opens Mortensen School of Photography, Laguna Beach.

1935 Perfects Metalchrome, a process for rendering black-and-white photographs in color through locally applied chemicals.

Publications

1933–53 Numerous articles on photography published in *American Photography* and *Camera Craft. Projection Control* (San Francisco: Camera Craft, 1934). *Pictorial Lighting* (San Francisco: Camera Craft, 1935). *Monsters and Madonnas* (San Francisco: Camera

Craft, 1936). *The Command to Look* (San Francisco: Camera Craft, 1937). *The Model* (San Francisco: Camera Craft, 1937). *Print Finishing* (San Francisco: Camera Craft, 1938). *Mortensen on the Negative* (San Francisco: Simon & Schuster, 1940). *Outdoor Portraiture* (San Francisco: Camera Craft, 1940). *Flash in Modern Photography* (San Francisco: Camera Craft, 1941).

Exhibitions

Smithsonian Institution, Washington, D.C., solo exhibition, 1948. San Francisco Museum of Modern Art, *California Pictorialism*, 1977.

Collections

International Museum of Photography at George Eastman House, Rochester, New York; Metropolitan Museum of Art, New York; Oakland Museum of Art.

Chronology adapted in part from Deborah Irmas, *The Photographic Magic of William Mortensen* (Los Angeles: Los Angeles Center for Photographic Studies, 1979).

Jean Harlow, 1927

Silver gelatin photograph

12 ¹¹/₁₆ x 10 ⅛ in.

■

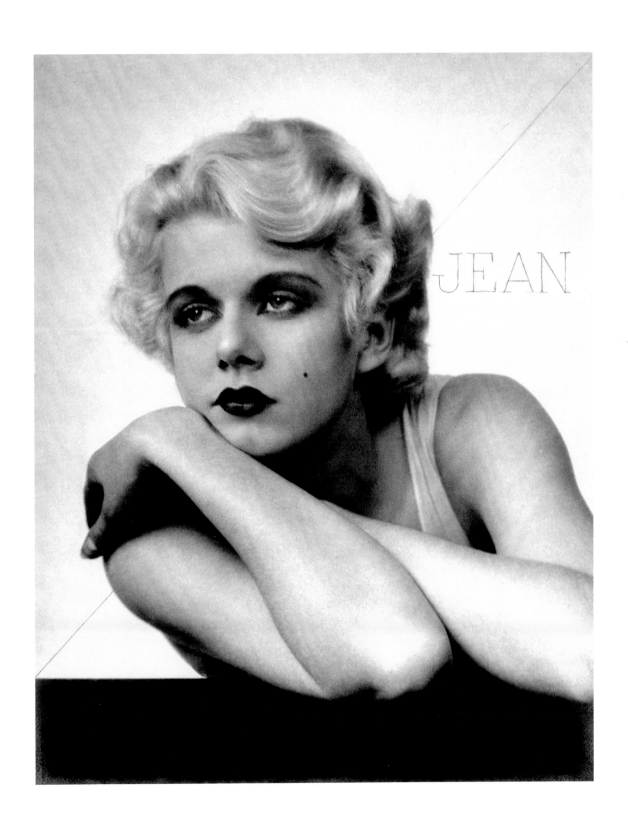

Jean Harlow, 1927

Silver gelatin photograph

12 ¹¹/₁₆ x 10 ⅛ in.

"The Last Supper"

The King of Kings, *1927*

Silver gelatin photograph from the book The Life of Christ

9 ³/₄ x 12 ¹³/₁₆ in.

■

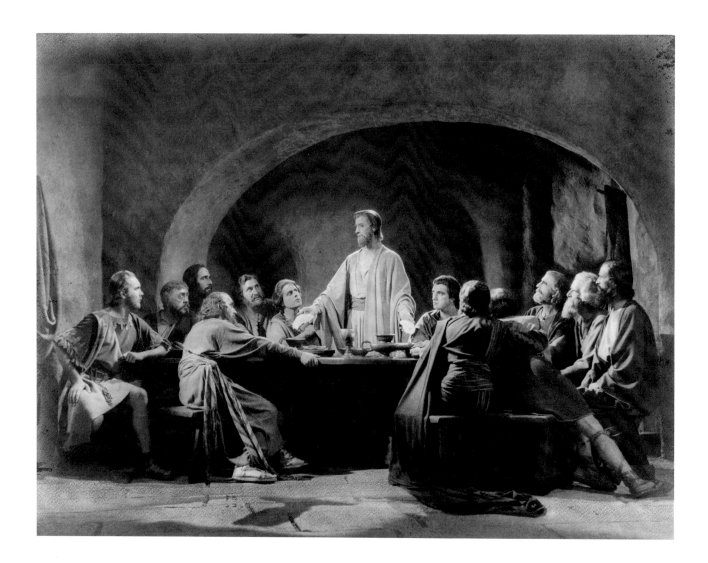

Cecil B. DeMille hired William Mortensen to photograph the stills for his film The King of Kings *(1927). They are of historical significance today not only as a record of the making of the film but also as the first motion picture stills made with a hand-held camera. Its use accounts in part for Mortensen's aston- ishing productivity: about four hundred negatives. What emerged was a series of photographs that capture scenes as they were being shot, not posed afterwards. So pleased was DeMille with the results that he commissioned Mortensen to produce a limited-edition album of sixty of the most impressive images, one rare remaining example of which is in the Vatican library.*

"The Ninth Hour"

The King of Kings, *1927*

Silver gelatin photograph from the book The Life of Christ

10 1/16 x 13 1/4 in.

■

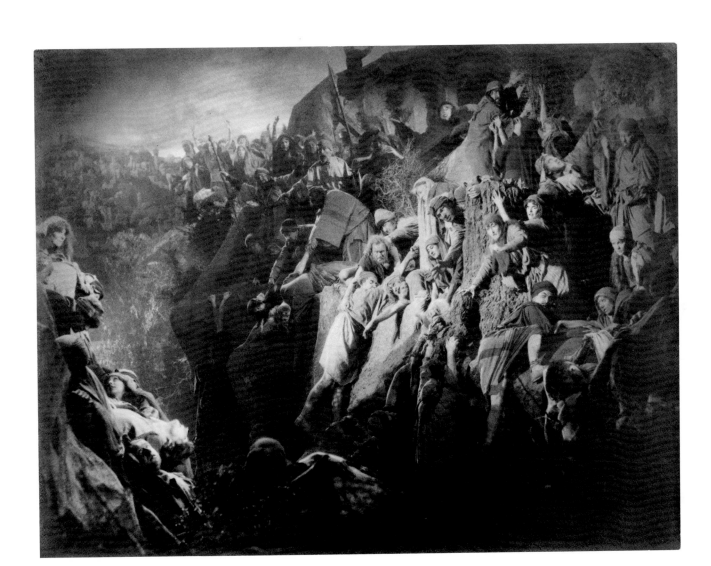

EDWIN BOWER HESSER

United States, 1894–?

Birthplace unknown.

1915 Arrives in Hollywood.

1917 Capt., Photographic Section, U.S. Army Signal Corps. Writes, produces, and directs featurette *The Triumph of Venus*. Experiments with color photography.

1918–28 Returns to Hollywood as photographer in the pictorial style, making seductive seminude portraits of Clara Bow, Jean Harlow, Bessie Love, Norma Shearer, Gloria Swanson, Norma Talmadge, and Anna May Wong.

1919 Nude studies and portraits first published in photographic magazines under the title "Sunlight and Shadow."

1922–about 1928 Publishes *Edwin Bower Hesser's Arts*.

1928 Provides photographic illustrations for *True Stories* magazines. Joins IATSE #659 (motion picture and still photographers union).

1929 Leaves Hollywood when portrait galleries become widespread on the studio lots.

1929–33 Manages *New York Times* natural color photographic department. (Until that time most newspaper photography printed in color was based on hand-colored black-and-white prints.)

1933 Returning to Hollywood, introduces his newly patented Hessercolor separation and printing process. Begins work in advertising photography.

1934 Plans Hessercolor printing plant.

Little is known of Hesser's life and career after 1934. His photographic estate, including more than five thousand negatives of nudes, was partially dispersed through sale in the 1970s.

Publication
"The Wonders of Hessercolor," *International Photographer*, January 1934, 8–9.

Exhibition
National Portrait Gallery, Washington D.C., *The Art of the Great Hollywood Portrait Photographers*, 1983.

Chronology based in part on research by John Kobal, the Kobal Collection, London.

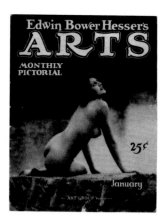

Melva Cornell, about 1925

Silver gelatin photograph

13¹³⁄₁₆ x 10¾ in.

■

Edwin Bower Hesser arrived in Hollywood just as Arthur Rice and Karl Struss were making their provocative pictorialist portraits and production stills. While he made portraits of many of the most renowned male and female stars, he established a reputation as one of the foremost photographers of young women trying to break into the movies. He charged his subjects nearly triple the rate of other photographers and photographed only those beauties who appealed to him visually.

Hesser's photographs embody a more natural approach to sensuality than do those of the other pictorialists. He often photographed nudes out of doors. One of his favorite locations was an idyllically landscaped area on Lookout Mountain in the Hollywood Hills. Whether photographed outdoors or in the studio, however, Hesser's models seem somehow removed from their environments both physically and emotionally, evoking a kind of spirituality. Hesser often shot from low camera angles, making his subjects, sometimes posed in imitation of widely reproduced art nouveau statuary of the period, appear monumental. Draped in flowing, translucent fabrics, their figures are tantalizingly revealed.

Jean Harlow, 1928

Silver gelatin photograph

9 ½ x 12 ⅞ in.

■

Anonymous
Ruth Harriet Louise, Joan Crawford, 1928
Silver gelatin photograph
9 7/16 x 7 1/2 in.

■

RUTH HARRIET LOUISE

United States, 1906–44

Born in New York City.

1923 Opens commercial photography studio, New York City.

1925 Opens commercial photography studio on Hollywood Boulevard and within a few months becomes a contract photographer at MGM.

1925–30 Heads her own portrait gallery at MGM, the only woman ever to hold that post full time at a major Hollywood studio. Selected by Garbo as her exclusive studio portrait photographer (until 1929). Asked by William Randolph Hearst, whose Cosmopolitan productions were distributed by MGM, to photograph his star Marion Davies (about 1926). Hearst's influence may have accounted for the generous terms of Louise's contract, which included the privilege of photographing subjects outside the studio, approval of prints to be reproduced, and attribution by name upon reproduction.

1930– As freelancer photographs performers not under studio contracts.

Little is known about Louise's career between 1930 and her death in 1944.

Exhibition
National Portrait Gallery, Washington D.C., *The Art of the Great Hollywood Portrait Photographers*, 1983.

Chronology adapted in part from John Kobal, *The Art of the Great Hollywood Portrait Photographers* (New York: Knopf, 1980).

Ramon Novarro, 1920s

Silver gelatin photograph

12 ⅛ x 9 3/16 in.

■

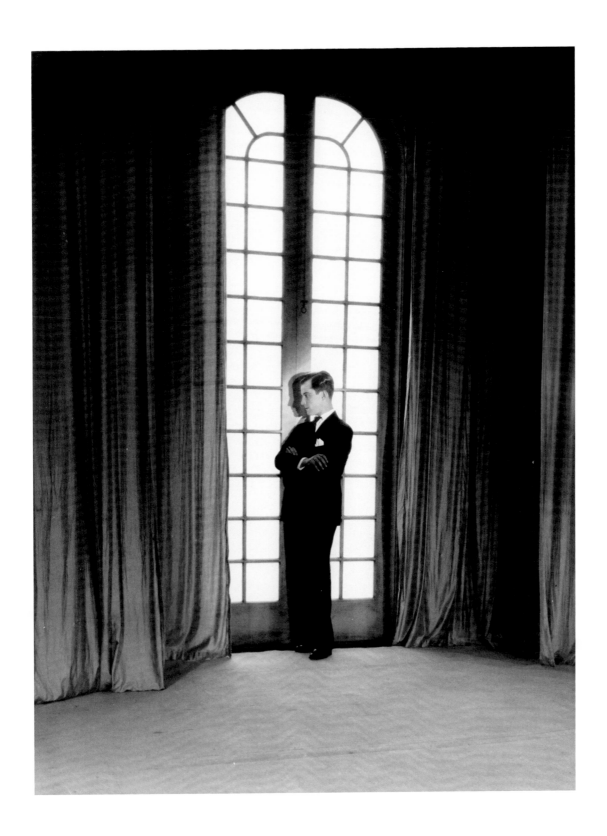

Anna May Wong

China Bound, *1929*

Silver gelatin photograph

12 ⅛ x 9 ³/₁₆ in.

■

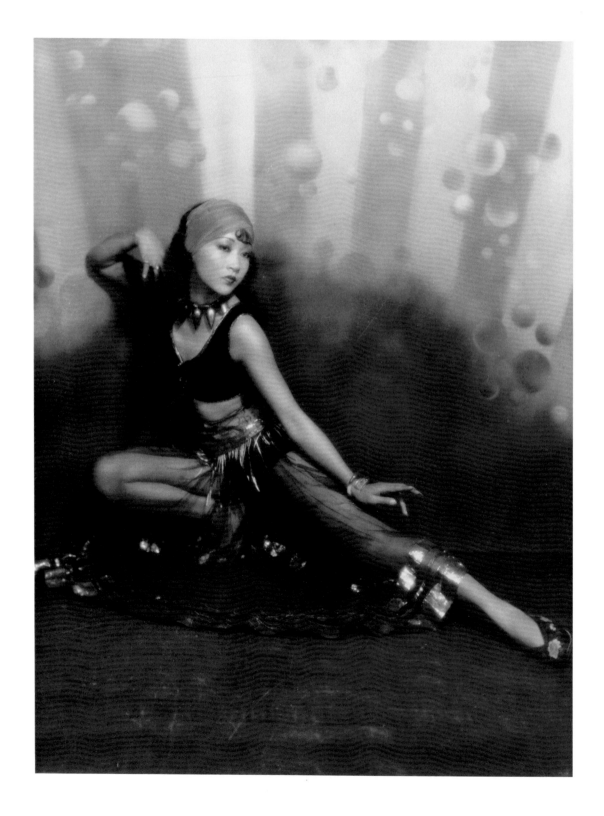

Lon Chaney

The Road to Mandalay, 1926

Silver gelatin photograph

13 ½ x 9 ¼ in.

■

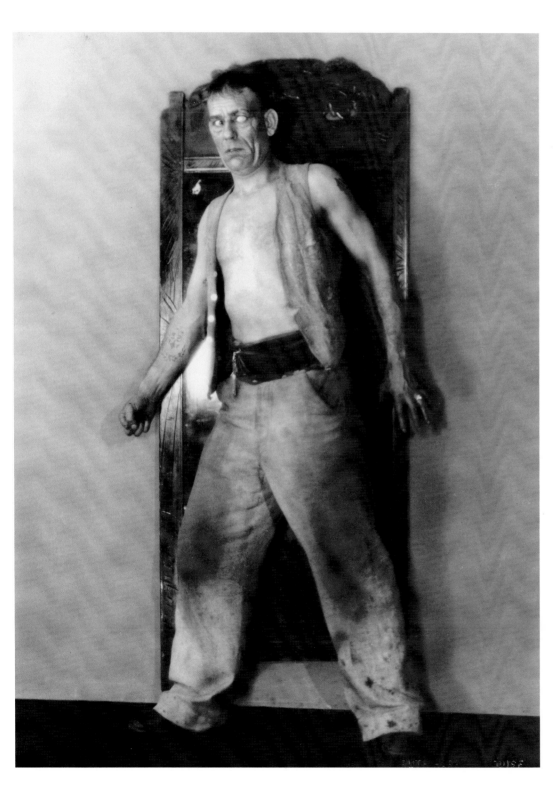

Occasionally Louise confronted a subject who brought a font of personal experience to a sitting. Lon Chaney was an ideal subject for her sensitive, gestural portraits. The "man of a thousand faces" frequented New York City night court "watching the crooks and whores and all of the petty criminals…studying them, watching their mannerisms and listening to their speech so he could adapt what he saw and heard to his own characterizations."[1]

Greta Garbo, late 1920s

Platinum photograph

13 ⅛ x 10 ½ in.

■

Louise was able to capture the magical quality of stardom, and Garbo preferred her to other MGM photographers during the 1920s. Although her subjects seldom looked directly into the camera, they seemed to project themselves into it nevertheless.

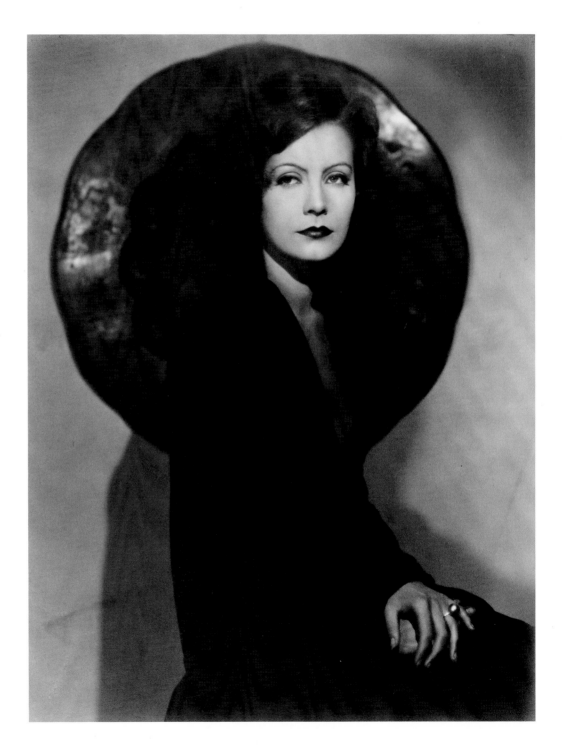

Attributed to Ruth Harriet Louise

Greta Garbo, Nils Asther

The Single Standard, 1929

Silver gelatin photograph

9 $^{15}/_{16}$ x 13 in.

■

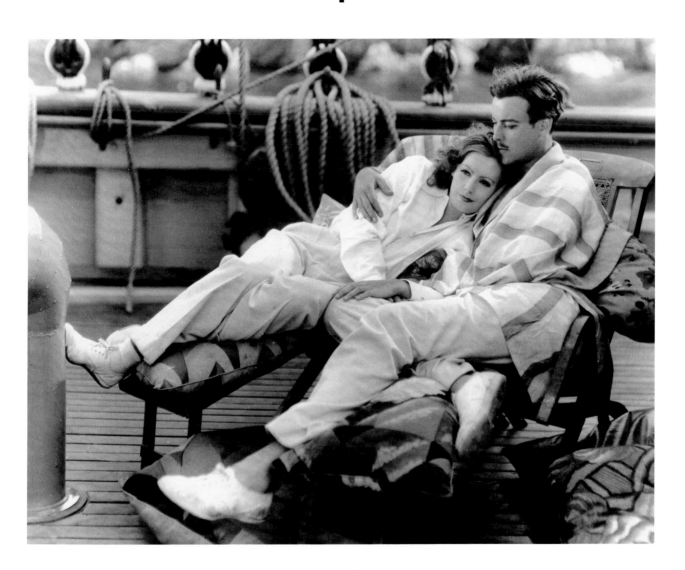

In posing her subjects, Ruth Harriet
Louise often elicited gestures that are
highly exaggerated. In a production still
from The Single Standard (1929) attrib-
uted to Louise, Greta Garbo and Nils
Asther pose in a precisely calculated
way: their legs almost symmetrically
crossed, their hands thoughtfully
arranged.

BERT LONGWORTH

Birthplace and life dates unknown.

1910 Portrait photographer in Columbus, Ohio.

After 1910 Itinerant portrait photographer. News photographer at *Chicago Tribune.*

1921–26 Still man at Universal. Films include *The Hunchback of Notre Dame* (1923) and *Phantom of the Opera* (1926).

1926–29 As still man at MGM makes the first Hollywood portraits of Greta Garbo and production stills for *Flesh and the Devil* (1927) and *The Temptress* (1927). Extreme camera angles in his work sharply criticized by the studio.

1929 Creates first photo montages. Hired immediately thereafter by Warner Bros.

1929–40 Demand for montage layouts in newspapers, magazines, and theater advertising, quickly established, remains strong. Creates montage photographs for *Forty-second Street*

and *Gold Diggers of 1933* (both 1933) and production stills for films, including *Dames* (1934), *Wonder Bar* (1934), *Anthony Adverse* (1936), and *The Sea Hawk* (1940).

No career information is available beyond 1940.

Publication

Hold Still…Hollywood! (Los Angeles: self-published in a limited edition of 1,000 copies, 1937).

Exhibition

National Portrait Gallery, Washington D.C., *The Art of the Great Hollywood Portrait Photographers*, 1983.

John Barrymore

Svengali, *1931*

Silver gelatin photograph

13⁷/₁₆ x 10⁹/₁₆ in.

■

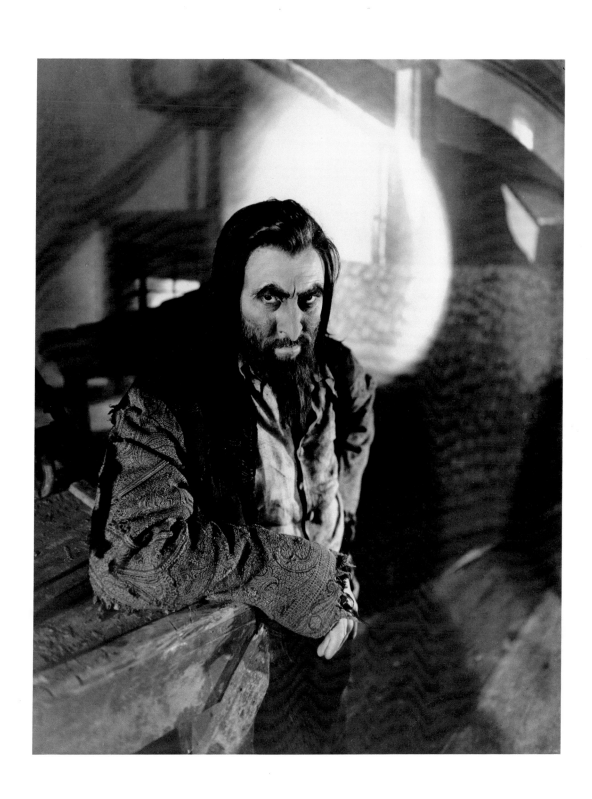

Helen Hayes
A Farewell to Arms, 1932
Silver gelatin photograph
13⁷⁄₁₆ x 10⁹⁄₁₆ in.

Helen Hayes
A Farewell to Arms, 1932
Silver gelatin photograph

Anonymous
Irving Lippman, Eugene Robert Richee, about 1933
Silver gelatin photograph
4 3/8 x 6 7/16 in.

■

EUGENE ROBERT RICHEE

United States, 1895–?

Born in Denver, Colorado.

1923–35 At Paramount shooting
production stills (one source, John
Kobal, suggests he began late 1910s).
First photographer to pose Gary Cooper
(about 1925). Photographs Marlene
Dietrich during and after her associ-
ation with Josef von Sternberg
(1930–35).

1936–44 Scouts talent in Vienna for
Louis B. Mayer, returning with Hedy
Lamarr, Luise Rainer, and photogra-
pher Laszlo Willinger.

1944 Photographs *Kismet* at Dietrich
and Ronald Colman's request, continu-
ing to do some publicity photography
for MGM.

No career information is available
beyond the 1940s.

Louise Brooks, 1928

Silver gelatin photograph

12 x 9 ¹/₁₆ in.

■

In his portrait of Louise Brooks layers of art nouveau motifs—the butterfly-painted backdrop, the curved area of the sofa she curls against, and her body contours—create a sense of three-dimensional space.

Gary Cooper, 1931

Modern silver gelatin photograph, 27/50

13⅞ x 10⅞ in.

■

Eugene Robert Richee placed his subjects in richly textured environments reflecting popular design styles of the day. His portrait of Gary Cooper utilizes art deco set elements: an oversized, simply styled leather chair and a single potted palm. Triangular shapes repeat throughout. The placement of a window with an exterior view behind Cooper establishes a convincing three-dimensional space, a characteristic of Richee's best work. More stylized is his portrait of Lillian Roth (p. 87). The abstract backdrop is entirely imaginary. The shadows in the background of his portrait of Nino Martini are accentuated yet integrated into the structure of the photograph.

Tallulah Bankhead, about 1932

Silver gelatin photograph

13³⁄₈ x 10⁹⁄₁₆ in.

■

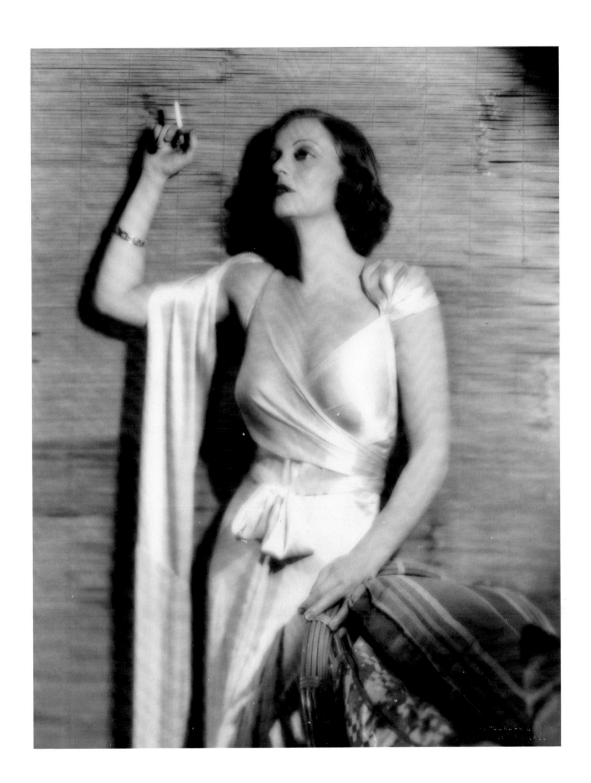

Nino Martini, 1930

Silver gelatin photograph

13 ½ x 10 ⅝ in.

Lillian Roth

"Checker Board Girl," 1930

Silver gelatin photograph

13⅝ x 10⅜ in.

∎

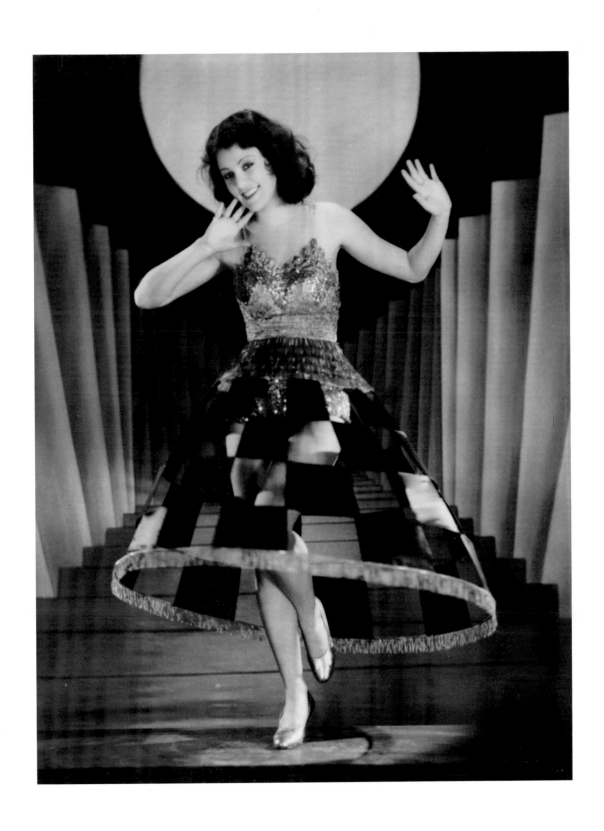

Self-portrait, 1934
Silver gelatin photograph
6 7/16 x 4 7/16 in.

■

GEORGE HURRELL

United States, 1904–

Born in Cincinnati, Ohio.

1912 Interest in painting and drawing develops. Later uses photography to make studies.

1920 Studies painting and drawing at Art Institute of Chicago.

1922 Assistant to portrait photographer Eugene Hutchinson.

1925 Hired by Edgar Payne, founder of Laguna Beach Museum of Art, to photograph paintings, then persuaded to move West to paint and photograph.

1927 Opens photography studio in Los Angeles. Chance printing assignment for Steichen leads to work in commercial portrait and advertising photography. First Hollywood celebrity portrait: Ramon Novarro.

1928 Portraits of Novarro, seen by Norma Shearer, lead to job creating a new, more sexually provocative image for Shearer. Resulting photographs, shown to her husband, Irving Thalberg, lead to her role in *The Divorcee* (1930).

1930–33 Hired by Thalberg as head of MGM portrait gallery at $150 a week. Subjects at MGM include Joan Crawford, Clark Gable, and Greta Garbo (in a single session for *Romance*, 1930).

1933 Leaves MGM to open studio on Sunset Strip, continuing to photograph Hollywood's leading celebrities as well as pursuing other commercial work.

1935 Leases New York City studio to work in fashion industry and pursue portraiture.

1936 Contributing photographer for *Esquire*, then returns to Hollywood.

1938 Under contract at Warner Bros. subjects include Humphrey Bogart, James Cagney, Bette Davis, and Errol Flynn.

1941 Opens Beverly Hills studio with Garbo as his landlord.

1942 While under contract at Columbia, joins First Motion Picture Unit, U.S. Army Air Force; photographs generals at the Pentagon.

1943 Discharged from armed services, resumes work at Columbia.

1946–49 Leaves Columbia to resume commercial photography career, working on both coasts.

1954–56 Produces television commercials for J. Walter Thompson Advertising Agency.

1958 Producer, director, and occasional cinematographer for television commercial production company coorganized with Walt Disney Productions.

1960–69 As freelance still photographer photographs *The Danny Thomas Show* and *Gunsmoke*.

1969–76 Feature films as freelance still photographer include *Butch Cassidy and the Sundance Kid* (1969), *The Towering Inferno* (1974), and *All the President's Men* (1976). Subjects of commissioned portraits include Liza Minnelli, Paul Newman, and Robert Redford.

1976–80 Semiretirement.

1981– Continues freelance portraiture for magazines; subjects include Farrah Fawcett, Bette Midler, Brooke Shields, and John Travolta.

Publication
With Whitney Stine, *The Hurrell Style* (New York: John Day, 1977).

Exhibitions
Museum of Modern Art, New York, *Glamour Portraits*, 1965. Museum of Modern Art, New York, *The Hollywood Portrait Photographers 1921–41*, 1981. National Portrait Gallery, Washington D.C., *The Art of the Great Hollywood Portrait Photographers*, 1983.

Norma Shearer, 1929

Silver gelatin photograph

12⁷⁄₈ x 10³⁄₁₆ in.

■

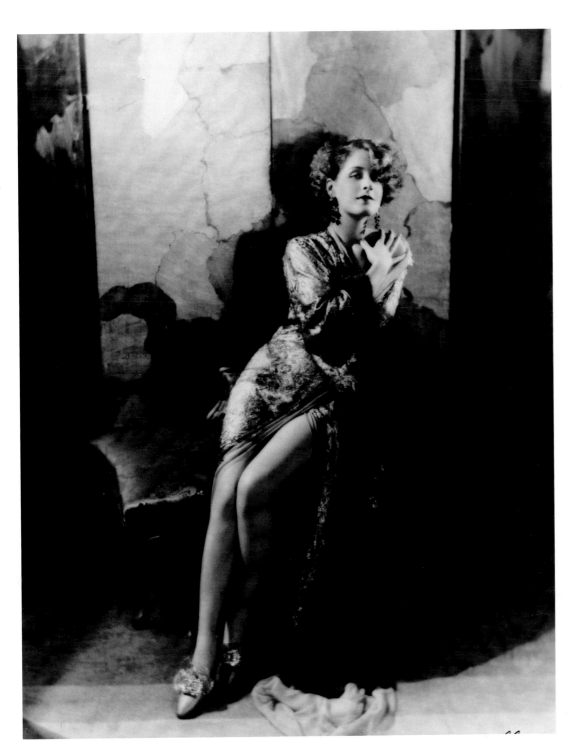

Hurrell's portraits of Norma Shearer
helped transform her image from demure
to sexually provocative. The background
screen, a favorite Hurrell studio prop,
reappears in his portraits of Marlene
Dietrich and Ramon Novarro as a
clown.

Ramon Novarro, 1928

Silver gelatin photograph

10³/₁₆ x 13¹/₁₆ in.

■

For one of his portraits of Ramon
Novarro, George Hurrell "set up his
camera under a giant oak tree at the
Poncho Barnes house and photographed
Novarro costumed in a peasant's tunic,
standing next to a white horse. The
whole scene was covered with dappled
sunlight.

"When Poncho saw the proofs, she
exclaimed, 'My God, George, even the
horse looks glamorous.' "²

Later Novarro told Hurrell, "You
have caught my moods exactly. You have
revealed what I am inside."³

Dorothy Jordan, about 1929

Silver gelatin photograph

9 $^{3}/_{16}$ x 12 $^{1}/_{16}$ in.

■

Marlene Dietrich, 1937

Platinum photograph

10 7/16 x 7 in.

■

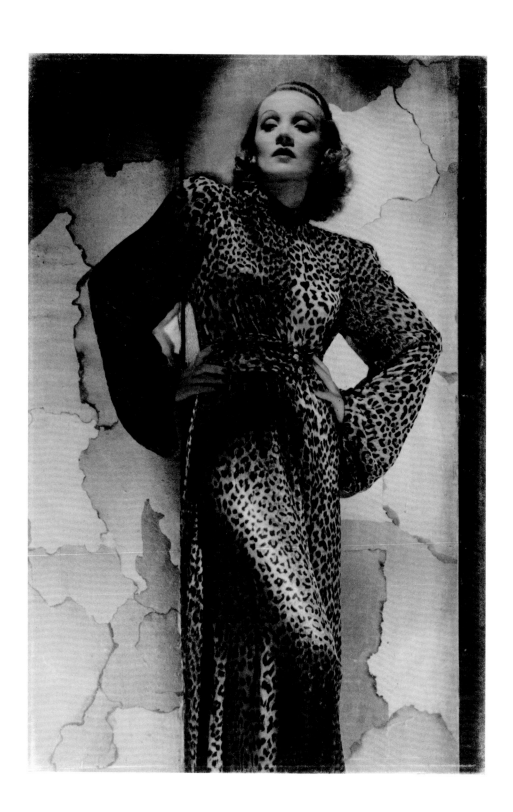

Ramon Novarro, about 1930

Silver gelatin photograph

12 7/8 x 10 1/16 in.

■

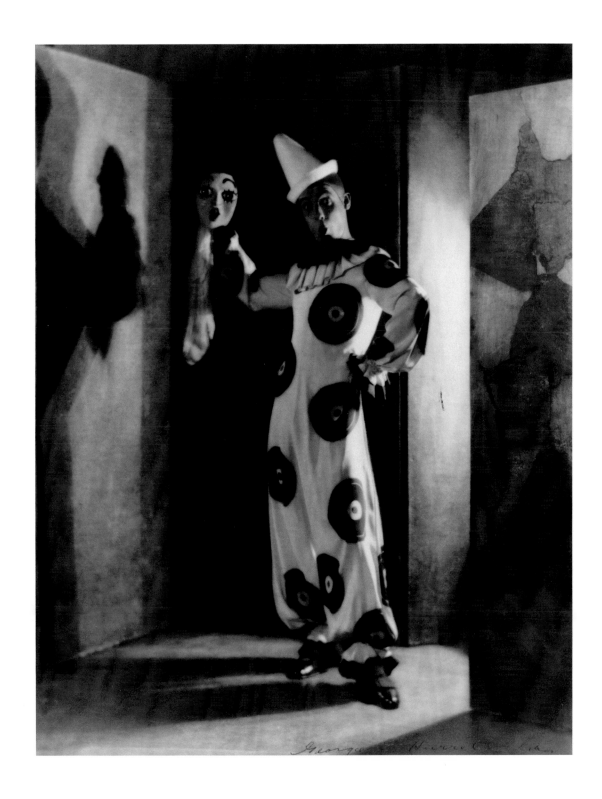

Bill ("Bojangles") Robinson, about 1935

Silver gelatin photograph

8 ¹⁵⁄₁₆ x 6 ¼ in.

■

Hurrell revered Edward Steichen, with whom he worked briefly in 1927, as the quintessential artist challenging convention in both his commercial and fine art photography. Hurrell's portrait of Bill "Bojangles" Robinson has the sophistication of an Edward Steichen portrait in Vanity Fair.

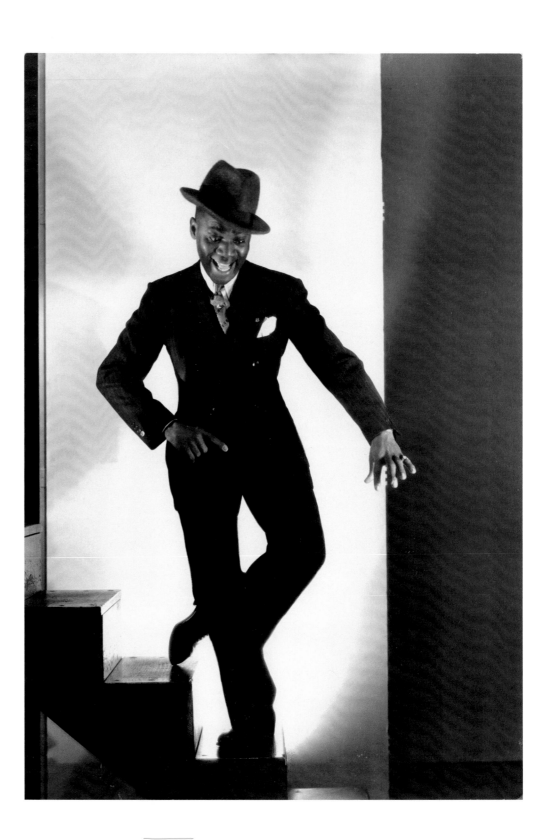

Jimmy Durante, 1931

Silver gelatin photograph

12 1/16 x 9 1/4 in.

■

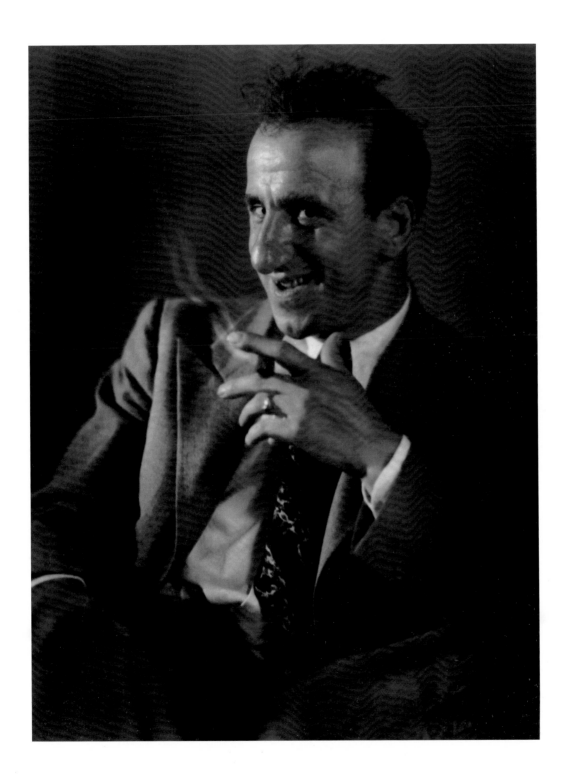

Cecil B. DeMille, 1938

Silver gelatin photograph

13 ⅛ x 10 ⅛ in.

■

Tyrone Power, Loretta Young, 1937

Silver gelatin photograph

8 ½ x 6 ⁹/₁₆ in.

■

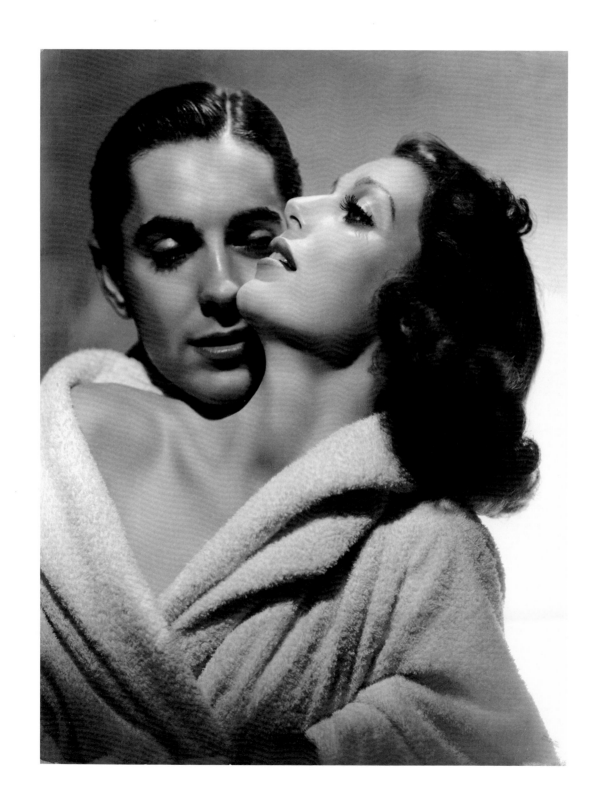

Tom Evans (birthplace and life dates unknown)
Virginia Gray, Clarence Sinclair Bull, 1939
Silver gelatin photograph
9 ½ x 7 ½ in.

■

CLARENCE SINCLAIR BULL

United States, 1895–1979

Born in Sun River, Montana.

1912 Spending time at the studio of Western artist—and family friend—Charles M. Russell, Bull develops an interest in art and at Russell's suggestion buys a Kodak, selling bicycles and magazines on horseback to pay for it.

1915–18 Staff photographer at *Michigan Daily* while attending University of Michigan.

1918 In Los Angeles after graduation joins Metro Pictures as an assistant cinematographer; takes stills during production breaks.

1920 Hired by Samuel Goldwyn to shoot publicity stills.

1924–58 Appointed first head of stills department when Metro merges with Goldwyn. Staff photographer at MGM; Garbo's exclusive photographer (1929–41). During the sixteen years of their relationship, shoots more than 2,000 negatives. Photographs hundreds of stars, including Gary Cooper, Clark Gable, Katharine Hepburn, James Stewart, Gloria Swanson, and Elizabeth Taylor. Technical innovations include improved lens shade and shutter synchronizer, camera monostand, and system for numbering and identifying negatives.

Publication
With Raymond Lee, *The Faces of Hollywood* (Garden City, N.J.: Barnes, 1968.)

Exhibition
National Portrait Gallery, Washington D.C., *The Art of the Great Hollywood Portrait Photographers*, 1983.

Awards
Four Academy awards for still photography (1942, 1943).

Hedy Lamarr, 1940

Silver gelatin photograph

13 x 10⁷/₁₆ in.

■

Helen Ferguson

Hungry Hearts, 1922

Silver gelatin photograph

13 ½ x 10 ⅝ in.

■

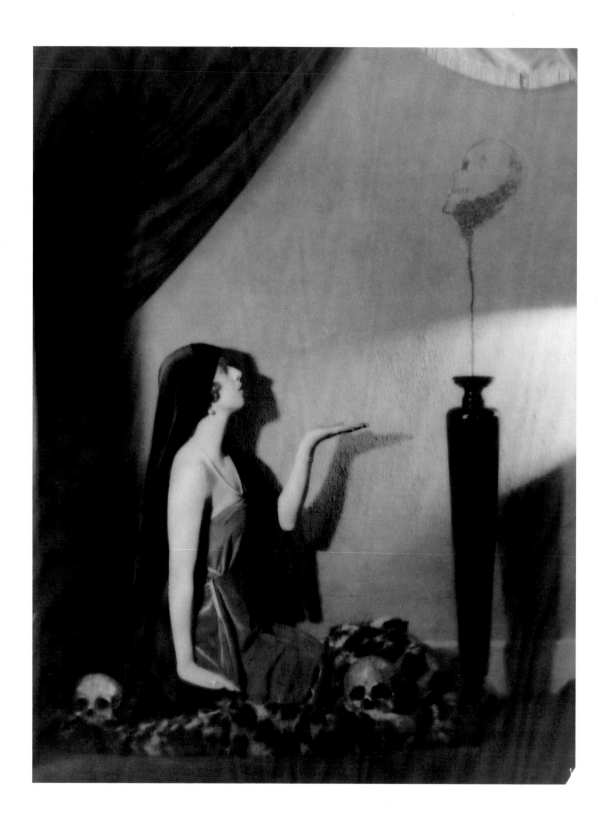

Greta Garbo

Mata Hari, *1931*

Silver gelatin photograph

12 ¼ x 9 ¼ in.

■

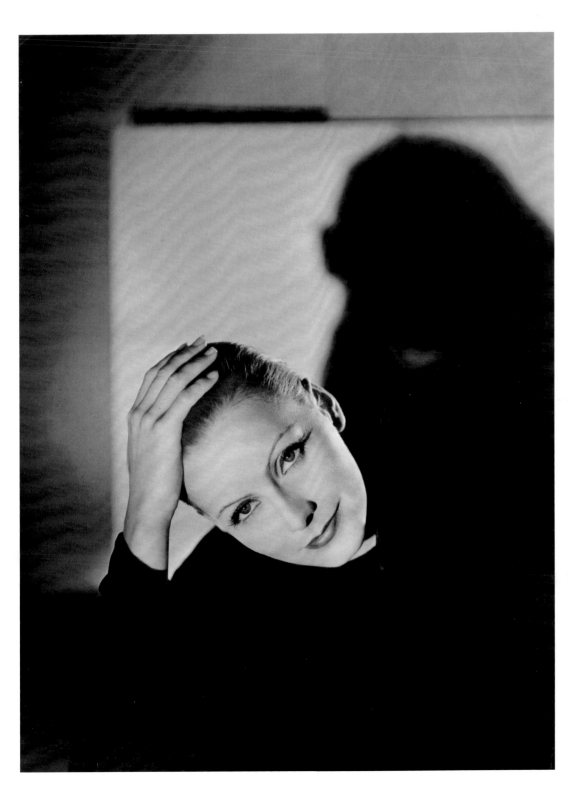

In her introduction to his autobiography,
The Faces of Hollywood, *Hedda Hopper
wrote about Clarence Sinclair Bull's first
encounter with Greta Garbo [1929], who
four years later requested Bull as her
exclusive photographer: "Hollywood—
first time Greta Garbo put her foot
into…Bull's portrait gallery at MGM,
she posed for three hours straight without
uttering one word. So nervous was
Garbo, she didn't realize that the man
behind the camera was just as scared.
But after that, Clarence was the only
man who could take her picture."[4]*

*"Others had tried before me to solve
the mystery of that beguiling face," Bull
wrote in his own recounting of his rela-
tionship with the actress. "I accepted it
for what it was—nature's work of art….
She was the face, and I was the cam-
era. We each tried to get the best out of
our equipment.[5]*

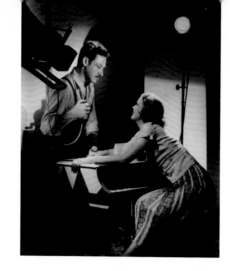

Self-portrait with Eleanor Powell, 1936
Modern silver gelatin photograph
9 15/16 x 7 15/16 in.

■

TED ALLAN

United States, 1910–

Born in Clifton, Arizona.

1929 Working as a commercial artist for the Art Guild, Los Angeles, creates drawings, paintings, and pastels from still photographs for Metropolitan Theatre lobbies. Experiments with simple Brownie camera and mirror reflectors, making portraits of friends. Opens portrait studio on Hollywood Boulevard, photographing actors appearing in Hollywood Playhouse productions. Part-time actor.

1932 Hired by photographer Otto Dyar as still photographer on Charlie Chan series at Fox.

1933 Photographs *Tarzan and His Mate* with Johnny Weismuller and Maureen O'Sullivan for MGM. Makes on-location, off-stage candid portraits with a Graflex 5x7 camera. The resulting photographs of O'Sullivan attract the attention of Howard Strickling, head of MGM publicity, who promotes him to studio portrait gallery, replacing George Hurrell.

1936 In competition with Russell Ball and Tom Evans, chosen as Jean Harlow's exclusive photographer.

1937 As still photographer at Selznick on *A Star Is Born*, *Nothing Sacred*, and *The Prisoner of Zenda*. Joins IATSE #659.

1937–45 Photographs radio personalities at CBS; hires Hurrell.

1945–56 On a contract basis working as still photographer for producers, including Cecil B. DeMille, photographs *Samson and Delilah* (1949) and *The Ten Commandments* (1956).

1946 Television cameraman on *Colgate Comedy Hour.*

1947–51 As a member of Screen Actors Guild appears in supporting roles in feature films.

1952–55 Opens Ted Allan Film Studios and as cinematographer and still man, shoots featurettes, documentaries, and low-budget feature films.

1961–68 Still man and cinematographer for Frank Sinatra film productions and Reprise Records. "Rat pack" name: Farley Focus.

1970–80 As cinematographer, resumes making short documentaries.

Exhibition
National Portrait Gallery, Washington D.C., *The Art of the Great Hollywood Portrait Photographers*, 1983.

Robert Taylor, Jean Harlow, about 1936

Modern silver gelatin photograph

13 ¹³⁄₁₆ x 10 ¾ in.

■

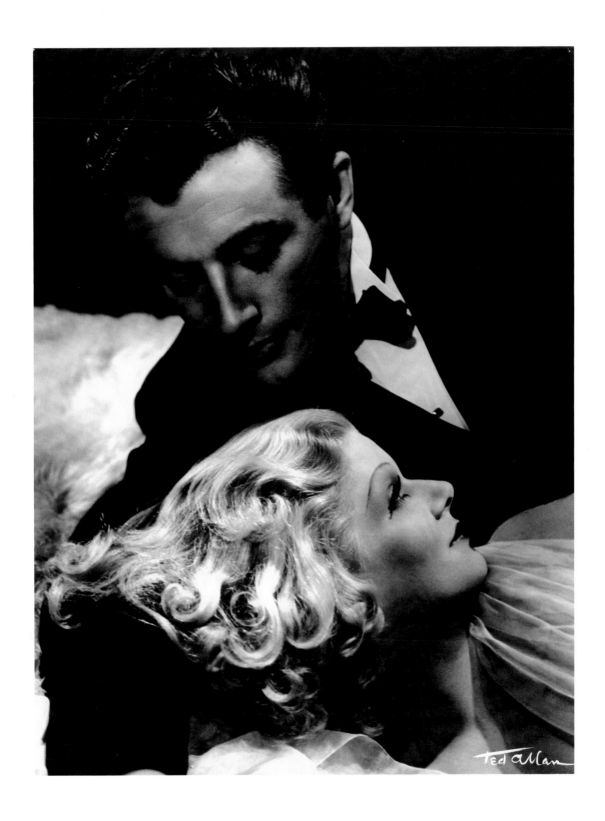

Luise Rainer, 1936

Modern silver gelatin photograph

12¾ x 10⅜ in.

■

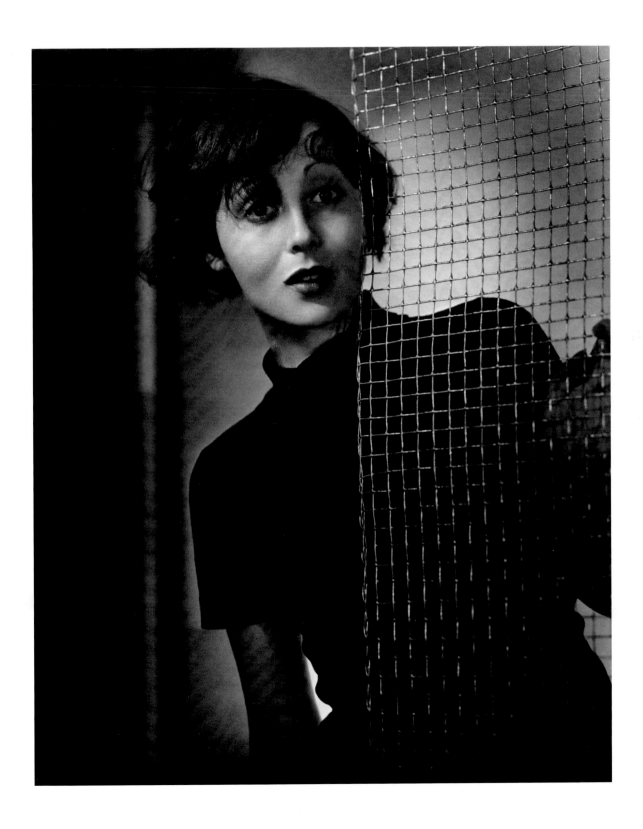

Dancing Lady, *1933*

Modern silver gelatin photograph

19¾ x 23¾ in.

■

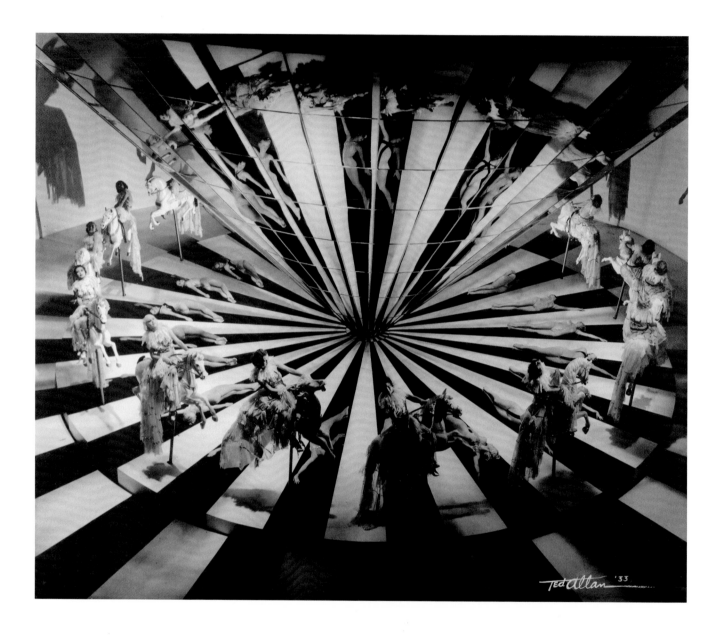

Eleanor Powell

Broadway Melody of 1936, *1936*

Modern silver gelatin photograph

10⁷⁄₁₆ x 13¹⁄₂ in.

■

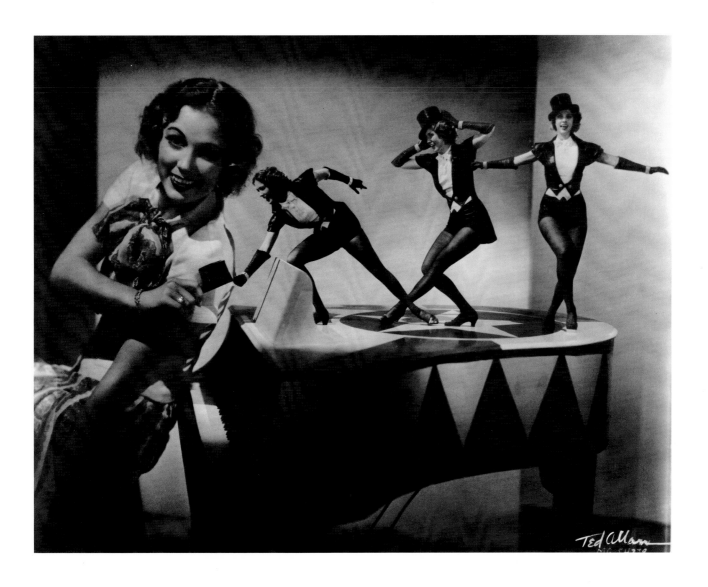

Eric Carpenter (United States, active 1933–76)
Laszlo Willinger, 1937
Silver gelatin photograph
9 1/8 x 7 1/8 in.

■

LASZLO WILLINGER

Hungary, active in Europe and the United States, 1909–

Born in Budapest.

1925–27 First learns photography from his mother, a photographer, and his father, owner of a news agency. Leaves school in Berlin to pursue a career in photography.

1929–33 Establishes studio in Paris, then in Berlin (1931). Freelance photojournalist for *Berliner Illustrierte*, *Hamburger Illustrierte*, and *Munchener Illustrierte*, stringer for *London Daily Express* and *Keystone View*, and at Talbot Studio, Paris, as advertising and portrait photographer. Subjects include Josephine Baker, President Paul Doumer, Sacha Guitry, and Yvonne Printemps.

1932 Visits America on assignment for Mercedes-Benz.

1933 Leaves Berlin when Hitler is appointed chancellor.

1933–37 Unable to secure permits, photographs reproduced in German photo annuals are credited to his mother, Margaret Willinger. Establishes studio in Vienna. Photographs celebrities, including Marlene Dietrich, Sigmund Freud, Emil Jannings, Karl Jung, and Hedy Lamarr. Also documents Max Reinhardt stage productions. Contributes photographs to *Pageant*.

1936 Photographs made in Africa, India, Italy, and Russia for Keystone Press Agency published in *London Daily Express*. Stationed in Spain during the civil war.

1937 "Discovered" by Richee, emigrates to the United States, replacing Allan at MGM.

1946–54 Establishes Hollywood photographic studio, specializing in color work for studios and advertising agencies and editorial photography for magazines. Photographs widely published on magazines covers and calendars.

1954– Freelance photographer for advertising agencies and periodicals.

Publications
Berlin (Berlin: publisher unknown, 1927). *London* (Berlin: publisher unknown, 1927).

Exhibitions
International Museum of Photography at George Eastman House, Rochester, New York, *Faces and Fabrics/Feathers and Furs*, 1982. National Portrait Gallery, Washington D.C., *The Art of the Great Hollywood Portrait Photographers*, 1983.

Yvonne Gale, 1928

Silver gelatin photograph

11 ½ x 8 ¹⁵/₁₆ in.

■

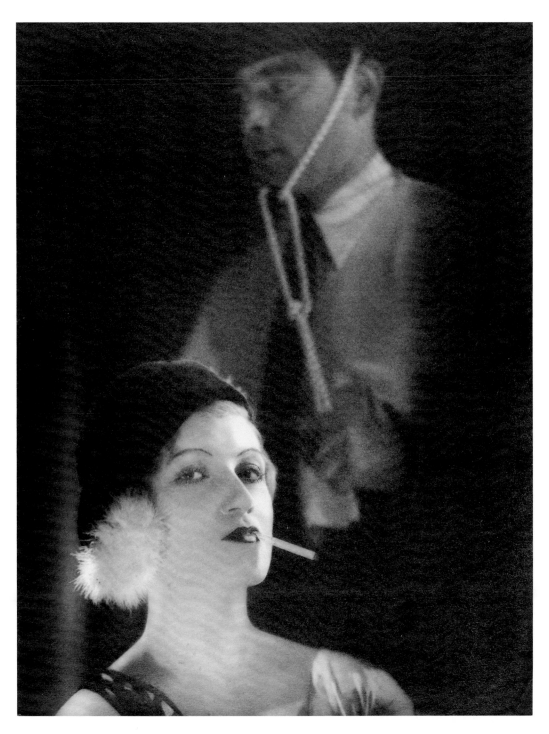

"Whether you photograph a box of matches or the president of the United States, it doesn't make any difference. You have to make it more dramatic than it is."[6]

Props were often integral elements in Laszlo Willinger's portraits. "MGM had an enormous building filled with nothing but props that I used to haunt every day, trying to find something that looked different."[7] If the props weren't found, they were made. Robert Montgomery, elegantly dressed, stares at a spotlit pistol. Antithetical elements such as these heighten the sense of mystery and anticipation.

Lucille Ball, about 1946

Modern silver gelatin photograph

12 ⁵/₁₆ x 9 ⁹/₁₆ in.

■

Willinger shot this photograph of Katharine Hepburn and chickens for a fashion layout in Vogue. *Hepburn's only requirement had been that she like the dress. Commissioned by Dr. Agha,* Vogue's *art director, Willinger was given complete control over the session. "From the time I was very young I always made it clear that I ran the show. Photographing portraits, if you do it right, is a short but intensely personal relationship."[8]*

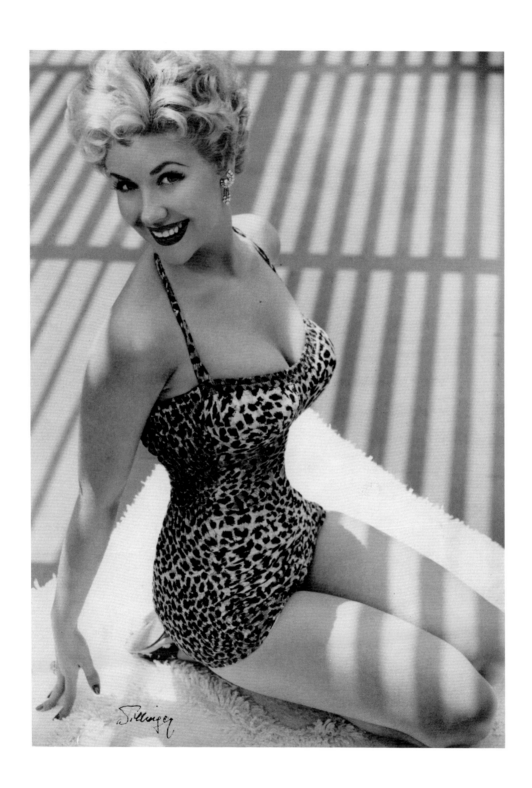

Anonymous
Marilyn Monroe, Frank Powolny, 1953
Modern silver gelatin photograph
7 ½ x 9 ½ in.

■

FRANK POWOLNY

Austria, active in the United States, 1901–86

Born in Vienna, son of the court photographer to Emperor Franz Josef of Austria-Hungary.

1907 Receives a toy glass-plate camera from his father; first portrait is of his mother. Learns to develop film.

1914–17 Family emigrates to Clarkson, Nebraska, where Powolny's brother opens a portrait studio, while Powolny sculpts cherubs for gravestones.

1918 U.S. Army artilleryman.

1920 In Los Angeles works in a lumberyard and paints billboards until his first job in a motion picture film laboratory. First movie as assistant cameraman, *The Kid* (1921).

1923–66 At Fox until retirement. Switches to still photography while working on *The Three Bad Men* (1926). Silent and early sound productions include *Seventh Heaven* (1927) and *In*

Old Arizona (1929). Numerous technical innovations include a sliding device for f-stops on 8x10 cameras, a redesigned housing for flash lamps that improves distribution of light, and a method for increasing the speed of shooting and processing early forms of color film. Photographs many heads of state and dignitaries visiting Fox.

1929–63 Documents every Academy Award ceremony.

1943 Creates the famous Betty Grable pinup. Included in *Ripley's Believe It or Not* after more than 5 million copies are distributed free to servicemen.

Award
Academy Award for still photography (1941).

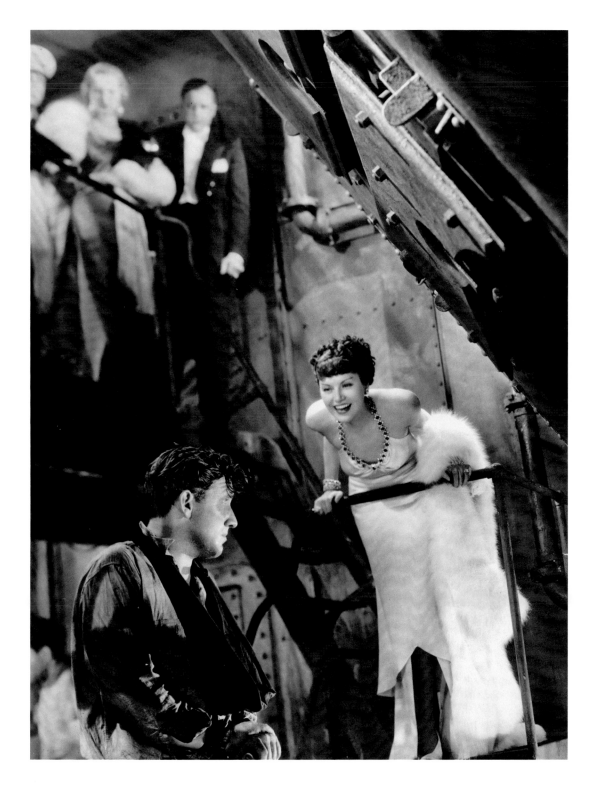

Anonymous
Roman Freulich, Adele Mara, 1947
Silver gelatin photograph
7⁹⁄₁₆ x 9½ in.

∎

ROMAN FREULICH

Poland, active in the United States, 1898–1974

Born in Czenstockowa.

1912 Emigrates to New York City.

1917 A member of the Jewish Legion of the British army in Palestine, upon demobilization tours the Middle East taking photographs, deciding to abandon an anticipated career in electrical engineering to become a photographer. Upon return to U.S., works for Lumiere, a New York photographer. Sells collection of his photographs to Underwood and Underwood photographic agency.

1920–32 In Hollywood as a still photographer at Universal.

1930s Experiments with 35mm on-set photography.

1934–36 Writes, produces, and directs two short films: *The Prisoner* (1934) and *Broken Earth* (1936).

1944–65 Chief portrait artist and head of the stills department at Republic.

Publications
With Ray Hoadley, *How They Make a Motion Picture* (New York: Crowell, 1939). With Joan Freulich Abramson, *Soldiers of Judea* (New York: Herzl, 1964), documenting his experiences in the Jewish Legion. With Joan Freulich, *The Hill of Life* (New York: Yoseloff, 1968). With Joan Freulich, *Forty Years in Hollywood* (South Brunswick, N.J.: Barnes, 1971). With Joan Abramson, *The Faces of Israel* (New York: Yoseloff, 1972).

Exhibitions
Baltimore Museum of Art, *Baltimore International Salon of Photography*, 1946. Los Angeles County Museum of Art, *The Camera Pictorialists of Los Angeles*, 1947.

Awards
Academy awards for photography (1941, 1942, 1944, 1947).

Orson Welles

Macbeth, 1948

Silver gelatin photograph

17 ³/₄ x 14 ¹/₈ in.

■

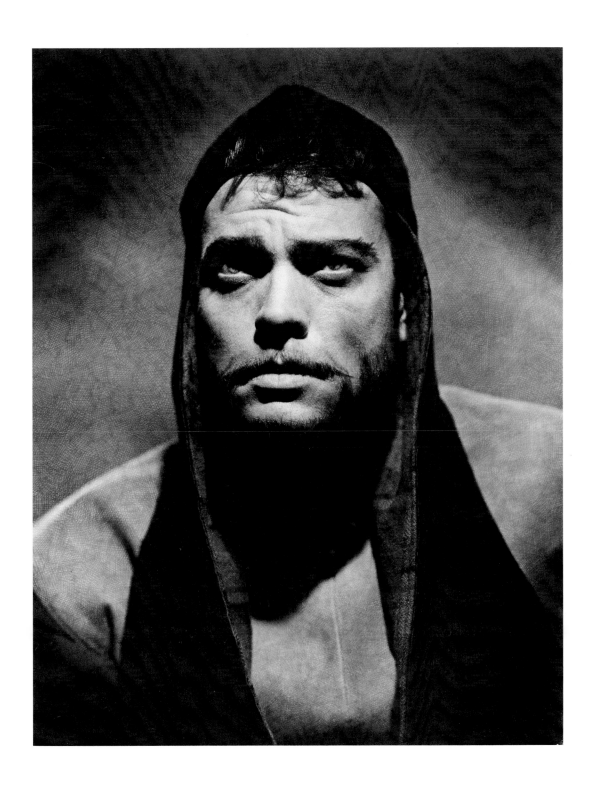

Boris Karloff

Frankenstein, *1931*

Silver gelatin photograph

13 ¾ x 10 ¹³⁄₁₆ in.

■

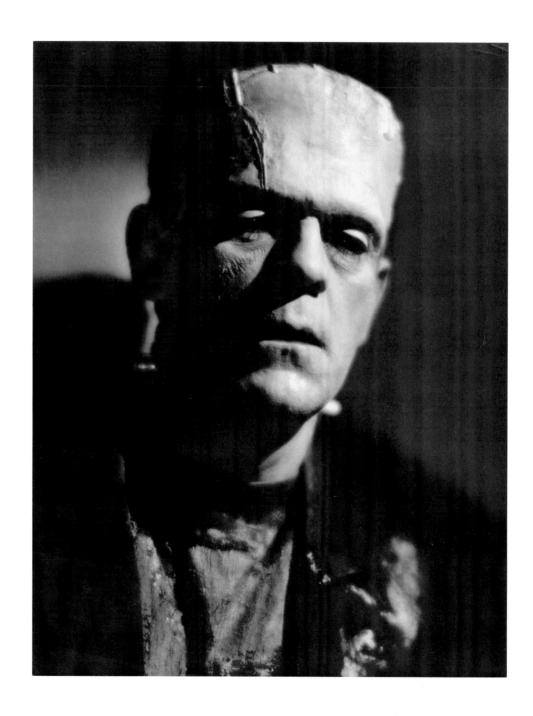

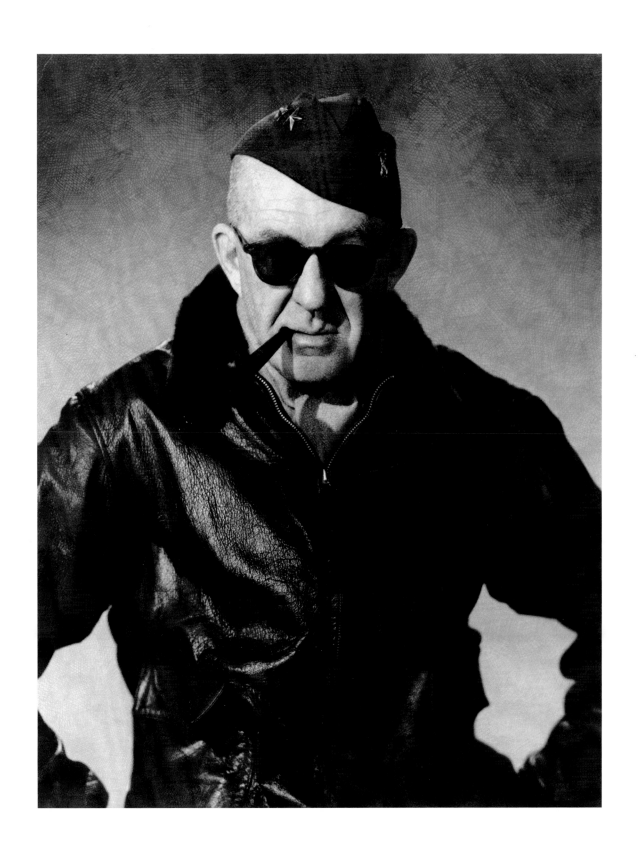

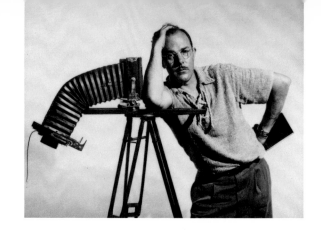

Self-portrait, about 1928
Silver gelatin photograph
11¾ x 13¹³/₁₆ in.

∎

WILL CONNELL

United States, 1898–1961

Born in McPherson, Kansas.

1910 Given a Brownie camera by his grandmother.

1917 Joins Los Angeles Camera Club.

1918–20 Serves with Air Service of U.S. Army Signal Corps. Following military service, works as pharmacist's assistant learning enough about chemistry to pass state pharmacy examination (retains lifelong certification). Cartoonist for San Francisco newspaper.

Early 1920s Knowledge of cameras and chemistry leads to choice of photography as a career.

1921 Joins Camera Pictorialists of Los Angeles, participating in salons (1927, 1928, 1930).

1925 Photos illustrate articles for *Collier's* and *Saturday Evening Post*.

Late 1920s–early 1930s Using knowledge of chemistry, with two partners overcomes the impediment of "slow" color film stocks that had virtually ruled out making stills of actors anywhere but in formal portrait sessions; develops "faster" color stock, permitting photography of actors at work. Photographs Charles Laughton in color.

1930s Advertising photographer with numerous industrial clients.

1931 As member of Camera Pictorialists publication committee (along with James Doolittle and Karl Struss) selects photos by Imogen Cunningham, Laura Gilpin, Willard Van Dyke, and Brett Weston for salon catalogue. Their works confirm his aesthetic interest in geometry.

1931–61 Founds Art Center School Photography Department, remaining on faculty until his death, conducting weekly roundtable discussions where students meet prominent photographers, art directors, and editors.

1937 Takes leading role in creating Southern California chapter of American Society of Magazine Photographers.

1938–53 Author of monthly column on photographic techniques in *U.S. Camera*.

1940 Lighting consultant on *Citizen Kane*.

1946 Still cameraman on *Duel in the Sun*.

Publications
With Nunnally Johnson, *In Pictures: A Hollywood Satire* (New York: Maloney, 1937), photographs of Hollywood and the motion picture industry; medal of merit awarded by Paris Exposition. *The Missions of California* (New York: Hastings House, 1941). *About Photography* (New York: Maloney, 1949).

Exhibition
San Francisco Museum of Modern Art, *California Pictorialism*, 1977.

Myrna Loy, 1932

Silver gelatin photograph

11 ½ x 9 ⁷⁄₁₆ in.

■

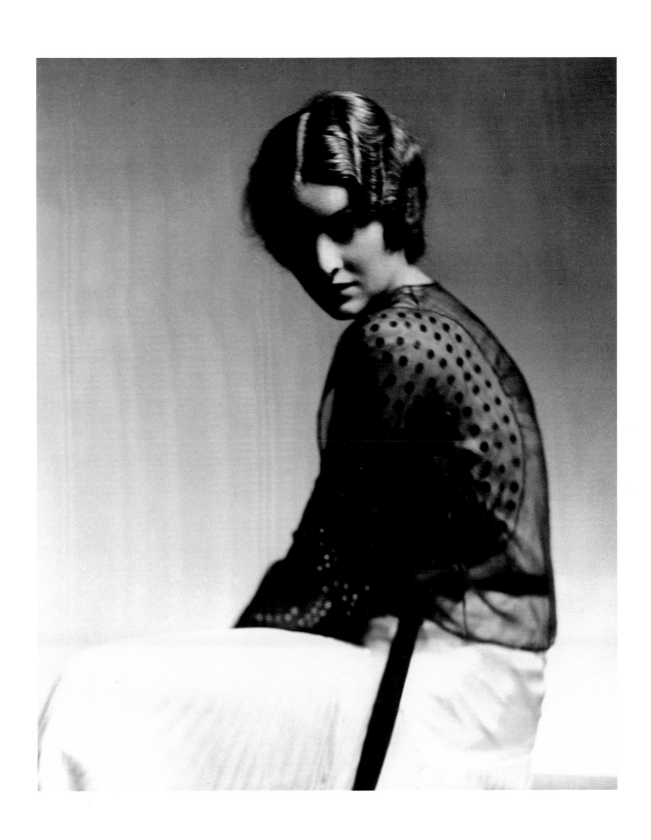

Ginger Rogers, 1931

Silver gelatin photograph

11 ½ x 9 ⁷⁄₁₆ in.

■

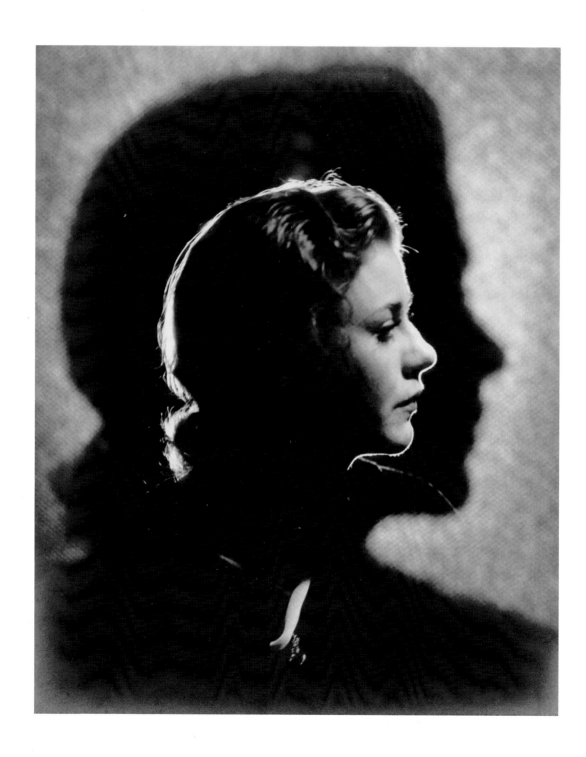

Chorus Line, about 1937

Silver gelatin photograph

11 ½ x 9 ⅜ in.

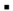

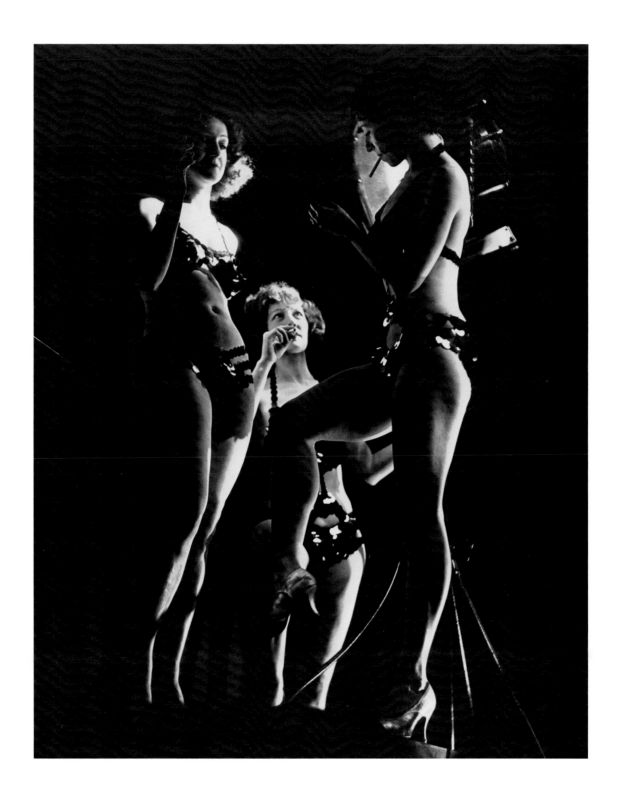

George Arliss, about 1928

Silver gelatin photograph

8³⁄₁₆ x 9³⁄₈ in.

■

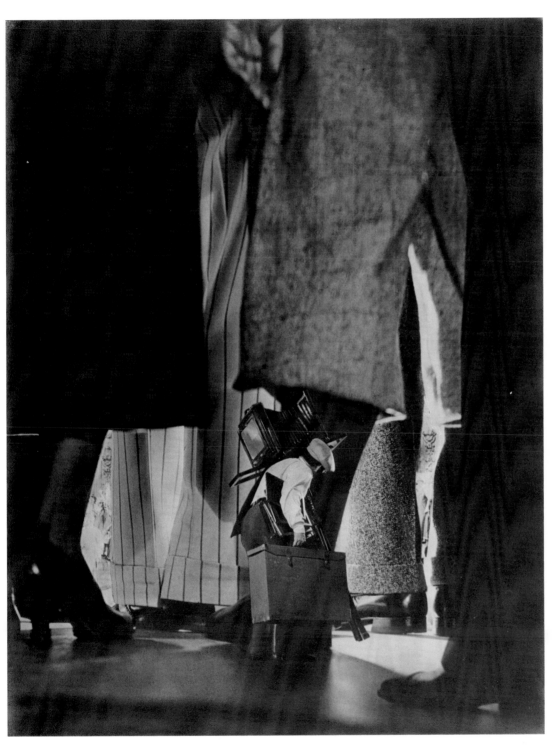

In 1932 Will Connell initiated what was to become a series of images satirizing the film industry, highlighting its illusionism, poking fun at stars and moguls alike. Actors among his circle of friends served as models. The result, In Pictures, was published in 1937. "[In Pictures] started out to be a series of experimental shots for possible show use somewhere and was quite innocently and blithely undertaken. Actually it became a prolonged and agonizing lesson in the gentle art of thinking."9

After conceiving an image, Connell used sandwiched negatives, photograms, photo montages, and rephotography to achieve it. Some of these images effectively convey several points of view simultaneously. Like the photo montages of Bert Longworth, these photographs were stylistically progressive. The montages are precise, hard-edged images with sharp, constructivist design elements.

"*Cutting,*" *1937*

Silver gelatin photograph

11 9/16 x 9 7/16 in.

■

Al Jolson, 1935
Silver gelatin photograph
12 ¹/₁₆ x 9 ½ in.
∎

"A Study in Rain, Downtown," about 1927

Silver gelatin photograph

11 11/16 x 9 11/16 in.

■

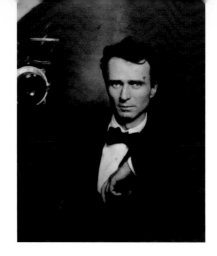

Self-portrait, about 1906
Modern silver gelatin photograph
9 ¼ x 7 ½ in.

■

EDWARD STEICHEN

Luxembourg, active in the United States, 1879–1973

Born in Luxembourg.

1881 Family emigrates to Hancock, Michigan.

1894–98 Lithography apprentice at American Fine Art, Milwaukee, while studying painting. Uses photography (self-taught) as basis of poster designs.

1900 Photographs seen at Chicago salon by eminent photographer and teacher Clarence White.

1900–1902 Exhibits paintings and photographs while living in Europe.

1901 Elected member of Linked Rink pictorialist photography society, London.

1902 Returning to New York, establishes residence at 291 Fifth Avenue; founding member of the Photo-Secession; designs cover of its quarterly *Camera Work*.

1905 "291," the Photo-Secession gallery, established by Alfred Stieglitz in former Steichen studio.

1906–17 While living in Europe (1906–14) and painting, photographs notables of Paris art community and later (1914–17) of New York art community. Experiments with color photography.

1917 Technical advisor to U.S. Army on aerial photography during World War I. Awarded Distinguished Service Citation by Gen. John Pershing.

1922 Renounces painting and burns all remaining canvases.

1923–37 Chief photographer, Condé Nast Publications. Works published principally in *Vanity Fair* and *Vogue*. During early years with Condé Nast makes annual trips to Hollywood to photograph film personalities. Most of his portraiture, however, done in New York City studio.

1938 Closes commercial studio. Resumes color photography while vacationing in Mexico.

1942–45 Commissioned Lt. Cmdr., USNR, becoming director, Naval Photographic Institute. Placed in command of all naval combat photography in the Pacific Theater. Retired with rank of Capt.

1947–62 Director, Department of Photography, Museum of Modern Art, New York. Organizes more than forty-five exhibitions, including *The Family of Man*.

1962 Retires once again and undertakes experiments with color still and motion picture photography.

Publication
A Life in Photography (Garden City, N.Y.: Doubleday, 1963).

Exhibitions and collections
Works exhibited widely throughout the century; included in numerous public collections.

Award
Presidential Medal of Freedom, 1963.

Douglas Fairbanks, Jr., about 1932

Silver gelatin photograph

9 ½ x 7 ⅝ in.

■

Gloria Swanson, 1924

Silver gelatin photograph

9 7/16 x 7 9/16 in.

∎

In A Life in Photography *(1963) Steichen reminisced about portrait sessions with Gloria Swanson (1924) and Marlene Dietrich (1932).*

"Gloria Swanson and I had had a long session, with many changes of costume and different lighting effects. At the end of the session, I took a piece of black lace veil and hung it in front of her face. She recognized the idea at once. Her eyes dilated, and her look was that of a leopardess lurking behind leafy shrubbery, watching her prey. You don't have to explain things to a dynamic and intelligent personality like Miss Swanson. Her mind works swiftly and intuitively.

"At the sitting in which the picture of Marlene Dietrich was made, Sternberg was not present. We had a fine time, and she was her own magical self. When the sitting was over, she said to me in a voice tremulous with excitement, "You know, this is the first time I have ever had a picture made without Sternberg...." When I met [von Sternberg] for the first time, he told me he had directed many of the people I had photographed for Vanity Fair, *and he didn't understand how I got out of them what I did!"*[10]

Marlene Dietrich, 1932

Silver gelatin photograph

16³⁄₄ x 13³⁄₈ in.

■

Throughout the 1920s and early 1930s Edward Steichen photographed celebrities in New York and made annual photographic excursions to Hollywood. By that time he had transformed his opulent, soft-focus style to one reflecting the modernist aesthetic. His portraits were composed of sharply focused geometric design elements and dramatic angles.

Noel Coward, 1932

Modern silver gelatin photograph

13 1/16 x 10 3/8 in.

■

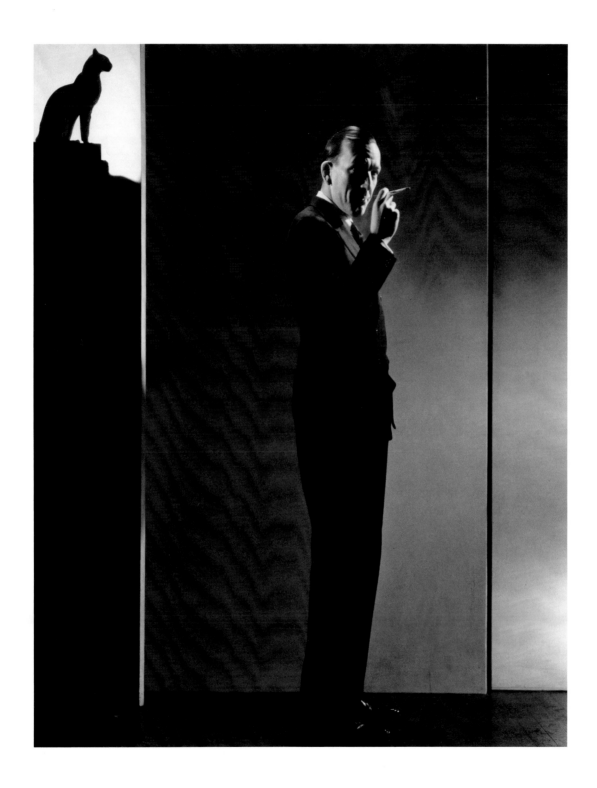

L. Stesson (birthplace and life dates unknown)
Martin Munkacsi, about 1930
Silver gelatin photograph
9 ⅛ x 6 ¾ in.

■

MARTIN MUNKACSI

Hungary, active in the United States, 1896–1963

Born in Kolosvar.

1912–21 In Budapest writes poetry and personality stories for newspapers and magazines. Photography self-taught.

1921–27 Sports photographer-editor for newspaper *Az Est*; photographs praised as rendering movement in a dramatic fashion. Becomes photojournalist after one photograph helped prove an unjust verdict in a murder trial.

1927–30 In Berlin as contract photographer for Ullstein Verlag. Photographs published regularly in *Berliner Illustrierte*, *Dame*, *Koralle*, and *Uhu* magazines.

1930–33 As freelance press photographer travels worldwide on assignment contributing to *Deutsche Lichtbild*, *Harper's Bazaar*, *Modern Photography*, *Photographie*, and *Studio*. Influenced by photojournalists Alfred Eisenstadt, Erich Solomon, and others responsible for developing new ideas in photojournalism, including the picture essay.

1933 On first visit to the United States hired by *Harper's Bazaar* editor Carmel Snow to photograph bathing suits; resulting photographs, shot outdoors, introduce the snapshot aesthetic to fashion photography, conveying an innovative sense of motion.

1933–40 Emigrates to the United States, becoming contract photographer for *Good Housekeeping*, *Harper's Bazaar*, Hearst Newspapers, *Life*, and *Town and Country*.

1940–46 Contributing photographer for *Ladies Home Journal*.

1946–52 Freelance photographer and cameraman-lighting designer for television. Debilitated by a heart attack, returns to journalism.

Publications

Fool's Apprentice (New York: Readers Press, 1945), an autobiographical novel. *Munkacsi Nudes* (New York: Greenberg, 1951). Nancy White and John Esten, eds., *Style in Motion: Martin Munkacsi Photographs of the '20s, '30s, and '40s* (New York: Clarkson N. Potter, 1979).

Exhibitions

Museum of Modern Art, New York, *Photography 1839–1937*, 1937. Museum of Modern Art, New York, *Glamour Portraits*, 1965. Victoria and Albert Museum, London, *Fashion 1900–1939*, 1975. International Museum of Photography at George Eastman House, Rochester, New York, *Fashion Photography*, 1977. International Center for Photography, New York, *Spontaneity and Style*, 1978. San Francisco Museum of Modern Art, *Avant-Garde Photography in Germany 1919–1939*, 1980.

Collections

International Museum of Photography at George Eastman House, Rochester, New York; San Francisco Museum of Modern Art.

Joanne Woodward, Paul Newman, 1961

Silver gelatin photograph

13⁷⁄₈ x 10¹⁵⁄₁₆ in.

■

MUNKACSI

Jean Harlow, 1937

Silver gelatin photograph

11 ³⁄₈ x 9 ¹⁄₈ in.

■

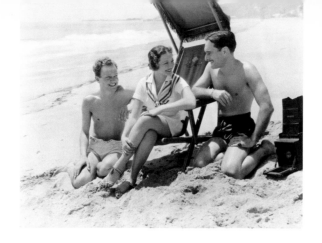

Anonymous
John Engstead, Sylvia Sidney, Paul Hesse, about 1940
Silver gelatin photograph
7 7/16 x 9 9/16 in.

■

JOHN ENGSTEAD

United States, 1912–84

Born in Los Angeles, California.

1926 Hired as an office boy by Harold Harley, head of studio publicity, Paramount.

1927 Still as an office boy arranges on his own initiative for Otto Dyar to photograph Clara Bow in a garden exterior, an unusual setting for its day. Resulting photographs hailed by Harley as "Clara Bow's best sitting."

1928 In response to fan magazine requests, Engstead appointed Paramount magazine contact on condition he wear a coat and tie every day.

1929–41 Promoted to art supervisor, putting him in charge of all stills, based on his creative direction of photographs of Louise Brooks in *The Canary Murder Case* (1929). Assumes position of studio portrait photographer during a still photographers strike (1932), despite never having photographed anyone before. Cary Grant poses for his practice shots. Resumes art supervisor's job when strike concludes.

1941 Fired from Paramount, undertakes freelance advertising and portrait photography assignments "on spec" for *Harper's Bazaar*.

1942–49 Continues fashion photography on assignment for *Harper's Bazaar* along with assignments from *Collier's, Esquire, House Beautiful, Ladies Home Journal, Life, Look, Mademoiselle, McCall's, Vogue,* and *Women's Home Companion.*

1942–54 Photographs celebrity clients outdoors and at home, an innovation in fashion photography. Photographs annual spring and fall fashion collections for Adrian.

1949–50 Builds studio in Los Angeles, which becomes a gathering place for celebrities.

1950–70 Commercial work and society portraiture.

1950s Photographs promotional portraits for television personalities.

1970 Closes studio. While in semiretirement continues to accept special celebrity portraiture and television assignments.

Publication
Star Shots (New York: Dutton, 1978).

Joan Crawford, 1945

Silver gelatin photograph

13 ¼ x 10 ⅜ in.

∎

Gene Kelly, 1945

Silver gelatin photograph

$9\,^{5}/_{8}$ x $7\,^{11}/_{16}$ in.

■

Gene Kelly, 1945

Kirk Douglas, Lauren Bacall

Young Man with a Horn, 1950

Modern silver gelatin photograph

12 $^{15}/_{16}$ x 10 in.

■

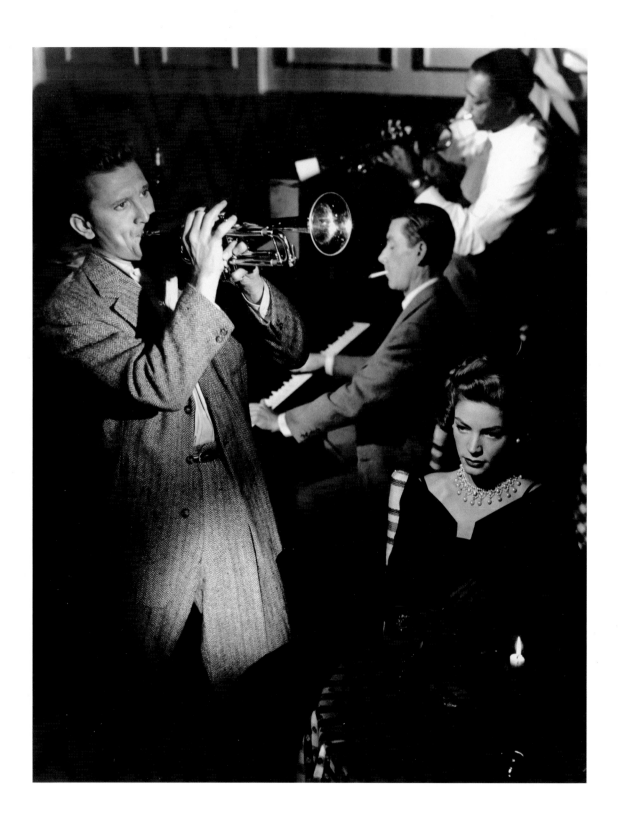

Alfred Hitchcock, 1960

Silver gelatin photograph

13 15/16 x 10 7/8 in.

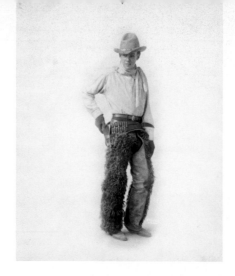

Self-portrait
The Sunset Princess, *about 1916*
Silver gelatin photograph
$9^{13}/_{16} \times 7^{7}/_{8}$ in.
∎

ROBERT COBURN

United States, 1900–

Born in Chateau, Montana.

1912 Father buys him his first East-man Kodak folding camera 2-A. Self-taught, photographs ranch life.

1916 Befriended by cinematographer Billy Beckway during filming of a Western on the family ranch.

1917 Travels to Hollywood. Assistant, then second cameraman and camera operator for Sherwood Productions. Learns camera special effects. Attends Hollywood High School. Plays juvenile roles in western films.

1918–24 Still photographer for Robert Bruce, Al Christie, Sherwood Mac-Donald, and Josh White productions.

1925–28 Chief still photographer for Cecil B. DeMille at Paramount. A. L. ("Whitey") Schaefer in still department simultaneously.

1929–34 Still photographer at RKO. Assistant to Ernest Bachrach. Based on his experience with composite "trick" photography, assigned to makes stills and montages for *King Kong* (1933).

1935–40 As codirector of Goldwyn portrait gallery with Donald Biddle Keyes, devises a natural color process for stills. Begins making color Carbro photographs (1937). As one of the first still photographers experimenting with color in Hollywood, makes production stills and special effects photographs for *The Goldwyn Follies* (1938). Incorporation of pure white arc as background light for color photography gives resulting pictures a three-dimensional quality. Illustrates booklet "A Day with Charlie McCarthy and Edgar Bergen" from *The Goldwyn Follies*.

1938 First *Life* cover: Gary Cooper.

1940 Freelancing briefly, makes portraits, glamour shots, production stills, and advertising photographs, then begins a twenty-year association with Columbia as head of the stills production department and chief portrait photographer. Begins making dye-transfer photographs.

1944 Portraits, an integral part of Rita Hayworth film *Cover Girl*, earn Coburn first screen credit for a Holly-wood portrait photographer.

1960–64 Semiretirement. Occasional freelance assignments at Universal, including *That Touch of Mink* (1962) and *The Birds* (1963).

1965 Retires.

Exhibition
National Portrait Gallery, Washington D.C., *The Art of the Great Hollywood Portrait Photographers*, 1983.

Awards
Two Academy awards for still photography (1941, 1943).

Camera Crew, 1931

Silver gelatin photograph

$13^{5}/_{16}$ x $10^{7}/_{16}$ in.

■

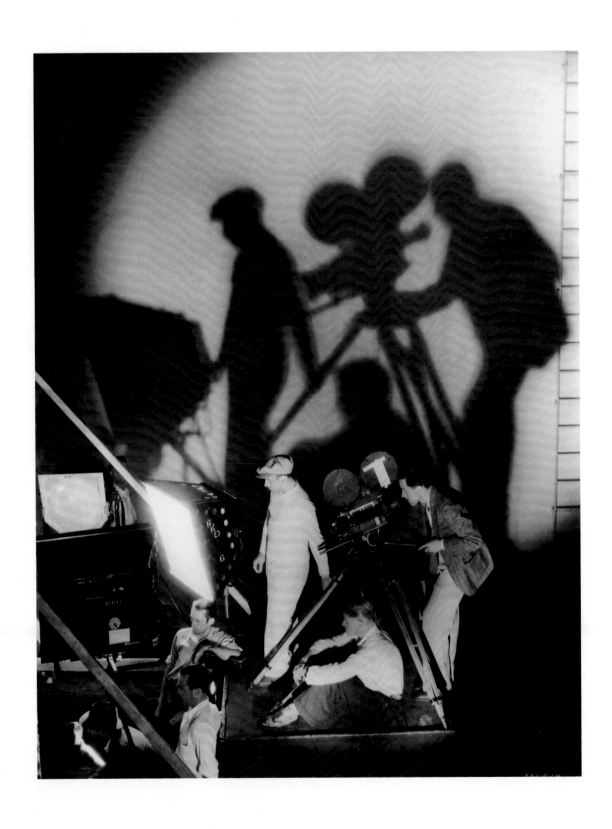

COBURN

For his work with Rita Hayworth in Cover Girl *(1944), Coburn became the first still photographer to be credited on screen.*

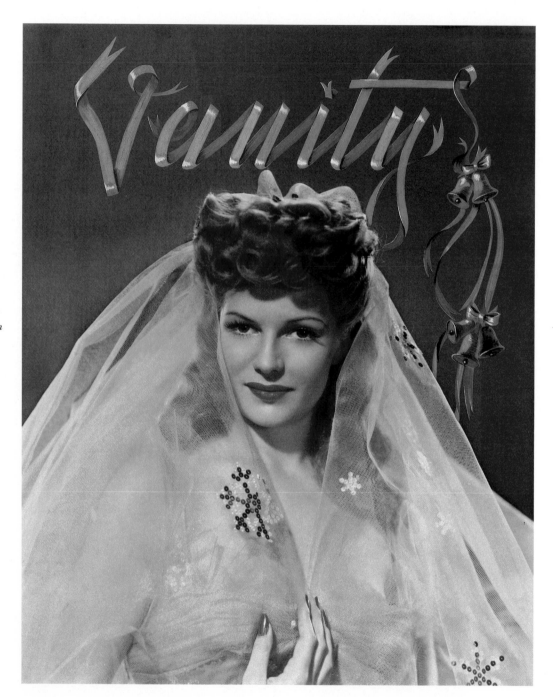

Kim Novak, 1955

Dye transfer photograph

15 9/16 x 12 5/8 in.

■

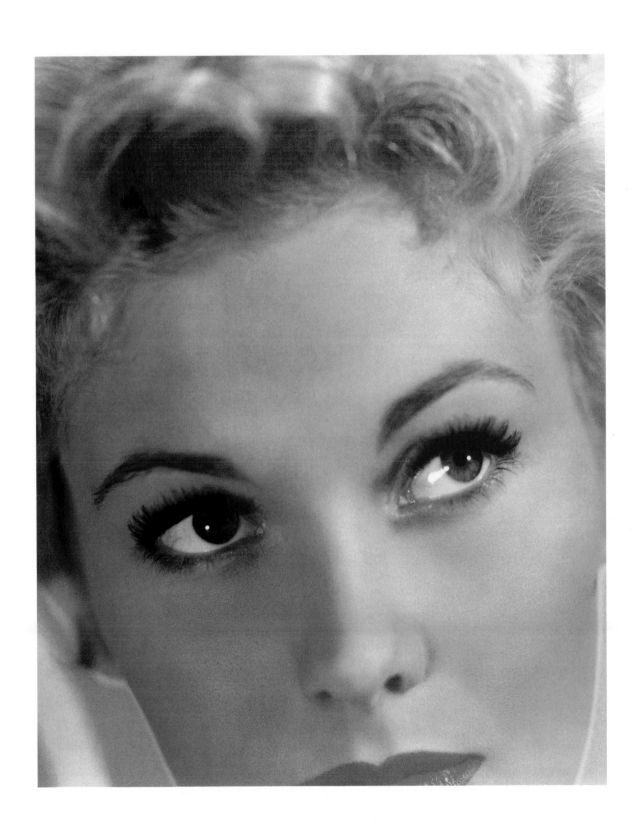

Kim Novak, 1955

Broderick Crawford

Down Three Dark Streets, 1954

Silver gelatin photograph

19 ¹³⁄₁₆ x 15 in.

■

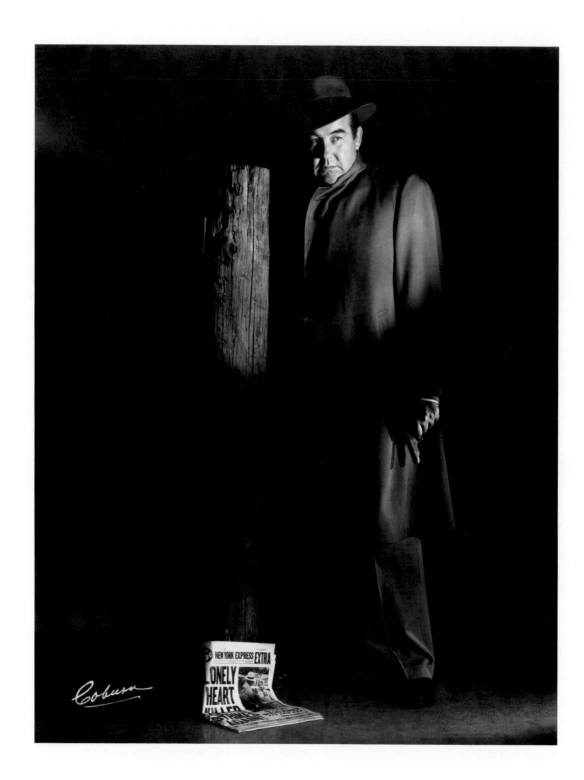

William Holden, Kim Novak

Picnic, 1955

Silver gelatin photograph

19 ¼ x 15 ¹/₁₆ in.

■

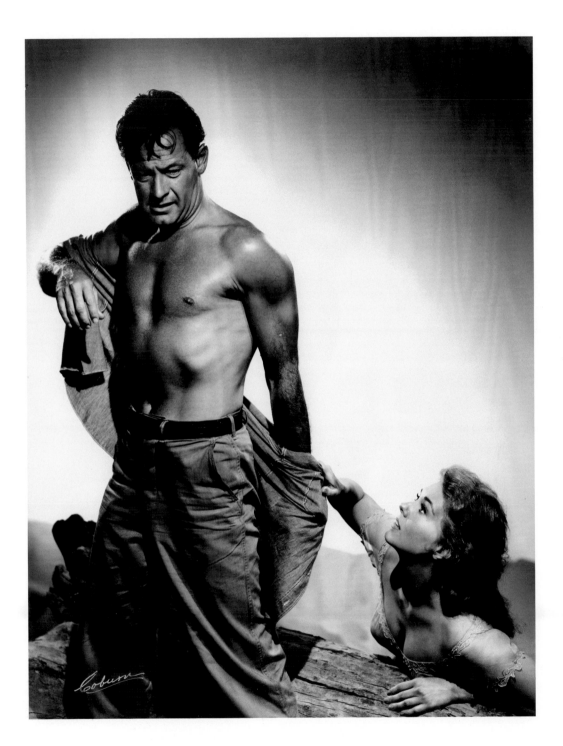

Many of Coburn's double portraits are charged with believable sexuality. His ability to create dynamic, realistic compositions and to utilize color emotionally are factors that distinguished his contribution to glamour photography.

Judy Holliday

Born Yesterday, 1950

Dye transfer photograph

15⁹/₁₆ x 12⁵/₈ in.

■

Many of the ideas in Robert Coburn's gallery portraits originated as scenes in films, such as this one from Born Yesterday *(1950), which he re-created in the portrait gallery.*

Rita Hayworth, Glenn Ford

Gilda, 1946

Silver gelatin photograph

19 ¼ x 15 in.

■

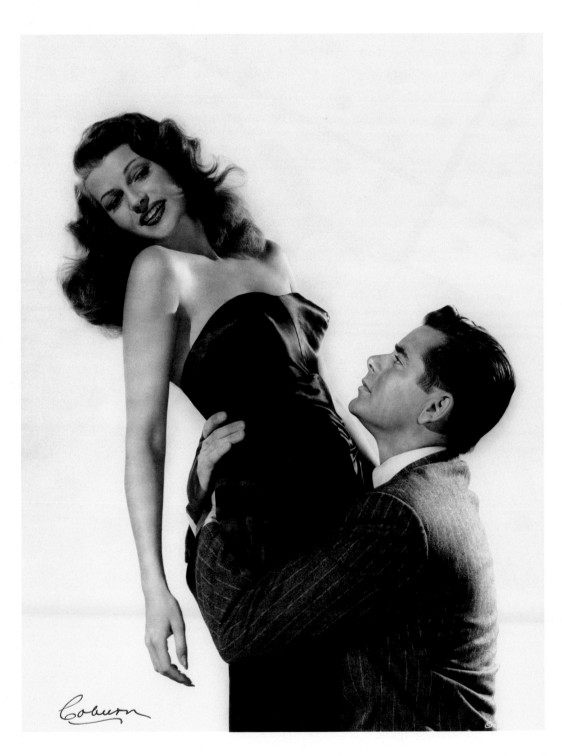

"During the shooting of portraits, Bob is director as well as photographer. He usually outlines to Rita [Hayworth] the action he wants to catch with the camera and sometimes even acts it out for her. Before each shooting, he makes a careful study of the motion picture script and plans the poses that he thinks will advertise the film to best advantage....

"Rita had just finished her...dramatic role as the heroine of Gilda *(1946) and her portraits had to show an entirely different personality than the one she had long displayed in musical pictures. To portray this new daring and enticing Hayworth, I concentrated on simple but dramatic poses."[11]*

Jinx Falkenberg, late 1940s

Silver gelatin photograph

15 5/16 x 19 5/16 in.

■

Deep shadows, contrasting black against white, were devices Coburn employed to achieve a greater illusion of three dimensionality. He also juxtaposed curves with angles to play up the sensuality of the female figure, a compositional trick that may have helped his photographs slip past the censors.

Kim Novak
Bell, Book, and Candle, *1958*
Dye transfer photograph
15 9/16 x 12 11/16 in.

■

Self-portrait with Cary Grant, undated
Silver gelatin photograph
10 3/8 x 13 7/16 in.

■

PAUL HESSE

United States, 1896–1973

Born in New York City.

1913–15 Experiments with photography while attending Pratt Institute.

1917–18 In France during World War I as head of a camouflage corps of 500 French women.

1918–early 1920s Poster illustrator. His illustration of a tintype photographer appears as cover of *Collier's*. Impatient with the time-consuming aspects of painting and drawing, purchases a secondhand vest-pocket camera and begins working again with photography. Avidly interested in photographic theory, reads all photography books in the New York Public Library.

Mid-1920s Establishes successful commercial photography studio.

Late 1920s Shoots first color portrait: Broadway star Diana Manners.

Early 1930s First color portrait of a movie star: Marion Davies. Experiments with one-shot color camera, based on simultaneous exposure of three separate plates. Persuades his commercial clients to allow him to work in color, becoming the first photographer to use color in national advertising campaigns. Travels to Hollywood several times each year to photograph stars for *Photoplay*.

1938–63 Earns six-figure income as photographer for Rheingold Breweries, continuing to produce Trichrome Carbro prints at client's request long after commercial discontinuation of the process. Conceives and executes the "Miss Rheingold" campaign—Jinx Falkenberg, the first—at one time second only to the Miss America competition in popularity. Obsessed with detail, designs sets, lighting, and clothes; applies models' makeup; and directs poses.

1940–63 Resettled in Los Angeles, his Sunset Strip studio becomes a gathering place for advertising and motion picture industry notables.

1945 Awarded the "title" Hollywood's Photographic Ziegfeld by an unofficial committee of movie stars in recognition of his contribution to their careers.

1948 With partner, Harvey Prebel, buys patents to French three-dimensional camera, producing thousands of primarily religious photographs (still being manufactured).

1963 Retires.

Chronology adapted in part from Susan Stowens's manuscript, "Hollywood's Photographic Ziegfeld," 1980.

Claudette Colbert

Cleopatra, 1933

Tricolor Carbro photograph

$11\,^{7}/_{8} \times 9\,^{7}/_{16}$ in.

■

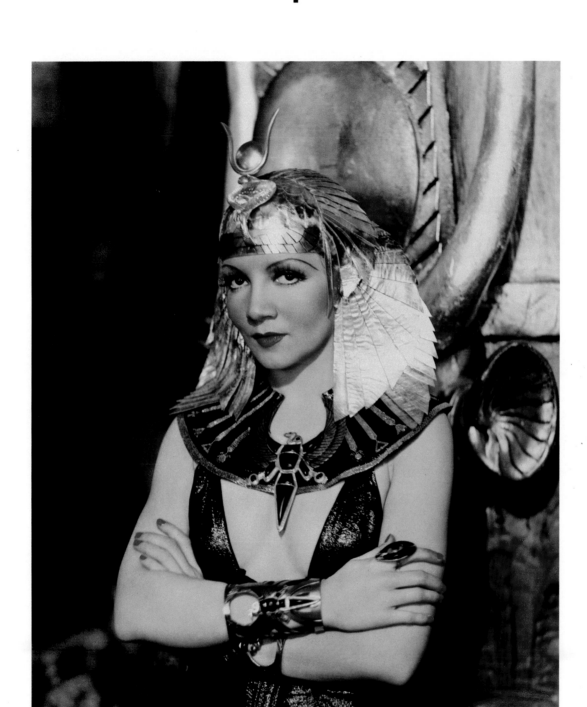

Ava Gardner, 1940s

Tricolor Carbro photograph

16⁵/₁₆ x 13³/₈ in.

■

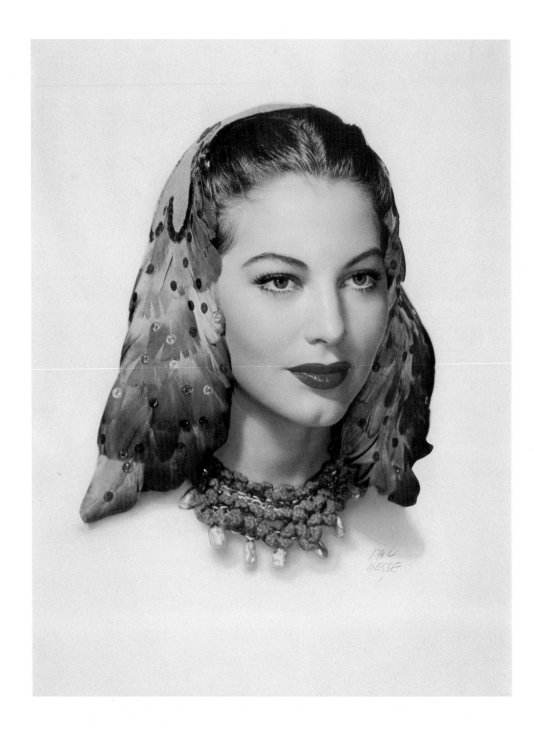

Lana Turner, about 1945

Tricolor Carbro photograph

16¾ x 13 in.

■

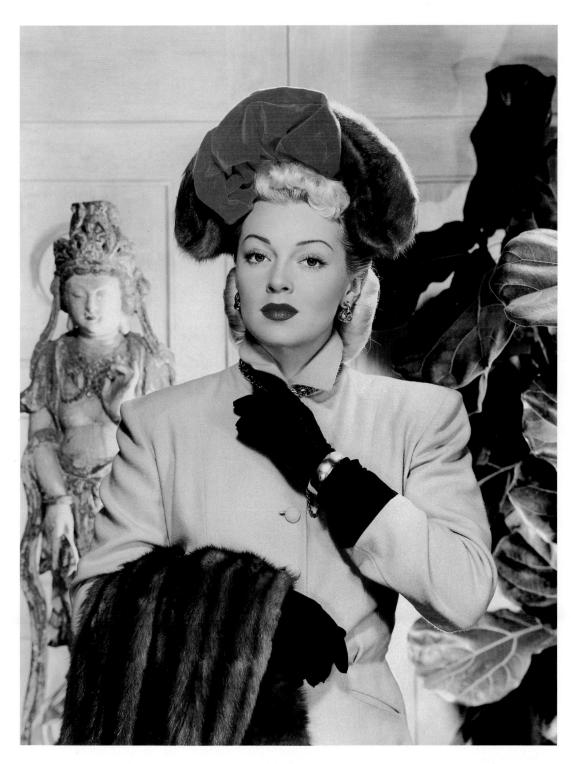

Paul Hesse's photographs characteristically reveal the saturated hues of the Carbro color process. But their gentle modulation of lighter colors and exquisite gracefulness of composition—whether a casual close-up or the tightly packed tableau vivant of an advertising scene—set his work apart from any other color portraiture of the 1940s and 1950s.

Marlene Dietrich, late 1940s

Tricolor Carbro photograph

14 ¾ x 18 in.

■

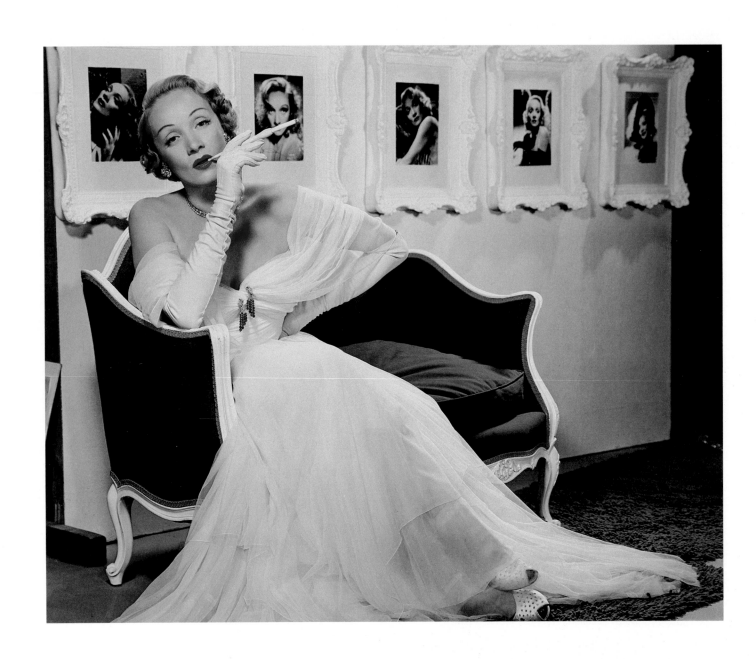

Ingrid Bergman

Joan of Arc, 1948

Tricolor Carbro photograph

15 3/4 x 12 5/8 in.

■

HESSE

Gregory Peck, 1940s

Tricolor Carbro photograph

17 ¼ x 12 ¹¹/₁₆ in.

■

John Wayne

Legend of the Lost

For Rheingold Beer, 1957

Modern Cibachrome photograph

19 ½ x 15 ½ in.

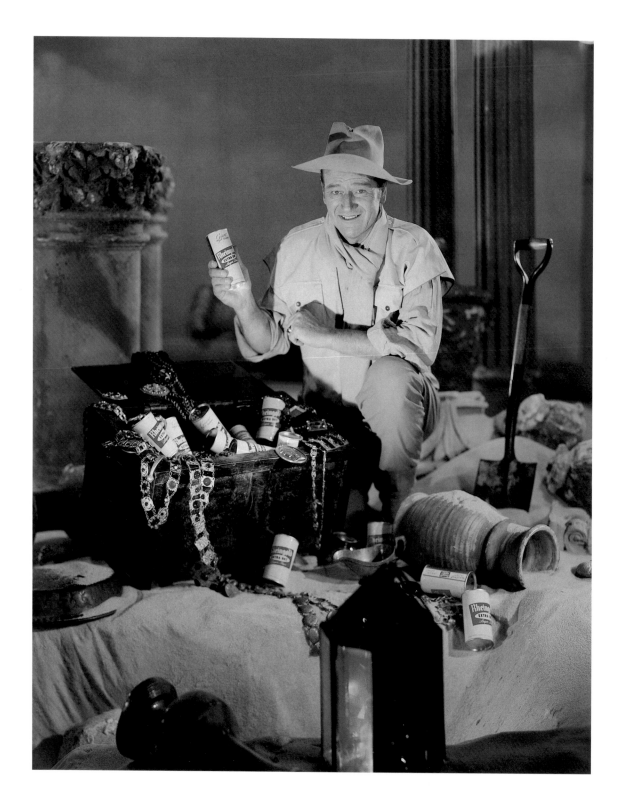

Susan Hayward

For Chesterfield Cigarettes, about 1950

Modern Cibachrome photograph

15 ½ x 19 ½ in.

■

Robert Coburn
Irving Lippman, 1942
Silver gelatin photograph
9 1/4 x 7 1/4 in.

■

IRVING LIPPMAN

United States, 1906–

Born in Edendale, California, the suburban location of Mack Sennett's and William Selig's original studios.

1929 Still man and assistant cameraman on independent film productions, including *A Million for Love* and *When Seconds Count*, and freelancing occasionally for Paramount and Warner Bros.

1929–34 At Warners as still photographer, hired by publicity director Hal Wallis. Pictures include *Sonny Boy* (1929), an early Al Jolson talkie, and several John Barrymore films, including *Show of Shows* (1929), *Moby Dick* (1930), and *Svengali* (1931).

1934–38 Still photographer at Columbia on seven Frank Capra films, including *It Happened One Night* (1934) and *Lost Horizon* (1937).

1942 Commissioned a 2d Lt. in U.S. Army and assigned to the Pictorial Service in Paris. Establishes a photography school for U.S. Army personnel in London.

1947–56 Returns to Columbia, where pictures include *From Here to Eternity* (1953) and *Picnic* (1955).

1956– As motion picture camera operator, first at Columbia Screen Gems, later at MGM, Paramount, and Universal, films Westerns and other television series including *Route 66* (46 episodes) and *The Love Boat* (125 episodes).

Picnic, 1955

Silver gelatin photograph

$10^{7}/_{16}$ x $13^{5}/_{16}$ in.

■

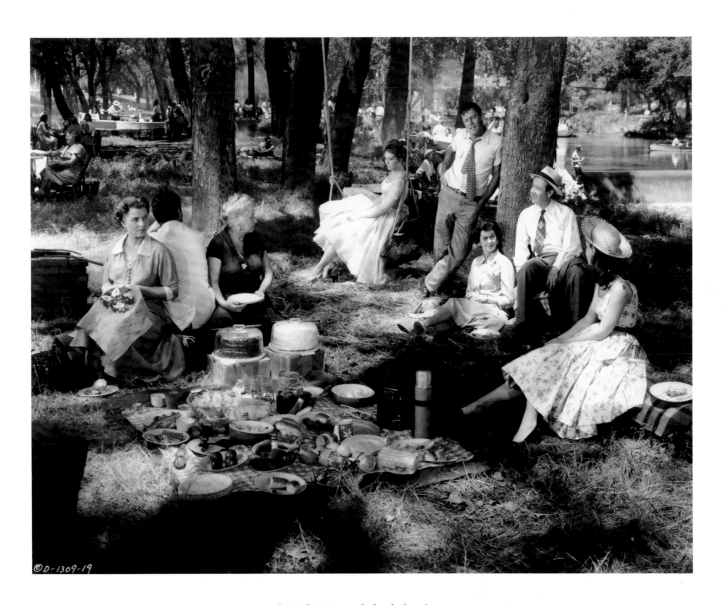

©D-1309-19

*Irving Lippman worked as both a cine-
matographer and a still photographer.
His portraits of the 1930s highlighted in a
soft-focus pictorial fashion the personality
of the star. In the 1950s he used lighting
and compositional skills to create a
"natural look" about an entire scene as in
his production still from* Picnic *(1955).*

Anonymous
Clark Gable, William E. Cronenweth, about 1940
Silver gelatin photograph
7³⁄₁₆ x 9³⁄₁₆ in.

∎

WILLIAM E. CRONENWETH

United States, 1903–

Born in Wilkensburg, Pennsylvania, the son of a camera shop owner.

1918 While in high school worked as cameraman's assistant at Famous Players-Lasky rushing exposed film from the set to the darkroom.

1920–25 Assistant cameraman at Universal on numerous features, including *The Hunchback of Notre Dame* (1923).

1926 Still man at Warner Bros.

1927 Assistant process photographer in the special effects department at Paramount. Intertitle designer at Technicolor. Still man at Universal, working with Roman Freulich.

1928–late 1930s Still man and later part-time gallery photographer at MGM, working with Clarence Bull. From 1933 still man on numerous Clark Gable films, including *Dancing Lady* (1933), *San Francisco* (1936), *Saratoga* (1937), and *Too Hot to Handle* (1938). For *Broadway Melody of 1938* shoots the portrait of Gable to which Judy Garland sings "You Made Me Love You."

1937 Wife, Rosita, doubles the Jean Harlow role when the star dies suddenly while filming *Saratoga*.

1938 Shoots some of earliest gallery portraits of MGM starlet, Lana Turner, the "sweater girl."

Late 1930s–66 Still man at Columbia, working with Robert Coburn.

1942 Selected by Rita Hayworth as her favorite still photographer.

1951 Selected by Glenn Ford as his favorite still photographer.

1953 Shoots gallery portraits of Marlon Brando and Mary Murphy for *The Wild One*.

1966 Back injury suffered while working on *PT 109* (1963) forces retirement.

Award
Academy award, best action photograph (1941) for Judy Garland/Mickey Rooney shots made originally for MGM photography contest.

Marlon Brando, Mary Murphy
The Wild One, 1953
Silver gelatin photograph
19 3/8 x 14 15/16 in.

■

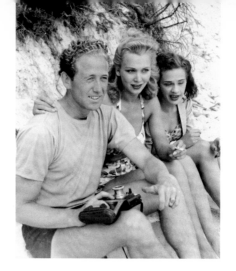

Anonymous
Peter Stackpole, Carole Landis, Landis stand-in, 1942
Silver gelatin photograph
9 ½ x 7 ½ in.

■

PETER STACKPOLE

United States, 1913–

Born in San Francisco, California.

1930—32 "Candids" shot with early model Leica shown in Oakland, California, high school exhibition. Part-time apprentice photographer for *Oakland Post-Enquirer*. Meets Edward Weston; almost convinced by the beauty of Weston's large-format technique to abandon 35mm format.

1934—36 Documents construction of Golden Gate and Oakland Bay bridges with still and motion picture photography. Resulting stills published in *Vanity Fair* (1935). Despite his use of 35mm handheld camera, invited by founder Willard Van Dyke to join f/64, a respected West Coast camera club devoted to straight, sharp, large format photography. Freelance assignments from *Time* following magazine's publication of his candid shot of Herbert Hoover dozing at a University of California ceremony. Photo essay on William Randolph Hearst at his Wintoon estate, first 35mm color images published in *Fortune*. Commissioned by Time, Inc., to compile prototypical picture stories and stock photographs for *Life* prototype issue.

1936 Hired along with Margaret Bourke-White, Alfred Eisenstadt, and Tom McAvoy as first *Life* staff photographers.

1938—51 In Los Angeles covering Hollywood for *Life*. Uses 4x5 camera, conducive to magazine reproduction.

1944—45 War correspondent for *Life*. Covers invasion of Saipan.

1951—61 In New York City as general-assignment photographer, specializing for *Life* in underwater photography. Designs and markets underwater camera housings.

1961 Retires from *Life* after twenty-five years, twenty-eight covers.

1962— Freelances for *California Living*, *Saturday Evening Post*, and other magazines.

Publication
The Bridge Builders (Corte Madera, Calif.: Pomegranate, 1984), commemorating the fiftieth anniversaries of the Golden Gate and Oakland Bay bridges.

Exhibitions
San Francisco Museum of Modern Art, solo exhibition of Bay Bridge photographs, 1935. Museum of Modern Art, New York, *The Family of Man*, 1955. Stanford Art Museum, Palo Alto, *Peter Stackpole: Retrospective*, 1986.

Frank Capra, 1936

Two modern silver gelatin photographs mounted together

Top: 5 ¹/₄ x 7 in.; bottom: 5 ¹/₁₆ x 6 ¹⁵/₁₆ in.

■

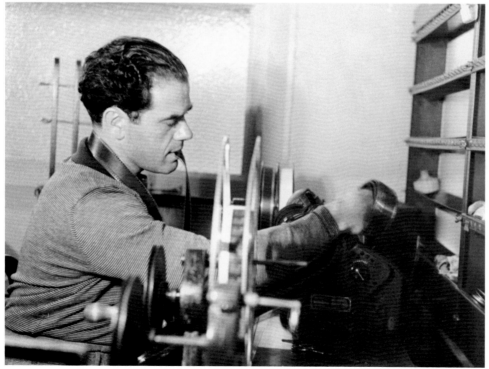

Vivien Leigh, 1951

Modern silver gelatin photograph

10 ⅛ x 9 ³/₁₆ in.

■

"I found Life *a very challenging atmosphere for a photographer because I didn't like what the studio stills conveyed to me. I thought there was an awful lot of phoniness in the stills, which is why* Life *had its own photographers out there: so we could get a little reality into some of these people and see what they were really like, not these horrible, doctored up, retouched, dead-looking pictures."*[12]

Hedy Lamarr, about 1947

Modern silver gelatin photograph

9 ½ x 7 ⅝ in.

■

"*After I saw her in* Ecstasy *(U.S. release, 1937), I thought Hedy Lamarr was one of the most beautiful creatures in the world. I didn't like what they did to her though when they brought her to this country and changed her hair. They made her a little more common looking.*

"*Just because she was a beautiful person was enough reason to go up to her house to take pictures. I had a new car at the time, a Buick convertible. I said, 'How about your driving my car to get some pictures?' but I discovered when I got into the car that I couldn't back up far enough, so I had to lie with my head on the floor and my legs in the air.*

"*She drove to Mulholland Drive, and suddenly she started laughing. People saw her driving with these two legs sitting next to her.*"[13]

William S. Hart, about 1945

Modern silver gelatin photograph

8 ½ x 7 ¼ in.

■

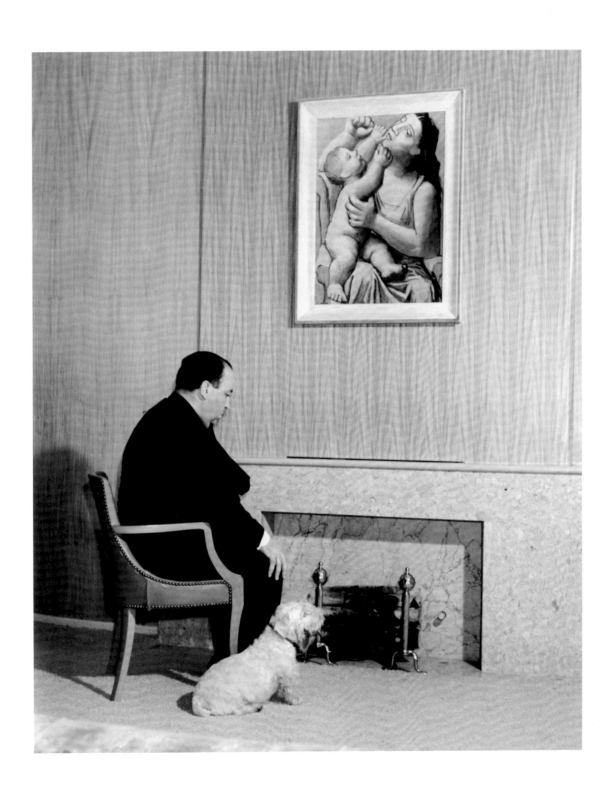

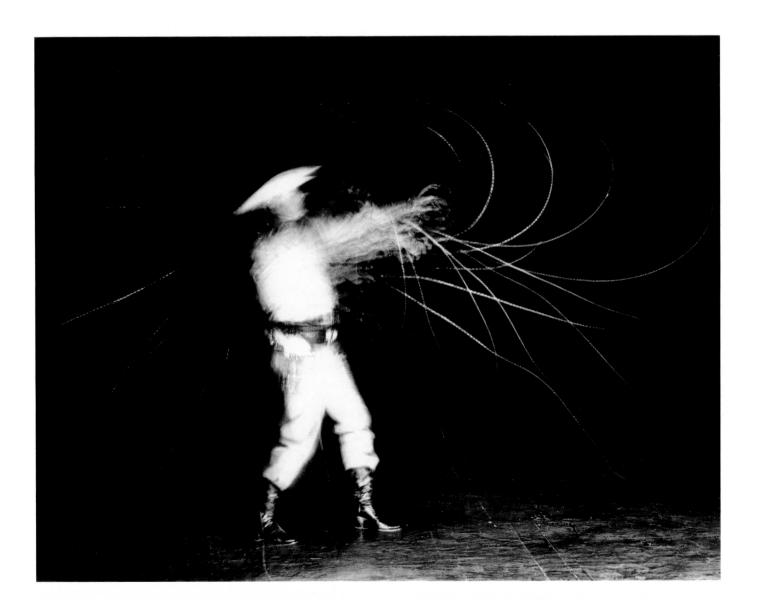

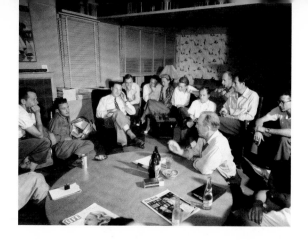

Anonymous
J R Eyerman (third from left), Will Connell (at table in profile)
at Connell's home, about 1958
Silver gelatin photograph
7⅝ x 9⅝ in.

■

J R EYERMAN

United States, 1906–85

Born in parents' Butte, Montana, photographic studio.

Through 1921 Makes hundreds of negatives in Yellowstone and Glacier national parks.

1921–27 Studies civil engineering and establishes engineering career.

1927–37 Abandons engineering for a career in photography, Opens studio with his mother in Roxy theater basement, Tacoma, Washington. Makes lobby displays of current attractions; shoots theatrical, portrait, and publicity photographs.

1930 As engineering specialist in legal cases makes photographic enlargements.

1937–41 Pacific Northwest stringer for *Life*. Name appears on masthead beginning 1938. Photographs scenery for Washington State Progress Commission.

1941–45 On staff at *Life* in San Francisco bureau, then as war correspondent covering the North Atlantic, North Africa, Sicily, and Salerno, then the South Pacific. Photographs aftermath of Hiroshima bombing.

1946–47 In New York City, then Los Angeles (1947) as chief of photography for *Life*, photographing color motion picture spectaculars, industrial, military, and scientific subjects, and miscellaneous picture essays. Develops high-speed color techniques, leading to first successful documentation of the Aurora Borealis.

1950 Perfects electric-eye mechanism to trip nine camera shutters and as first outside photographer permitted access by Atomic Energy Commission (AEC), uses device to document first atomic blast at Yucca Flats, Nevada. Photographs most AEC projects.

1951 Devises underwater camera to document submarine firing torpedoes at 3,600 feet. Founds Technical Photomation; develops and markets motors used on Leica cameras in the 1950s.

1961 Retires from *Life*. Establishes Beverly Hills photographic studio serving illustrated magazines, including *Life*, *National Geographic*, and *Smithsonian*.

Fredric March, Florence Eldridge

An Act of Murder, 1948

Silver gelatin photograph

12 ¹³⁄₁₆ x 11 ³⁄₁₆ in.

■

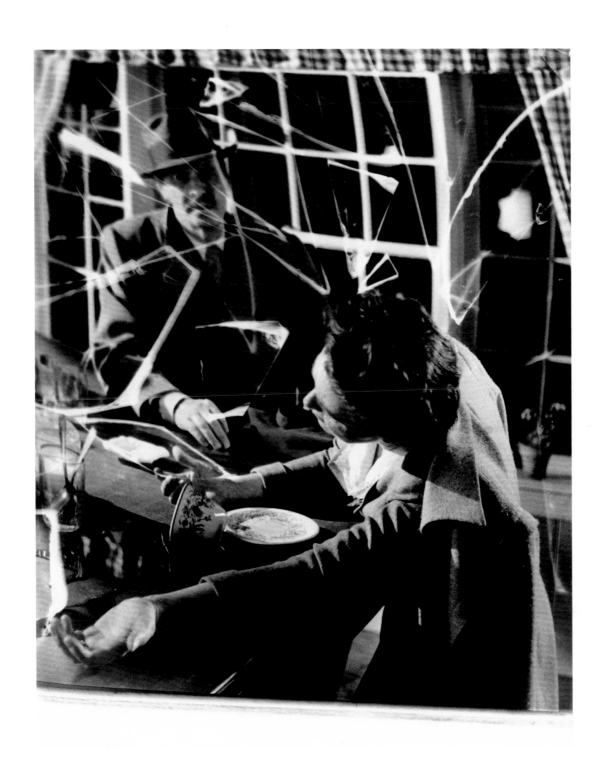

Lana Turner at the Johnny Stampanato Murder Trial, 1958

Silver gelatin photograph

8⁷⁄₈ x 13⁷⁄₁₆ in.

■

Cast and Crew of The Birds, 1963
Modern silver gelatin photograph
10 ½ x 13 ½ in.

Montezuma, 1958

Modern Cibachrome photograph

10 ½ x 13 ½ in.

■

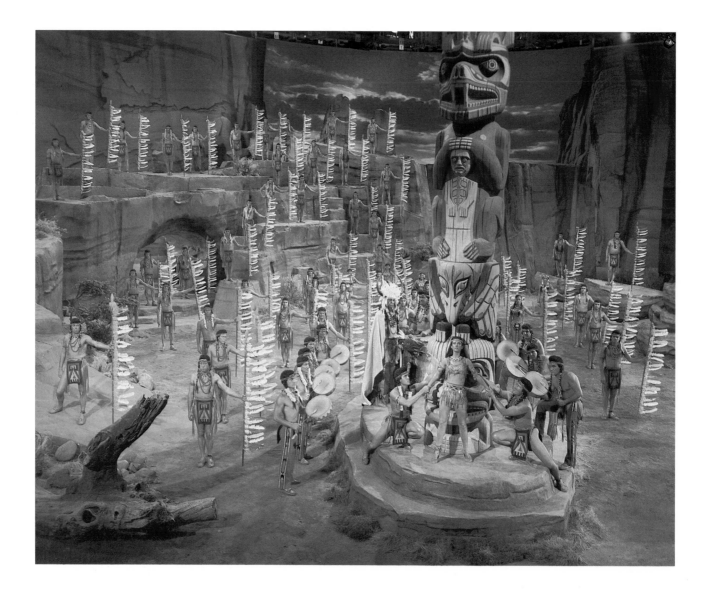

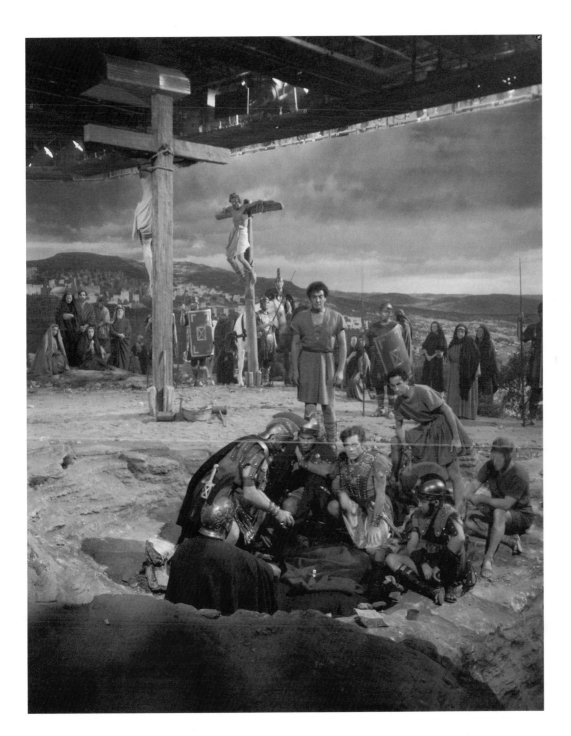

J R Eyerman composed photographs of elaborate color spectaculars, which required considerable planning and equipment to accomplish. Viewed full frame, not cropped for reproduction, as he originally intended, they reveal a great deal of humor, as in a scene from the making of The Robe *(1953), which might be convincing were it not for the upper edges of the backdrop slyly revealed.*

Gene Trindl (United States, 1924–)
John Florea, Marilyn Monroe, 1949
Modern silver gelatin photograph
7 1/2 x 7 1/2 in.

■

JOHN FLOREA

United States, 1916–

Born in Alliance, Ohio.

1932 Takes high school photography class.

1935 Assists Los Angeles portrait photographer taking high school yearbook pictures but becomes disenchanted because all his subjects want "to be cleaned up to look like Clark Gable."

1936 Laboratory technician and photographer for International News Photos, serving the Hearst newspapers.

1937–42 On staff as news photographer at *San Francisco Examiner* with ambitions of becoming a *Life* photographer. Hired by *Life* as a stringer reporting to the Los Angeles bureau after the magazine publishes one of his wire service images (1939). Photographs appear in thirty issues (1942).

1943–46 Staff photographer for *Life*, covering Hollywood, eleven western states, and war assignments. Directs *Life*'s "photo dramatization" of *The Song of Bernadette*. Photographs help win the title role for Jennifer Jones. As *Life* war correspondent photographs the European theater of war, including the Battle of the Bulge and the meeting of American and Soviet troops at the Elbe River, and later the South Pacific. Only person to photograph both VE Day in Europe and VJ Day in Japan. Between battlefront assignments, continues to cover the motion picture industry in Hollywood. Learns motion picture directing by watching directors he was assigned to photograph. Returns to the Pacific after VJ Day, photographing in China, Indonesia, Korea, and the Philippines. Given an island in the Celebes by President Sukarno of Indonesia as a token of appreciation; Florea remains the sultan.

1946–56 As freelance photojournalist contributes to *Collier's* and other magazines. Innovative combination of color gels and flash for photo essay "Yellow Sky" (*Life*, 1949) receives wide critical attention.

1952–56 Transition to motion picture photography made through producing, writing, and directing industrial films.

1957– Credited with directing more than 500 television shows and seven feature films, including *Underwater Warrior* (1964), *A Time for Every Purpose* (1969), and *The Astral Stranger* (1978).

Exhibition
Museum of Modern Art, New York, *The Family of Man*, 1955.

Award
Emmy as best director for an episode of *After School Special* (1974).

Bob Hope

USO Tour, 1942

Silver gelatin photograph

13⅜ x 10¼ in.

■

As a photojournalist working in the 1940s, John Florea covered both the fanciful side of Hollywood and the grim side of war.

"After World War II you could see photography changing. It was going toward the contrast and sharpness of Life. *My style became more realistic. I had been dealing in soft shadows prior to going overseas. Once I had seen enough war, I changed subconsciously....Photography was the TV of the day. You had to think quick on your feet, you had to be ready and have an eye—you were always looking for a picture that would describe something to the readership."[14]*

FLOREA

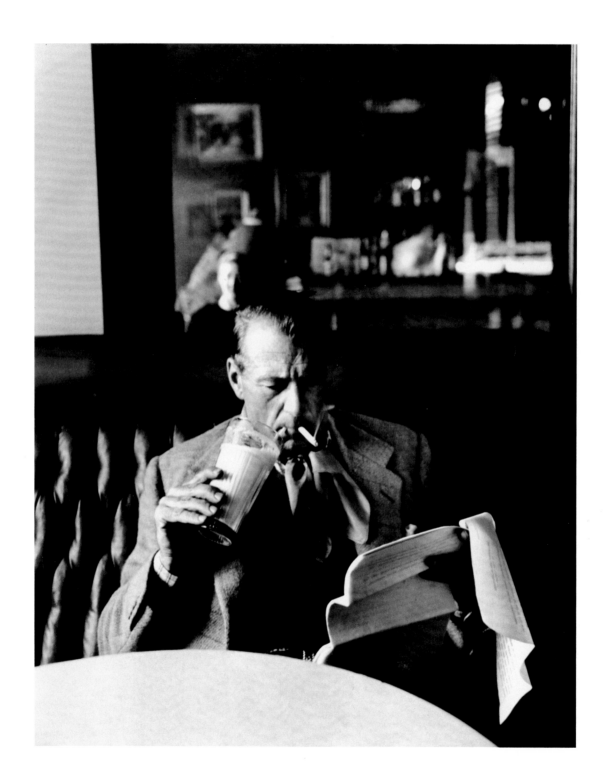

Joan Crawford, Allen Jenkins
He Kissed the Bride, *1942*
Modern silver gelatin photograph
15 ³/₈ x 19 ⁵/₁₆ in.

■

Yellow Sky, *1948*

Modern Cibachrome photograph

11 x 14 in.

∎

"I was trying to do something abstract here. I wanted to show that overall Western pictures had certain characteristics: the good guy wore a white hat, and the bad guy wore a black hat. There was always a lily-livered nephew who went bad. I was trying to show the cliches in Westerns by shooting abstractly against a seamless background. It was the first time [the editors] had seen seamless background photography."[15]

Marilyn Monroe, 1953

Modern Cibachrome photograph

11 x 14 in.

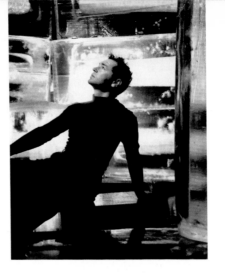

Peter Stackpole
Eliot Elisofon, 1941
Silver gelatin photograph
9 ½ x ⁷⁄₁₂ in.

■

ELIOT ELISOFON

United States, 1911–73

Born in New York City.

1930–33 While working at the New York Bureau of Workman's Compensation and planning to become a physician, makes and sells portraits of acquaintances at five dollars apiece.

1933–38 Graduated from Fordham University premed. program, but without funds to enroll in medical school opens photographic studio, August and Co., with friend Martin Bauman; first job: photographing a plate of fried chicken.

1936–51 Member of Photo League in New York; elected president (1940).

1938 Freelance photojournalist for *Life*. Early photo essays include "Tintype Photographer" and "The Jewish New Year." Abandons commercial photography for photojournalism. Perfects synchronized multiple-flash system, allowing photography of large interiors and nighttime exteriors.

1941 First *Life* color cover: Gen. George Patton. Patton nicknames him "Hellzapoppin."

1942–65 Staff photographer and war correspondent in Europe and Africa for *Life*. Shoots geographic picture essays in the United States and Africa (1946–47).

1948 Though Photo League is placed on the attorney general's list of subversive organizations, remains president so as not to suggest an admission of guilt; resigns 1951, when league fails to clear its name to attorney general's satisfaction.

1951 Production stills for *The African Queen*.

1952 Color consultant on *Moulin Rouge*.

1954–56 Continues traveling the world as *Life* photojournalist.

1958–65 Works intermittently in Hollywood as color consultant and still photographer—films include *Bell, Book, and Candle* (1958), *The War Lord* (1965), and *The Greatest Story Ever Told* (1965)—while continuing as photojournalist worldwide. Photographs Shirley Booth, Judy Holliday, Roddy McDowall, Anthony Perkins, Jason Robards, and Peter Ustinov in their

"dream roles" for *Life* (1958). Named Honorary Research Fellow in Primitive Art at Harvard University.

1966 Appointed Trowbridge Lecturer at School of Fine Arts, Yale.

Publications
Food Is a Four-Letter Word (New York: Rinehart, 1948). *The Sculpture of Africa* (London: Praeger, 1958.) *Color Photography* (New York: Viking, 1961).

Exhibition
Museum of Modern Art, New York, *Memorable "Life" Photographs*, 1951.

Collections
Fogg Art Museum, Cambridge, Massachusetts; Dallas Museum of Fine Arts; Museum of Modern Art, New York; Philadelphia Museum of Art; and Pennsylvania Academy of the Fine Arts, Philadelphia.

Roddy McDowall, 1958

Modern Cibachrome photograph

20 x 16 in.

■

For a Life *picture essay on the dream roles of the stars, Elisofon photographed Roddy McDowall as Ariel in Shakespeare's* The Tempest. *McDowall posed between sheets of sequined netting, which Elisofon shot out of focus to create an illusion of floating in space. To soften the effect of the actor's bizarre makeup, Elisofon kicked his tripod while the shutter was open, creating a slightly blurry effect.*

Veronica Lake

"The Girls of Hollywood" outtake, Life, 1942

Modern Cibachrome photograph

20 x 16 in.

■

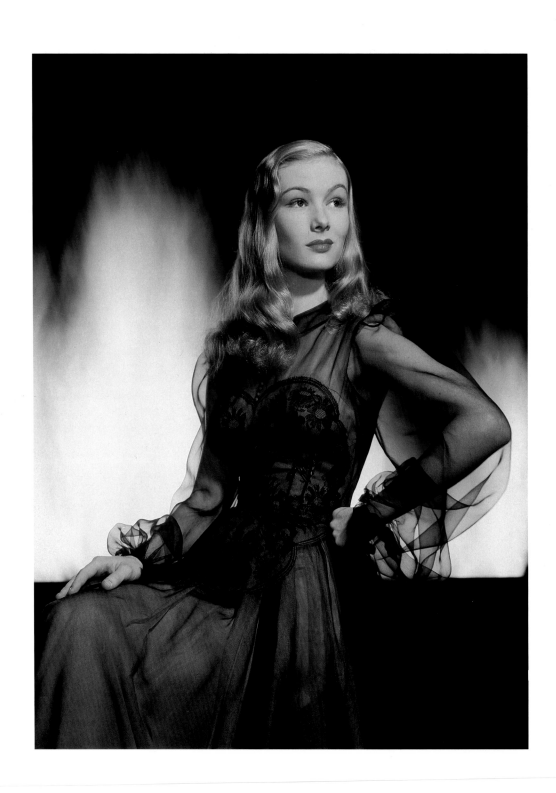

Moulin Rouge, 1952

Modern Cibachrome photograph

16 x 20 in.

■

Eliot Elisofon shot still photographs on the Kenyan sets of John Huston's The African Queen *(1951). Huston became so intrigued with the experimental theories that Eliosofon propounded for shooting color that he subsequently hired him as special color consultant on* Moulin Rouge *(1952), his biography of Henri de Toulouse-Lautrec. The color effects that Elisofon designed evoked a Toulouse-Lautrec painting come to life. He used color filters to enhance the mood of a scene and blue light on the petticoats of the dancers to make them appear whiter when they kicked.*

The Greatest Story Ever Told, *1965*

Modern Cibachrome photograph

16 x 20 in.

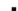

Gene Tierney

"The Girls of Hollywood" outtake, Life, 1942

Modern Cibachrome photograph

20 x 16 in.

■

Self-portrait with Norma Jean Dougherty (Marilyn Monroe), 1946
Silver gelatin photograph
9⁹⁄₁₆ x 7³⁄₄ in.

■

RICHARD C. MILLER

United States, 1912–

Born in Hanford, California.

1929 Introduced to Leica and Graflex cameras and to cinematography while attending, successively, Stanford University, Pomona College, and University of Southern California.

1934–35 While appearing at the Pasadena Community Playhouse, shoots photographs of fellow players with a borrowed Leica. Acquires a Zeiss Contax I 35mm camera and begins making photographs in available light. In New York looking for work as an actor, shows photographs to Edward Steichen. Continues photographing actors. Upon returning to Los Angeles, resumes acting and photographing and begins offering portraits for sale.

1939–40 Leaves acting for career as a photographer. Learns color Carbro printing process. Purchases one-shot color camera, enabling him to shoot live subjects.

1941 Carbro print of his daughter, submitted to *Saturday Evening Post*, adopted as a cover, one of only two photographic *Post* covers that year. Meets photographer Brett Weston, forming a lifelong friendship.

1942–44 Freelances for *Liberty* and *This Week*. On staff in photographic department, North American Aviation, photographs airplanes and provides illustrations for service manuals, while continuing to make Kodachrome transparencies as a personal sideline. Sells photographs through Freelance Photographers Guild, a New York City photographic agency.

1944–45 Continues to perfect his color printing while working as a printer for Bela Gaspar, inventor of Gaspar Color, the dye bleach process on which today's Cibachrome process is based. While at Gaspar Color consults with photographers Nickolas Muray and Paul Outerbridge. Choosing to remain independent, declines offers made by Robert Coburn to join IATSE #659 and to print color at Columbia.

1946 Photographs of Norma Jean Dougherty (later Marilyn Monroe) sold

1946–54 Changes representation from Freelance Photographers Guild to Rupho-Guillomette. Continues photographing children and animals freelance for calendars and magazine covers, including *Family Circle* and *Parents*. Assists photographers Valentino Sarra, Ruzzie Green, and John Engstead on commercial jobs. Photographs celebrities on assignment for *American Weekly, Collier's, Life,* and *Time*.

1952–55 Television lighting director (KLAC).

1955–62 On retainer at Globe Photos covering the film community and the West. First location coverage: *Giant* (1956). Eventually covers more than seventy films.

1962–66 Semiretirement, occasionally shooting motion picture and other assignments.

Jean Simmons stand-in, Kirk Douglas

Spartacus, 1959

Silver gelatin photograph

10¾ x 13¹³/₁₆ in.

■

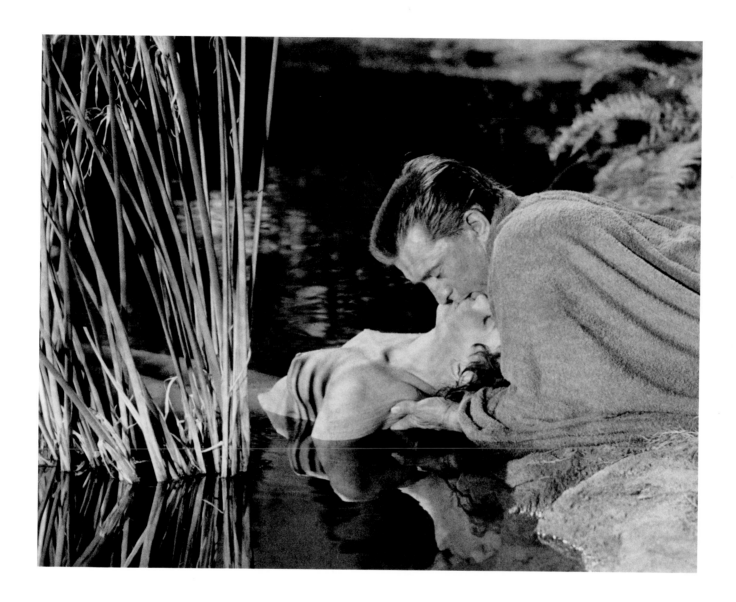

MILLER

Kelly Curtis, Tony Curtis, 1958

Silver gelatin photograph

$9^{7}/_{16}$ x $7^{3}/_{8}$ in.

"Jimmy Dean, Elizabeth Taylor

in the Pardos' Home, Dallas, Texas," 1955

Silver gelatin photograph

10 $^{11}/_{16}$ x 13 $^{9}/_{16}$ in.

■

Miller, on assignment from Globe Photos, was making photographs to be used to promote Giant *(1956). James Dean and Elizabeth Taylor were photographed in Dallas during a weekend break in the filming. Both Taylor and Dean, a photographer himself, were comfortable with Miller making natural-looking photographs in available light. Neither was posing, but Dean was not beyond assisting the photographer in creating an interesting picture. "Dean was a natural who understood the camera and what the photographer was doing. He aided you. As I began to photograph them on the couch, he saw me and picked up the magazine with Taylor on the cover as 'Mother of the Year.' He knew it was a good picture. He had a sense for good pictures."[16]*

Jack Lemmon, Shirley MacLaine, Billy Wilder

The Apartment, 1960

Silver gelatin photograph

7 9/16 x 9 3/4 in.

■

Laurence Olivier, Tony Curtis, Peter Ustinov

Spartacus, 1959

Silver gelatin photograph

10 ³⁄₄ x 13 ¹³⁄₁₆ in.

■

Richard Miller was influenced by photographers Brett Weston, a personal friend, and Henri Cartier-Bresson, photographers at opposite ends of the aesthetic spectrum. "I wanted to get the quality of an 8x10 negative in a 35mm negative. I liked the quick moment and 35mm vision, but I also want the sharpness of the 8x10 photograph. Much of my style is documentary. I like pursuing reality. I don't like to set things up."[17]

Miller used Norma Jean Dougherty (later Marilyn Monroe), whom he hired through a modeling agency, to illustrate the young bride in a True Romance *story. In this Carbro color photograph she wears the gown she wore at her wedding to first husband, Jim Dougherty, and holds Miller's wife's prayer book.*

"She had tremendous appeal when I first knew her. She had that appeal from the time she was very young: a quality, a sexuality. She wanted to be a great actress. She was not at all like she was later.

"What fame does for people is incredible. During Some Like It Hot *(1959) she insisted on approval of all proof sheets, though she was not in a position to review them all and make sensible choices as to what was best. I once asked director Billy Wilder why he used her when she created so much trouble on the set, and he said, 'It's like somebody who can play one note on an instrument. They play it perfectly, though they can't play anything else.'"[18]*

Self-portrait (left) with Henry Fonda and James Stewart, 1937
Modern silver gelatin photograph
7 x 5 in.

■

JOHN SWOPE

United States, 1908–79

"Marion Davies gave a party for William Randolph Hearst's seventy-sixth birthday down at their home in Santa Monica. She asked everybody to come in 'the spirit of '76,' so we—Jimmy Stewart, Hank Fonda and myself—decided to come as the spirit of '76 à la the Marx Brothers. We got there late, it was a big house filled with people. The butler came and we said, "Don't announce us." We walked through all the rooms, playing the drums and fife. When we arrived at the reception hall, we stood in front of all the people and played for them. I saw this blonde and like Harpo I said, 'I chase blondes.' I dropped the drumsticks and went and wrestled the blonde to the floor and then came back and continued to play. Fonda leaned over to me and said, 'Well, you dumb son of a bitch, do you know who that was? That was Marion Davies!'"[19]

Born in New Brunswick, New Jersey.

1927 Member along with Henry Fonda, Joshua Logan, and James Stewart of Harvard University Players.

1936 An avid sailor, takes camera along on Los Angeles-to-Honolulu yacht race; develops interest in photography.

1937 In Los Angeles (rooming with Fonda and Stewart) as Leland Hayward's production assistant.

1938 Commissioned by Henry Street Settlement House to document the work of nurses in Harlem and the Lower East Side.

1939 Accompanied by Logan as writer, tours South America photographing for *Harper's Bazaar*. At invitation of Bolivian government remains nine months photographing for state tourism program.

1940–43 U.S. Army flight instructor. With John Steinbeck produces *Bombs Away,* an illustrated book explaining pilot-training program to families of married trainees.

1943 Reassigned to Steichen's U.S. naval photographic unit.

1946–58 Freelance photographer for *Life*.

1952 Photographs *Julius Caesar;* photograph of star, Marlon Brando, appears on *Life* cover.

1956–78 Extensive worldwide travel. Continues photographing; works published and exhibited throughout the U.S.

Publications
With Leland Hayward, *Camera over Hollywood* (New York: Random House, 1938), commissioned by Bennett Cerf. With John Steinbeck, *Bombs Away* (New York: Viking, 1942), commissioned by U.S. Air Force. With James Ivory, *Autobiography of a Princess* (New York: Harper & Row, 1975).

Exhibitions
Albright Art Gallery, Buffalo, New York, dual exhibition (with Phillip C. Elliot), 1952. Santa Barbara Museum of Art, solo exhibition, 1953. Joclyn Art Museum, Omaha, Nebraska, *People and Places,* 1963. Los Angeles County Museum of Art, *Henry Moore in America,* 1973; photographic installation by Swope; catalogue text, Henry J. Seldis (New York: Praeger, 1973).

Mrs. Oscar Levant, Levant, Hope Lange, 1968

Modern silver gelatin photograph

10⅞ x 13¾ in.

■

Marlon Brando

Julius Caesar, 1952

Modern silver gelatin photograph

13½ x 10½ in.

■

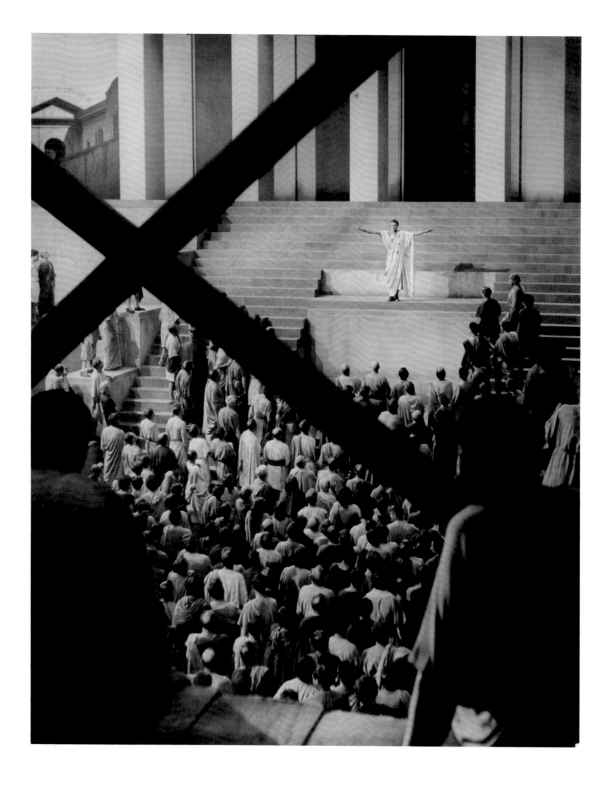

John Garfield, about 1940

Modern silver gelatin photograph

13½ x 10½ in.

■

John Swope welcomed the challenge of divulging the characters of famous people. Their juxtaposition with specific elements from their personal environments reveals intimate aspects of their lives. As an observer of human behavior, he "presents a picture of actors stripped bare of their mythical characters."²⁰

His approach included shooting from odd angles or in contrasty available light, essentially creating portraits that require a new way of looking at familiar faces. His deceptively simple but well-thought-out pictures are intricate arrangements of shape and form infused with emotion. "If I've had any influences at all in the way my photographs are structured, it probably comes from Mondrian. When I first came upon his paintings, I was held by his use of line. It was an entirely different experience for me. Although at the time I questioned the validity of his art, I was fascinated by his idea of linear space and what was not in that space."²¹

"Stage Set of a Hollywood Premiere," about 1937

Silver gelatin photograph

9 $^{15}/_{16}$ x 7 $^{15}/_{16}$ in.

■

"Stage Set of a Hollywood Premiere," about 1937

Silver gelatin photograph

Jane Fonda, Henry Fonda, 1955

Modern silver gelatin photograph

13 ½ x 10 ½ in.

■

Elsa Maxwell, Tyrone Power, the Duke of Windsor, 1942

Modern silver gelatin photograph

10 ½ x 13 ½ in.

■

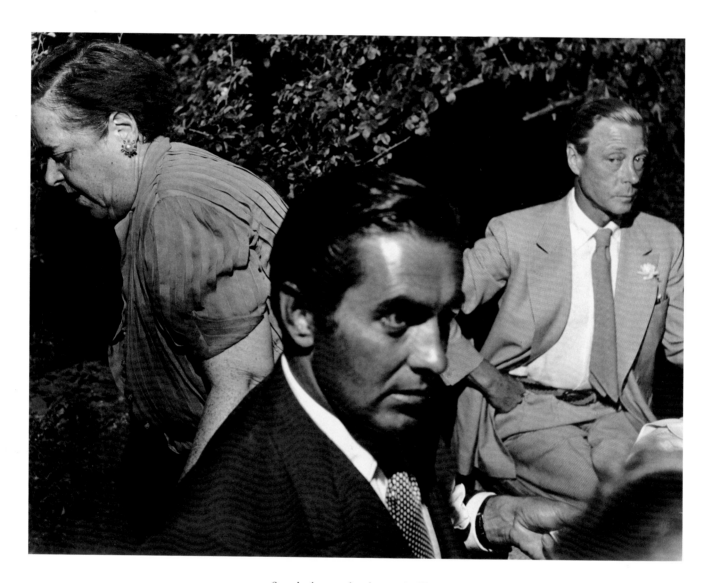

Swope's photographs, characterized by
their unconventional arrangement of
people, make us keenly aware of inter-
actions, or lack of interactions, among
the subjects within the frame. His com-
position of Elsa Maxwell, Tyrone Power,
and the Duke of Windsor at Maxwell's
home on the Riviera (1948) appealed to
him because "among three well-known
but diverse personalities it demonstrates
complete lack of communication."[22]

Anonymous
Sanford Roth (center), 1956
Silver gelatin photograph
7 1/2 x 13 7/16 in.

■

SANFORD ROTH

United States, 1906–62

Born in New York City.

1924 While attending New York University, visits Alfred Stieglitz's "291" gallery periodically.

1925–46 Continues photography while working as chain store executive.

1947–59 As an expatriate in Paris, photographs painters, including Dufy, Léger, Matisse, Picasso, Utrillo, Vlaminck; and writers, including Colette and Cocteau. Photographs film celebrities worldwide, including Joan Crawford, Judy Garland, Cary Grant, Audrey Hepburn, Jack Lemmon, Paul Newman, and James Stewart. Photographs reproduced in magazines, including *Fortune, Harper's Bazaar, Life, Look, Oggi, Paris Match, Stern,* and *Vogue.*

1955 As close friend of James Dean, photographs the actor on and off the set of *Giant,* then accompanies him on the trip that ended in Dean's fatal accident. Witnesses accident and photographs aftermath.

Publications
With Aldous Huxley, *Mon Paris* (Paris: Chene, 1954). With Beulah Roth, *James Dean* (Corte Madera, Calif.: Pomegranate, 1983).

Exhibitions
Museum of Modern Art, New York, *The Family of Man,* 1955. Galerie Municipale du Chateau d'Eau, Toulouse, France, *Sanford H. Roth: Retrospective,* 1983.

Collection
Museum of Modern Art, New York.

Paul Newman

Somebody Up There Likes Me, 1956

Silver gelatin photograph

13 ½ x 9 in.

■

In the best photojournalistic manner Roth captures the distinctive facial expression of Paul Newman while ignoring an age-old formula of composition: never have poles growing out of heads.

Audrey Hepburn

The Nun's Story, 1959

Silver gelatin photograph

15 x 11 ⅛ in.

■

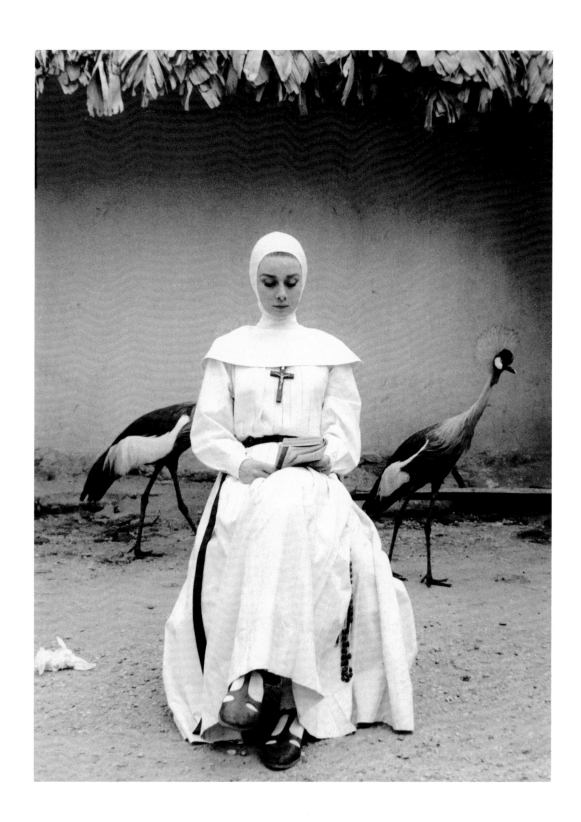

Joan Crawford, 1953
Silver gelatin photograph
10 ¼ x 13 ¼ in.
■

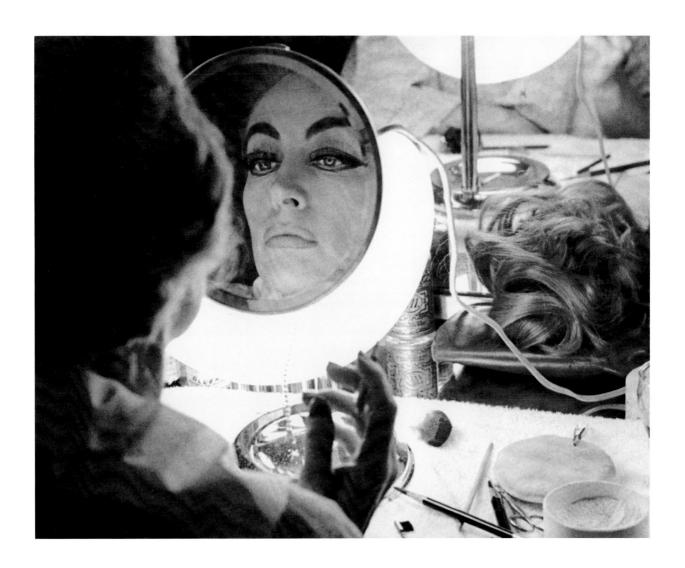

James Dean, 1955

Modern silver gelatin photograph

13⁷⁄₁₆ x 9¹⁄₁₆ in.

■

Roth and his wife, Beulah, met James Dean in the spring of 1955. They had mutual interests—the works of Wilde, Sartre, and Genet and a wish (unfulfilled) to visit Paris and Rome together—as well as a passion for cats. Roth photographed Dean frequently during the last six months of the actor's life.

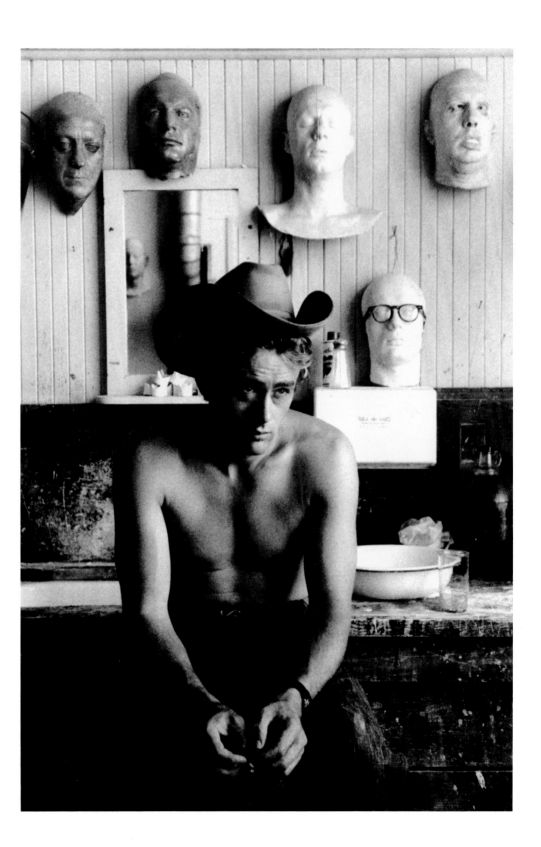

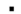
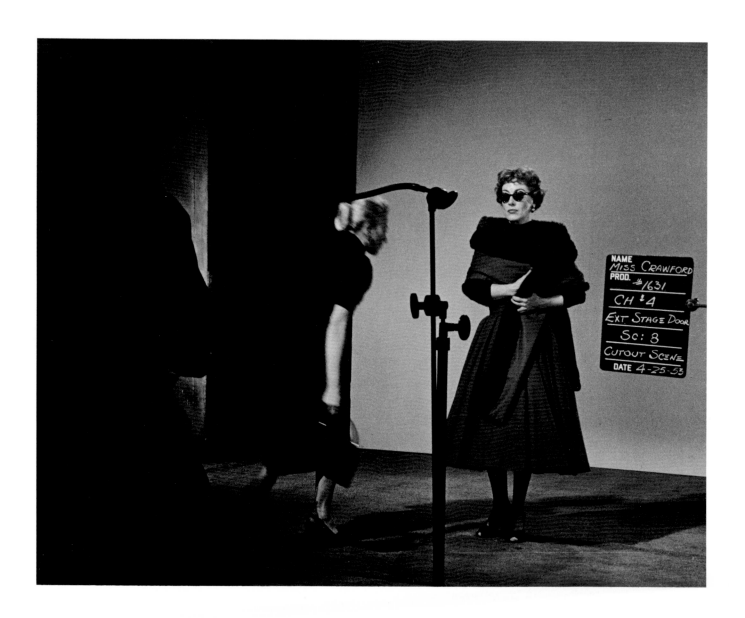

Judy Garland

A Star Is Born, *1954*

Silver gelatin photograph

10 ½ x 13 ⁷/₁₆ in.

■

The photographer Weegee described Hollywood as "the land of Zombies…full of phonies,"[23] but Sanford Roth shows us Judy Garland, Joan Crawford, and Gina Lollobrigida as hard-working people. Because of his unobtrusive way of working, his subjects were oblivious to his presence as in his environmental portrait of Gina Lollobrigida. Roth stood behind a wall and photographed the actress facing a mirror, recording his own reflection in the process.

Anonymous
Joan Crawford, Phil Stern, about 1946
Silver gelatin photograph
8 1/16 x 9 1/2 in.

■

PHIL STERN

United States, 1919-

Born in Philadelphia, Pennsylvania.

1938 Works days as commercial artist at photoengraving studio, nights as photographer for the New York City *Police Gazette*.

1939 Staff photographer at *Friday*, covering labor and other social issues.

1941 In Los Angeles at *Friday*'s West Coast office until the magazine folds, remaining on West Coast as contributing photographer for *PM*, a New York City newspaper. Freelance photographer for *Collier's, Life, Look, New York Times Magazine, Photoplay,* and *Saturday Evening Post*.

1942 Assigned by U.S. Army to a photographic unit in London, England. Volunteers for "Darby's Rangers," a much-heralded American fighting unit, as combat photographer; nickname: "Snapdragon." Wounded in North Africa and assigned, after recuperation, to cover invasion of Sicily for *Stars and Stripes*.

1944 Assigned by *Life*, along with author John Hersey, to produce a photo essay on the homecoming of Darby's Rangers. In Hollywood appears with film personalities promoting sale of war bonds.

1945 Photographs family of an unemployed shipyard worker for *Life*.

1946– As freelance photographer contributes to numerous magazines, including *Argosy, Ebony, Esquire, Interview, Life, Modern Screen, People, Photoplay, Saturday Evening Post, This Week,* and *TV Guide*; serving as "special," or unit, photographer on more than 200 feature films, including *Guys and Dolls* (1955) at the instigation of Dane Golding, former colleague at *Stars and Stripes*, *Darby's Rangers* (1958), in which he also acts, *In Cold Blood* (1967), *The Blue Bird* (1976), and *Once Bitten* (1985), and television programs, including *Fame* and *Family Ties*; photographing portraits of jazz performers for album covers.

1961 Engaged by Frank Sinatra, head of entertainment, to photograph Kennedy inaugural gala and private dinner. Travels to Soviet Union for Globe Photos; assignments include Abrazoff Puppet Theater, Bolshoi Ballet, and Russian film studios.

Anita Ekberg, 1956

Modern silver gelatin photograph

13 ½ x 10 ⅜ in.

■

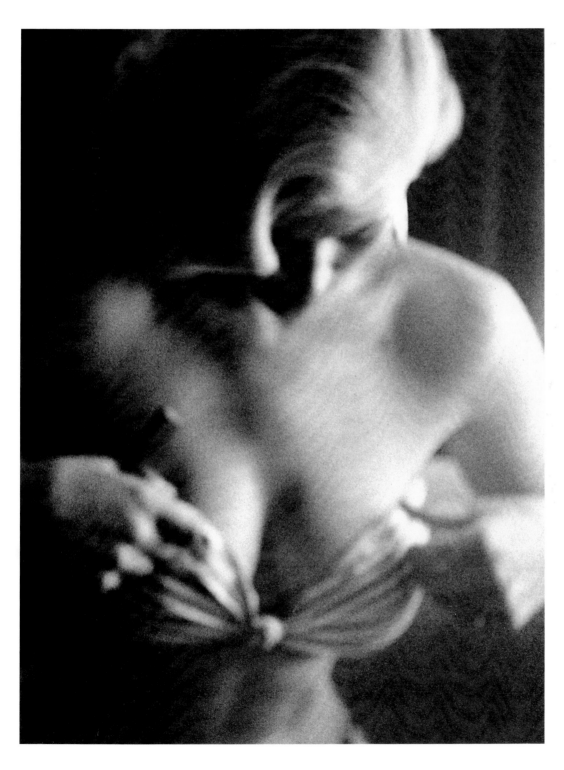

Photographed for Globe Photos, Anita Ekberg was an easy assignment for Stern. "All she needed was a camera pointed at her. I don't think she saw who was behind it, and I don't think she cared. She just loved that camera. And the cameras liked her too incidentally."[24]

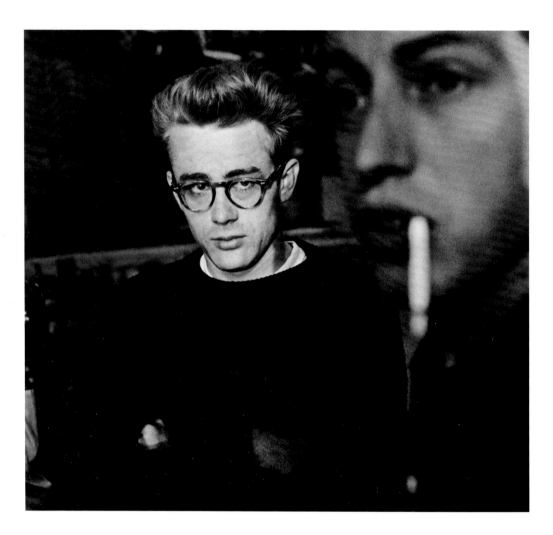

Phil Stern's photograph of James Dean and Dennis Stock resulted from a chance encounter.

7:30 A.M. cruising west on Sunset Blvd., heading for Life's photo lab on the Strip. Driving past the green light opposite Laurel Canyon, I was startled to see a cyclist zipping through the red light. We were on a collision course. We both careened and braked to a stop. Just a few inches saved the crazy bastard's life. I stuck my head out and screamed a dozen profanities as the guy got up off his grounded bike.

He slowly looked up at me with a wide, dopey grin. It was James Dean.

We walked over to Schwab's drugstore, opposite the intersection, where we chatted through a two-hour breakfast. It was there that I invited him over to the Guys and Dolls set, where I had a still gallery rigged to shoot Brando and Sinatra. He came. Such is the origin of my "frame" photos of Dean—and, of course, all the others."[25]

Marilyn Monroe, Jack Benny, 1953

Modern silver gelatin photograph

$12^{7}/_{16}$ x $19^{7}/_{16}$ in.

■

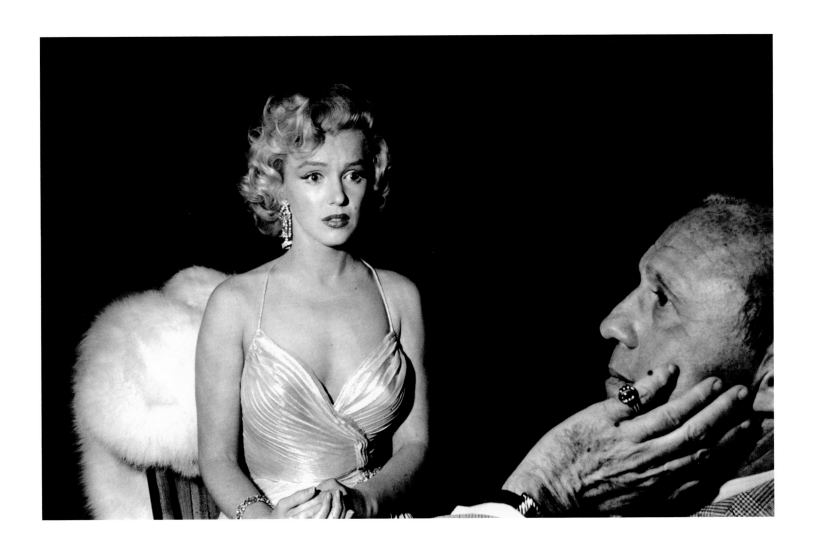

John Huston, Audrey Hepburn, Burt Lancaster, Charles Bickford,

Doug McClure, Audie Murphy, Lillian Gish

The Unforgiven, *1960*

Silver gelatin photograph

$5\,^{7}/_{16}$ x $13\,^{15}/_{16}$ in.

■

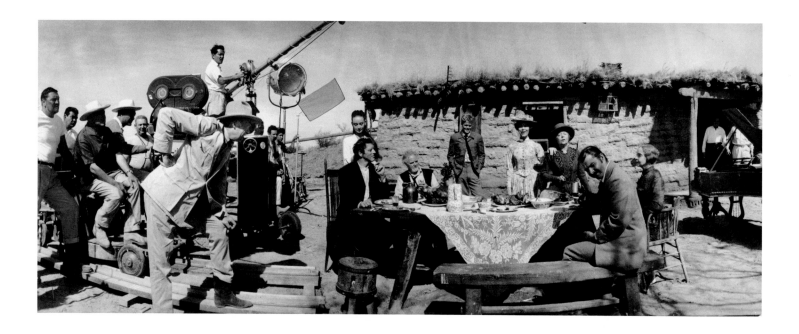

Jean Simmons

Elmer Gantry, *1960*

Bobby Darin, Andre Previn, 1960

Silver gelatin photograph

10 ¹⁵/₁₆ x 13 ⅞ in.

∎

Stern's photographs from In Cold Blood *(1967) were made in a reportage style intended not to beautify the scene but simply to describe it. It appears as if Stern had photographed the actual events on which Truman Capote's story was based, just as Richard Brooks's film was shot at the actual locations. Stern's sense of realism produced riveting photographs.*

Execution Scene

In Cold Blood, *1967*

Silver gelatin photograph

10 ¹⁵/₁₆ x 13 ¹⁵/₁₆ in.

■

In Cold Blood, *1967*

Silver gelatin photograph

14 x 19⅞ in.

∎

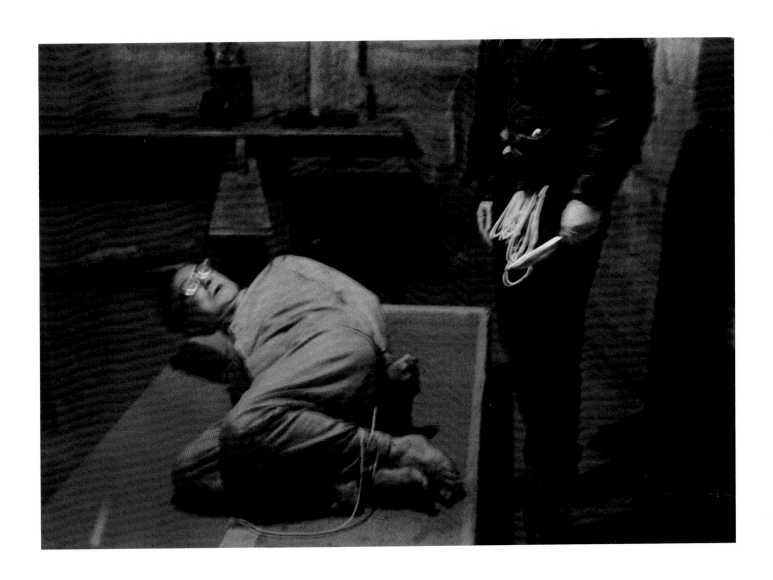

Anonymous
Bob Beerman, Earl Ziegler, Barbara Stanwyck, Sid Avery,
Claudette Colbert, Hymie Fink, and Jack Albin, 1941
Modern silver gelatin photograph
10 1/16 x 13 1/8 in.

■

SID AVERY

United States, 1918–

Born in Akron, Ohio.

1925 Introduced to photography by his uncle, a professional photographer.

1934–37 Photographs for Roosevelt High School, Los Angeles, yearbook.

1937 Studies photography at Frank Wiggins Trade School. Darkroom assistant at Morgan's camera store while attending Art Center School.

1938 Shoots celebrities in nightclubs for fan magazines.

1939 Opens studio specializing in portraiture, photojournalism, and publicity photographs.

1941–45 Assigned to Pictorial Service, U.S. Army Signal Corps, following a six-month course in photojournalism at *Life*. Stationed in London (1941–44), helps establish Pictorial Service laboratory, processing facility for all combat still and motion picture footage from the European theater of operations. Commissioned a Lt. prior to the Normandy invasion; in Paris (1944) helps establish second division of Pictorial Service.

1946 Reestablishes studio in Hollywood. West Coast contributor to magazines, including *Collier's*, *Photoplay*, and *Saturday Evening Post*.

1947–61 Forms Avery and Associates, photographing for numerous commercial accounts while continuing editorial photography for magazines.

1962 Discontinues editorial work.

1967–68 As director of television commercials, forms Avery-Kuhn Productions with title designer Dick Kuhn, developing special effects techniques, including solarization, motion picture strobe, and soft lens effects. Introduces "north-light" technique, creating a true-to-life look for commercials, and "golden hour" (sunrise/sunset) shooting for automobile commercials.

1969–85 As Avery Film Group produces about seventy commercials a year.

1985 Retires to devote full time to Hollywood Photographers Archives.

Exhibitions
California Museum of Science and Industry, Los Angeles, solo exhibition, 1962. Metropolitan Museum of Art, New York, *Photography in the Fine Arts*, 1963.

Awards
Professional Photographers Association (1956), Andy Award of Excellence (1971, 1975), Caddy Award (1975), Belding Award (1980), and Clio (1981).

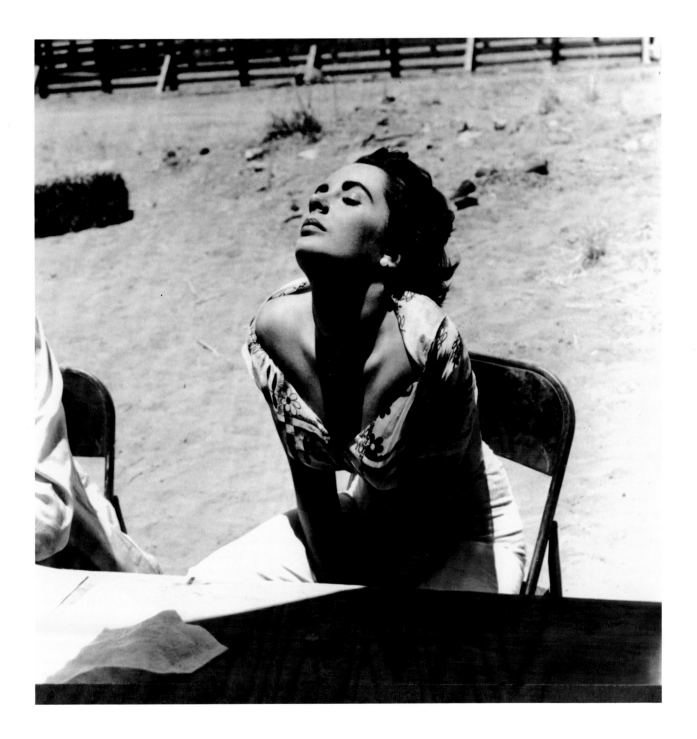

Yul Brynner, 1958

Modern silver gelatin photograph

14⅞ x 14⅞ in.

■

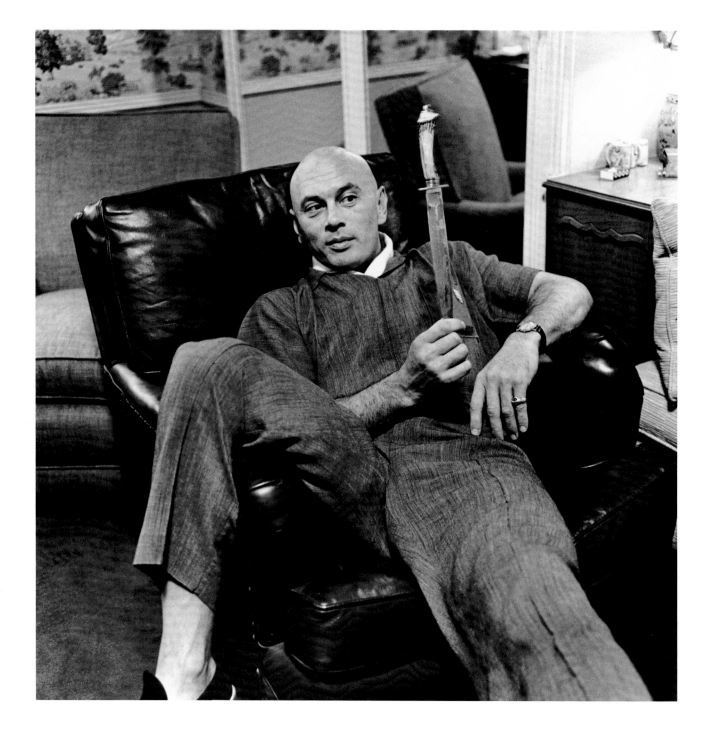

Yul Brynner, 1958

Modern silver gelatin photograph

14⅞ x 14⅞ in.

Sid Avery's general-interest pictorials offer the viewer private moments in the lives of public personalities. To capture those moments, he blended into the background allowing his subjects to relax. Then having gained their confidence, he "nudged" them into candid situations, creating portraits that reveal without exposing.

Joanne Woodward, Paul Newman
Rally 'Round the Flag Boys! *1958*
Modern silver gelatin photograph
14 ⁷⁄₈ x 14 ¹⁵⁄₁₆ in.

■

James Garner, 1958

Modern silver gelatin photograph

14⅞ x 14⅞ in.

■

"James Dean, Marfa, Texas, 1955," 1955

Modern silver gelatin photograph

18¾ x 13⁷/₁₆ in.

■

Marlon Brando, 1955

Modern silver gelatin photograph

14 7/8 x 14 13/16 in.

■

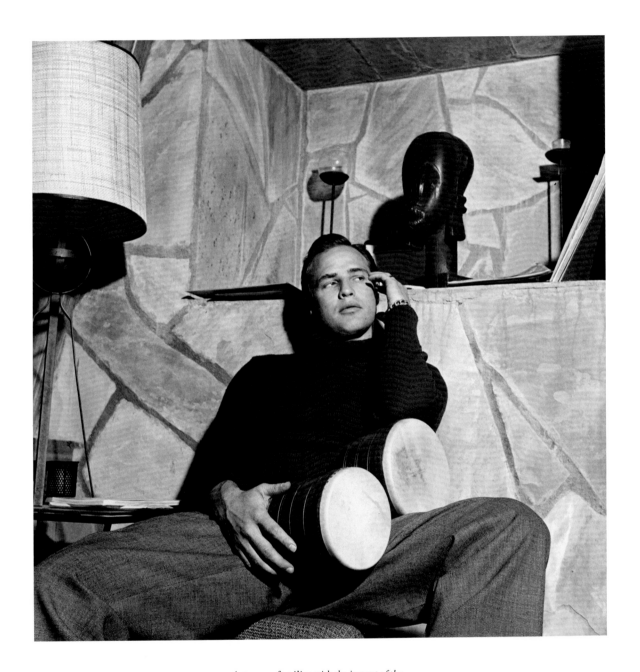

Actors are familiar with the impact of the
photograph. Avery simply let the
performers perform. His unobtrusive
approach enabled him to produce celeb-
rity portraits in photojournalistic style,
making exposures, waiting for the mo-
ment when the subject appeared most
natural. The portrait of Marlon Brando
with his bongos was made to illustrate a
Saturday Evening Post *article entitled*
"The Star Who Sneers at Hollywood" (1955).

Self-portrait with Julie Newmar, about 1960
Silver gelatin photograph
13 ⅞ x 11 in.

■

PETER BASCH

Germany, active in the United States, 1921–

Born in Berlin. Father, a prominent motion picture producer, director, and actor.

1933 Visits the United States as Hitler consolidates his power in Germany and anti-Semitism becomes state policy; remains as the situation in Germany worsens.

Late 1930s Inherits a Kodak folding camera from an aunt. Urged by his father, who had observed the career difficulties emigre actors were having in Hollywood, to develop his quickly apparent photographic talent. Wins first prize in a student photography contest. Collects photographs by Hurrell and others idealizing women.

1938 Darkroom assistant to Paulus Leeser, Austrian photographer working in Paris. Apprenticed to director G. W. Pabst in order to familiarize himself with cinematography.

1941 Assistant to Laszlo Willinger. Photographs numerous European film luminaries when they visit Hollywood.

1942–45 Wartime service with U.S. Army Signal Corps, eventually transferred to First Motion Picture Unit, U.S. Army Air Force.

1945–49 In New York after the war, establishes portrait studio in the St. Moritz Hotel, photographing models and actors and doing commercial work for cosmetics firms.

About 1948 Takes course in photography and design from Alexey Brodovitch, art director of *Harper's Bazaar*. Moves studio to building shared by Philippe Halsman and Arnold Newman.

1950–51 In Hollywood on assignment for *Pageant* photographing starlets, including Rita Moreno and Debbie Reynolds.

1950s Periodic trips to Hollywood photographing film celebrities for European and American magazines, including *Berliner Illustrierte, Charm,*

Cosmopolitan, Glamour, Ladies Home Journal, Life, Look, Paris-Match, Stern, Vogue, and fan magazines. Hired by Fox and Warner Bros. for special unit photography assignments, including *Giant* (1956) and *The Diary of Anne Frank* (1959), based on his success placing photographs with magazines.

Late 1960s Closes studio.

1970s Photographs on location in the United States and abroad.

Publications

Glamour Photography (Louisville: Whitestone, 1958). *Peter Basch Photographs Beauties of the World* (Louisville: Whitestone, 1963). *Peter Basch Photographs Female Beauty* (Greenwich, Conn.: Fawcett, 1963).

Brigette Bardot

Bijoutiers du clair de lune, 1957

Modern silver gelatin photograph

12 ¹⁵⁄₁₆ x 10 in.

■

Brigitte Bardot, Madrid 1957 Peter Basch 1987

Jane Fonda

Walk on the Wild Side, *1962*

Modern silver gelatin photograph

13 x 10 in.

■

Federico Fellini, Marcello Mastroianni

8½, 1963

Modern silver gelatin photograph

10 x 13 in.

■

Marcello Mastroianni, Sophia Loren

Yesterday, Today, and Tomorrow, 1963

Modern silver gelatin photograph

13 x 10 1/16 in.

■

Norma Jean Dougherty (Marilyn Monroe; United States, 1926–62)
André de Dienes, about 1945
Silver gelatin photograph
5 x 4⅞ in.

■

ANDRÉ DE DIENES

Hungary, active in the United States, 1913–85

Born in Transylvania (now Rumania).

Self-taught in photography.

1932 Travels throughout Europe and North Africa painting and taking photographs.

1933 As fashion photographer in Paris, influenced by George Hoyningen-Huene's work for couturier Captain Molyneux.

1938 Emigrates to United States with assistance of Arnold Gingrich, founding editor of *Esquire*. Establishes photographic studio in New York City.

1942 Makes fashion photographs for mail-order catalogues.

1944 Brought to Hollywood by David O. Selznick to photograph Ingrid Bergman; then moves West permanently, photographing film stars, including Linda Christian, Linda Darnell, Jane Russell, and Elizabeth Taylor.

1945 Makes first photographs of Norma Jean Dougherty (later Marilyn Monroe) and embarks on five-week Western states tours photographing her in California, Arizona, Nevada, and Oregon. One resulting photograph reproduced as cover of *Parade* (1947).

About 1950 "Discovers" Anita Ekberg.

Publications
Twenty-four books on photographing nudes (1955–79), including *The Nude* (London: Bodley Head, 1956); *Heibe Sexfotos* (Flensburg, West Germany: Stephenson Verlag, 1972); and *Exotic Nudes* (Los Angeles: Panu, 1974). *Marilyn Mon Amour* (New York: St. Martin's, 1985).

"Sweet Darling Marilyn Monroe," 1949

Ektacolor Type C photograph

21 1/16 x 18 3/8 in.

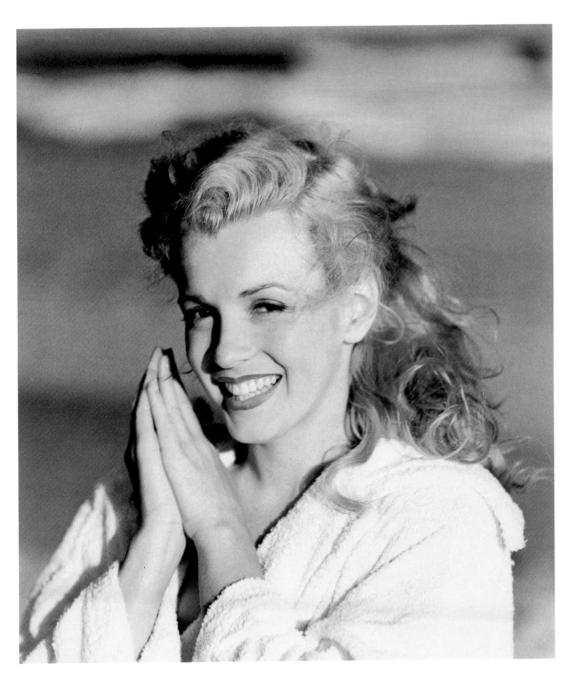

André de Dienes's Hollywood work consisted primarily of photographing starlets. An exponent of natural light and natural settings, he seldom photographed his models—among them Linda Christian, Anita Ekberg, Marilyn Monroe, Ruth Roman, and Jane Russell—in the studio. In fact, he never took pictures in Hollywood per se. The beach, the mountains, and the countryside were his studio. An emotional and passionate photographer, his objective was seeing beauty in nature. He was fascinated with beauty, and in an effort to make his photographs "true to life," he never retouched them. Sex appeal is their common denominator.

De Dienes's association with Marilyn Monroe began in 1945, when he hired her as a model, later photographing her on locations throughout the western United States. "He became her lover. They came back to Los Angeles. They were engaged. He spied on her and discovered she was going out with other men. Their engagement was broken. For years he claimed to have hated her, but from time to time would find himself accepting assignments to photograph her again, as at Jones Beach in 1950 when he took 'the sexiest picture I ever made.'"[26]

DE DIENES

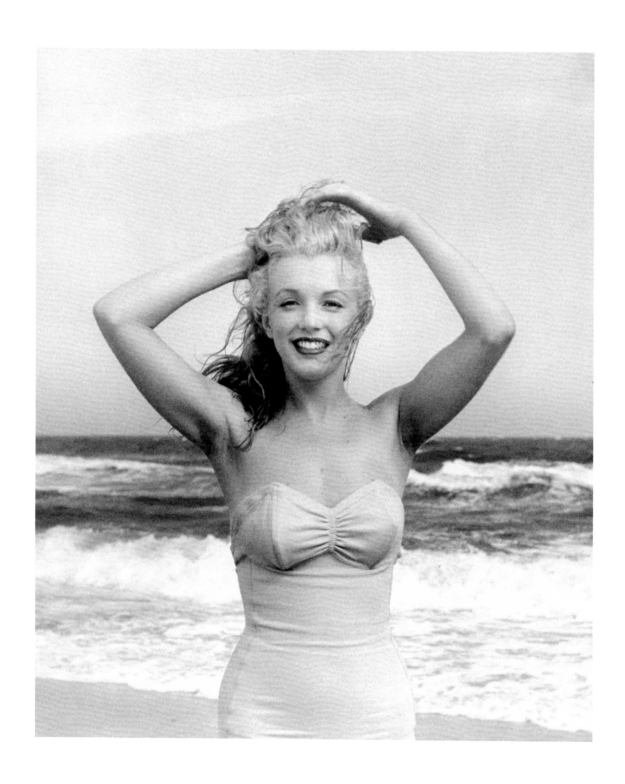

Marilyn Monroe, 1953

Silver gelatin photograph

23 ³⁄₄ x 20 in.

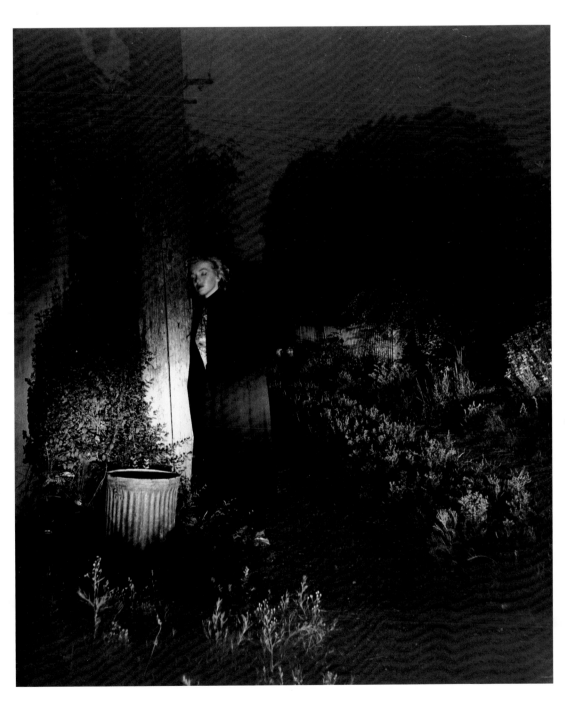

Experimentation and improvisation were regular aspects of a de Dienes photography session. When working outdoors, he was always prepared to adjust to the available light. At night he might use his car's headlights for illumination, as he did with Marilyn Monroe late one evening in 1953.

"One night…Marilyn called me. It was two o'clock in the morning. She could not sleep. She was alone, unhappy, on the edge of despair. She wanted me to come and fetch her. She suggested we could take a series of photos with one of the darkened streets of Beverly Hills as a backdrop. She was not wearing any make-up. Her hair was disheveled. She had dark-circled eyes. But this was what she wanted….I tried to find the right lighting to soften her drawn features, to pick out some greenery to lessen the squalor of the dustbin-lined street where she had taken me. Was this sinister dead-end street how she saw her future? I dared not say anything. I wanted to give her a chance to express her anguish and despair which had overwhelmed her that night….When we had finished, she said to me in a barely audible voice: 'You usually write captions for your photos. You can put "The end of everything" underneath these.' "[27]

John Jay (United Kingdom, 1920–)
Bob Willoughby, 1962
Modern silver gelatin photograph
9⅝ x 7½ in.

■

BOB WILLOUGHBY

United States, 1927–

Born in Los Angeles, California.

1939 First photographs using an Argus C-3 35mm camera, a gift from his father.

1948–49 Assistant to photographers Wally Seawell and Paul Hesse.

1948–54 Exhibition of photographs of jazz musicians and dancers (1948) leads to representation by Globe Photos.

1951–52 Commissioned by Alexey Brodovitch, art director at *Harper's Bazaar*, to illustrate articles on theater and culture in Los Angeles; photographic coverage of films includes *Limelight* (1952), *Hans Christian Andersen* (1952), and *The Desert Rats* (1953).

1953 Assigned by six magazines, including *Collier's*, *Harper's Bazaar*, and *Pageant*, to photograph Judy Garland making *A Star Is Born* (1954) at Warners. Subsequently hired by Warners to cover the filming of an added sequence, "Born in a Trunk"; resulting image becomes his first *Life* cover

(1954). This marks the first time a studio hires a "special," or unit, photographer specifically to generate images for sale to magazines.

1954–71 When freelancing as a special photographer for the studios becomes a possibility, leaves Globe, contributing photographs to *American Weekly*, *Collier's*, *Harper's Bazaar*, *Life*, *Look*, *New York Times*, and *Vogue*. Garland photographs lead to more than 125 motion picture studio assignments, including *The Man with the Golden Arm* (1955), *Raintree County* (1957), *Can-Can* (1960), *My Fair Lady* (1964), *The Graduate* (1967), *The Lion in Winter* (1968), *Rosemary's Baby* (1968), *They Shoot Horses, Don't They?* (1969), *Catch-22* (1970), *Klute* (1971), *The Cowboys* (1972), *The Tamarind Seed* (1974), and *Zandy's Bride* (1974).

About 1963 Devises first remote radio-controlled camera for on-set still photography.

About 1964 Devises brackets to attach 35mm camera to motion picture camera, enabling him to shoot where other still photographers could not and to achieve stills identical to motion picture footage. Codesigns "sound blimp" to permit simultaneous still photography during live-sound motion picture "takes."

1974–80 While in semiretirement in Ireland writes photography books and translates (and illustrates with photographs) ancient Irish poetry.

1980– Continues special assignments on films, including *The Nighthawks* (1980), *The Pirates of Penzance* (1982), and *The Name of the Rose* (1986).

Publications
With Richard Schickel, *The Platinum Years* (New York: Ridge Press, 1974). *Voices from Ancient Ireland* (London: Pan, 1981).

Exhibitions
Museum of Modern Art, New York, *The Family of Man*, 1955. International Museum of Photography at George Eastman House, Rochester, *Photography at Mid-century*, 1959. Privately organized traveling exhibition, *World Exhibition of Photography*, 1964, 1968, 1973. American Cultural Center, Paris, solo exhibition, 1979. National Portrait Gallery, London, *Stars of the British Screen*, 1985.

Collection
Museum of Modern Art, New York.

Jane Fonda
They Shoot Horses, Don't They?, 1969
Modern silver gelatin photograph
9 x 13⅜ in.

■

Frank Sinatra, Kim Novak, Otto Preminger

The Man with the Golden Arm, 1955

Modern silver gelatin photograph

19 ¹¹⁄₁₆ x 13 ⁷⁄₁₆ in.

■

Elizabeth Taylor

Raintree County, 1956

Modern silver gelatin photograph

9 7/16 x 13 15/16 in.

■

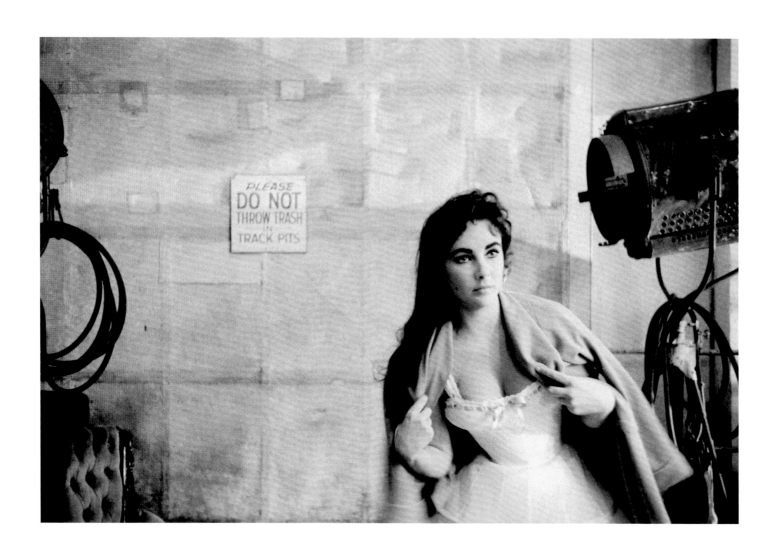

"*He has found beauty in the moments of concentration and relaxation of the actors, before or after a scene. They often seem tired, thoughtful....They wait, in a corner of an empty set....Willoughby shows the other side of the set without make-up, without malice. The actors have different myths to support, there are moments where they seem invaded or abandoned to their psyche.*"[28]

Elizabeth Taylor

Raintree County, *1956*

Modern silver gelatin photograph

13 ⁷/₈ x 19 ¹¹/₁₆ in.

■

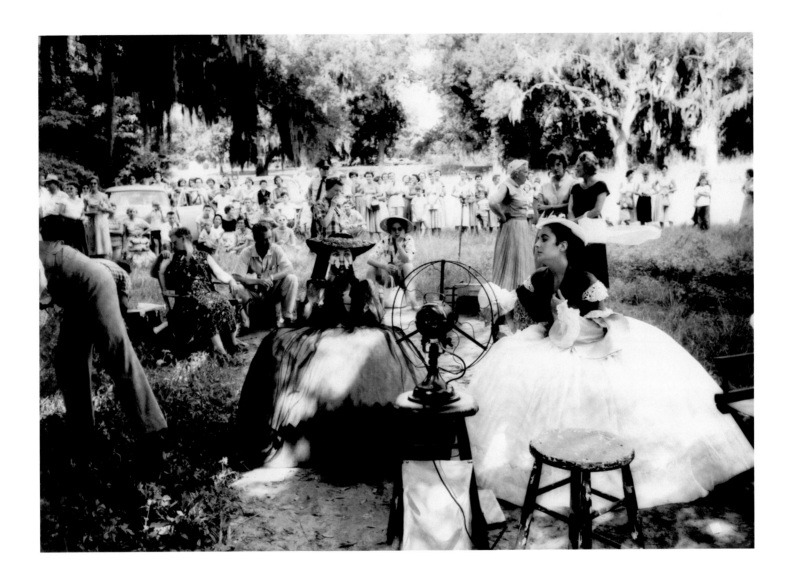

Alan Pakula, Jane Fonda, Donald Sutherland

Klute, 1970

Modern silver gelatin photograph

13 1/8 x 19 13/16 in.

■

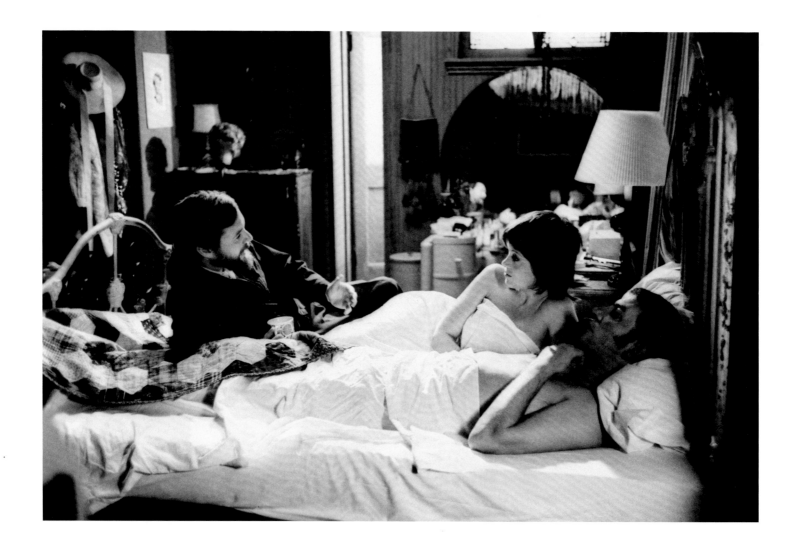

Dustin Hoffman, Anne Bancroft

The Graduate, 1967

Modern silver gelatin photograph

13 x 19¾ in.

■

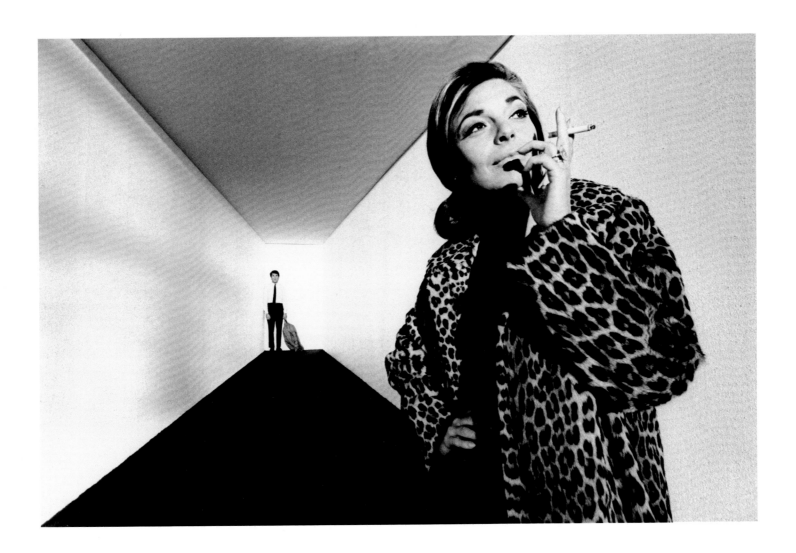

Anonymous
Ruth Orkin, about 1948
Modern silver gelatin photograph
9⅜ x 6½ in.

■

RUTH ORKIN

United States, 1922–86

Born in Boston, Massachusetts, daughter of a silent-film actress. Grows up in Hollywood attending previews and stars' funerals.

1932 Given her first camera as a gift.

1934 With her own 16mm movie camera, makes short films starring her mother.

1940 While attending Los Angeles City College, reads every book on film in the Hollywood Public Library.

1943–44 Hired by MGM as its first messenger girl, learns to run editing and sound-mixing equipment. Ambition to become a motion picture camera operator frustrated by nonadmittance into IATSE #659. Based on a billboard promising training in filmmaking, joins Womens Auxiliary Army Corps, but promise proves empty.

1945–47 In New York City takes odd jobs—soda jerk, nightclub photographer—to pay for Speed Graphic camera, then works assisting photographers. Joins Photo League. Establishes friendships with Morris Engel, whom she marries (1952), Arnold Newman, and Weegee.

1947–54 Freelance photojournalist for *Collier's, Cosmopolitan, Esquire, Ladies Home Journal,* and *Life.* Subjects include Albert Einstein, Alfred Hitchcock, and Marlon Brando. Also photographs New York City street life. Returns to MGM (1948) to do a story on the less glamorous side of movie making. Specializes in photographing literary figures and musicians performing in the United States. Assigned by *Life* to accompany Israel Philharmonic on its first American tour (1951).

1953 Collaborates with Engel on *The Little Fugitive,* short film nominated for an Academy Award, recipient of Silver Lion at Venice Film Festival, and credited by Francois Truffaut for having started the French *Nouvelle Vague.*

1955 With Engel writes, produces, and directs *Lovers and Lollipops.*

1959 Included among top ten women photographers by the Professional Photographers of America.

1960–85 Photographs reproduced widely in magazines, including *American Weekly, Collier's, Coronet, Cosmopolitan, Harper's Bazaar, Life, Look,* and *Vogue.* Many photographs made on assignment, but an equal number shot "on spec," a practice not entirely condoned by photojournalists.

1976 Photography instructor, School of Visual Arts, New York.

1980 Photography instructor, International Center for Photography, New York.

Publications
Legacy of Love (New York: Grosset & Dunlap,1971). *A World through My Window* (New York: Rizzoli, 1974). *A Photo Journal* (New York: Viking, 1981). *More Pictures from My Window* (New York: Rizzoli, 1983).

Exhibitions Museum of Modern Art, New York, *Young Photographers*, 1950. Museum of Modern Art, New York, *The Family of Man,* 1955. Metropolitan Museum of Art, New York, *Photography in the Fine Arts,* 1963. National Gallery of Canada, Toronto, *Photographic Crossroads: The Photo League,* 1978. Metropolitan Museum of Art, New York, *Art of the Olmstead Landscape,* 1981.

Collections Houston Museum of Fine Art; Metropolitan Museum of Art, New York; Museum of Modern Art, New York.

"Spencer Tracy on Location in N.Y.C.," 1950

Modern silver gelatin photograph

8 ⅝ x 13 in.

■

Ruth Orkin's purpose was to record precisely what she saw. Her photographs of celebrities often place them outside the Hollywood context, making them appear less like stars than ordinary individuals caught in expressive moments. "I think that taking pictures must be my way of asking people to 'look at this—look at that.' If my photographs make the viewer feel what I did when I first took them— 'isn't this funny— terrible—moving— beautiful?'—then I've accomplished my purpose."[29]

Anonymous
Robert Coburn, Jr., about 1955
Silver gelatin photograph
7 ½ x 7 ½ in.

■

ROBERT COBURN, JR.

United States, 1928–

Born in Hollywood, California.

1936 Taught by father, Hollywood photographer Robert Coburn, Sr., to use an adjustable Kodak folding camera.

1946 Photographs high school yearbook. Wins Kodak gold medal awards.

1946—50 As film laboratory technician at Columbia observes his father and colleagues William E. Cronenweth, Irving Lippman, and Homer Van Pelt photographing on the lot. Joins IATSE #683 (film technicians' union).

1950—52 Serves in U.S. Army Signal Corps at Photographic Center, Long Island City, New York.

1953 Returns to Columbia as film laboratory technician, later becoming assistant cameraman (and member of IATSE #659).

1954 Publicity photographer for television shows, including *Circus Boy, Father Knows Best,* and *Rin Tin Tin.*

1955—60 At Columbia (and occasionally other studios) makes 35mm publicity stills for films starring Rita Hayworth (*Pal Joey,* 1957, and *They Came to Cordura,* 1959) and Kim Novak (*Jeanne Eagels,* 1957, *Bell, Book, and Candle,* 1958, and *Vertigo,* 1958), among others.

1961—75 Still man at Disney on twenty feature films.

1975— Leaves Disney to freelance on episodic television and television movies.

Kim Novak, 1957

Silver gelatin photograph

10 ¼ x 13 ⅜ in.

■

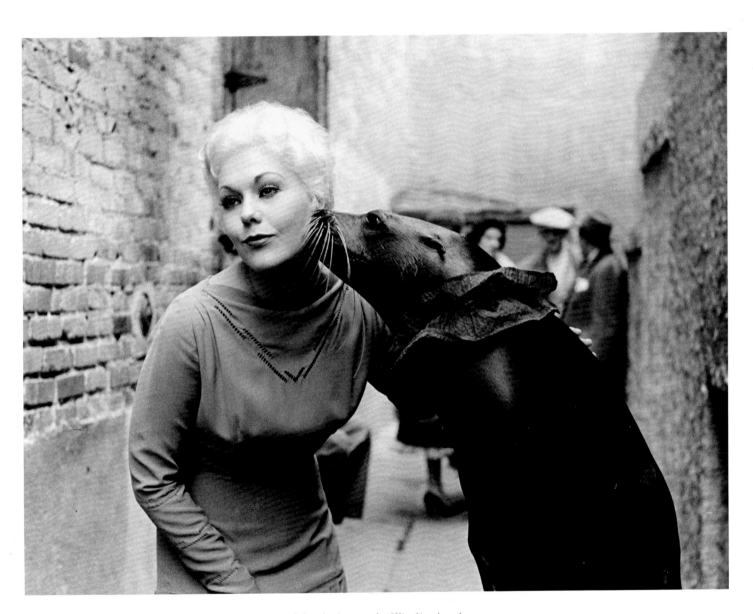

Coburn's photograph of Kim Novak and a seal demonstrates the photographer's ability, working with a small-format camera, to capture an unrehearsed, real-life comic (or dramatic) moment, which so characterized photography in the 1950s.

Anonymous
John Bryson, John Huston
Victory, *1981*
Silver gelatin photograph
7 1/16 x 9 7/16 in.

■

JOHN BRYSON

United States, 1923–

Born in Brownwood, Texas

1943–45 Still photographer and cinematographer on U.S. Army Air Force training films.

1947 Statewide scandal, created by a University of Texas student magazine article, "Cheating in College," written by Bryson and illustrated with his photographs, brings him to the attention of Time-Life publisher Henry Luce.

1947–52 *Life* correspondent and/or bureau chief in Atlanta (1947), Chicago (1948), Hollywood (1949–51), and Boston (1951–52).

1952–55 *Life* assistant picture editor, then acting picture editor, then "fast color" editor, New York. (Several weeks had been required for the processing and printing of editorial color. *Life*'s ability to process and print color in ten days was a breakthrough for print journalism.)

1955– Freelance photojournalist in Hollywood and New York for periodicals, including *Architectural Digest, Collier's, Fortune, Holiday, Life* (contributing photographer, 1970), *London Sunday Times Colour Magazine,*

Look, New York Times Magazine (contributing editor, 1963–68), *Paris-Match*, and *Saturday Evening Post* and as freelance unit photographer for motion picture studios. First *Life* cover: integration of Central High School, Little Rock (1957). On location in Russia photographs *The Brothers Karamazov* (1958) for *Life* and MGM; and in Rome, on set of *Ben-Hur* (1959). Interview with Nikita Khrushchev appears in *Time*. Photographs Democratic national convention for *Paris-Match* and subsequently makes photographs for John F. Kennedy's campaign posters (1960).

1963–68 Contributing photographer for *Saturday Evening Post* traveling worldwide and covering about a dozen films per year.

1972 Photographs and acts in *The Getaway.*

Publication
The World of Armand Hammer (New York: Abrams, 1985).

Jayne Mansfield-Mickey Hargitay Wedding, 1958

Modern silver gelatin photograph

14 ³/₁₆ x 19 ½ in.

■

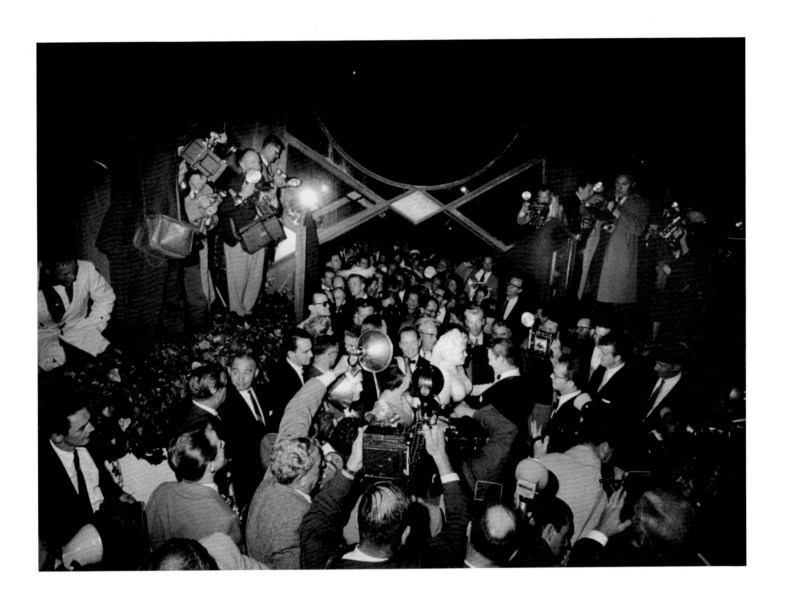

I had been hired as a "special" photographer by MGM and also had an assignment from Life, *which often happened. I told the producer, Sam Zimbalist, and the director, William Wyler, what I wanted to do; everybody had a heart attack. [The idea was to photograph the entire company], probably the biggest company MGM had ever assembled. We planned it like a military operation. I went out and drove stakes into the ground where Zimbalist, Wyler, [Charlton] Heston, and everybody else was to stand. I shot it in color and black-and-white, but I don't think it ran anywhere. Why? Because I had marvelous stuff of horses, chariots, and action blurs; that stuff ran all over the world. This particular picture no one ran because it was too static.[30]*

Ben-Hur, 1959

Silver gelatin photograph

12 1/8 x 19 1/4 in.

■

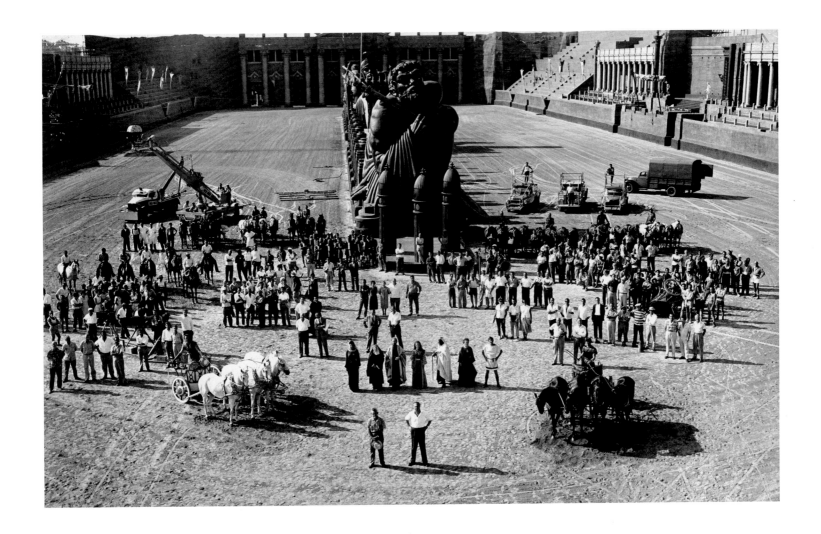

Sophia Loren, about 1958

Modern Cibachrome photograph

13 ½ x 10 ½ in.

■

Sophia Loren, about 1958

Modern Cibachrome photograph

Marilyn Monroe, 1960

Silver gelatin photograph

19 x 13⅛ in.

■

Orson Welles, about 1955

Silver gelatin photograph

13 ¼ x 10 ⅛ in.

■

Kirk Douglas

Lust for Life, 1956

Modern Cibachrome photograph

13 ½ x 10 ½ in.

■

"When they made Lust for Life *[1956]*, they photographed every van Gogh painting they knew of in existence. They did full-size color prints of every van Gogh painting. They were so good, you thought you saw the paint. I was covering this for Life, but MGM also had me photograph the whole picture. Vincente Minnelli was the director.

"They finished shooting, and we arranged for a stage at MGM. On two walls from ceiling to floor we put up as many of these van Gogh prints as we could get in. I brought old Kirk *[Douglas]* in there and put him in the middle and did the pictures: verticals and horizontals. When Minnelli saw the finished photographs, he took them to the head of the studio, who reopened the budget. They put up a wall of those *[prints]* and put old Kirk in the middle of it and reshot the finale of the film there. I didn't get any credit on the screen."[31]

Stan Moore (birthplace and life dates unknown)
Leigh Wiener, 1952
Silver gelatin photograph
7 ½ x 9 ½ in.

■

LEIGH WIENER

United States, 1929–

Born in New York City.

1939 First prize in a high school photography competition for a photograph submitted for him by a friend.

1944 First magazine sale (while still in high school): a photograph of theatrical agent Charles Feldman to *Collier's*.

1949–57 Freelances for *Life* while a staff photographer at *Los Angeles Times*; first *Life* sale: photograph of a roller-skating rooster (1951). *Times* tenure interrupted by military service; staff photographer for *Stars and Stripes* (1952–53).

1956 Accompanies Los Angeles Philharmonic Orchestra on Southeast Asian tour.

1957–72 Opens commercial photography studio (1958) with television networks as principal advertising clients. As freelancer photographs of performing artists, politicians, and athletes published in Time-Life magazines, *Paris Match*, and *TV Guide*.

1965–85 Creates *A Slice of Sunday* (ABC), prototype of *NFL Today* (1965), and *Talk about Pictures* (NBC, 1974–85).

1970– Produces corporate films while continuing to shoot still photographs and produce television shows.

Publications
Here Comes Me (New York: Odyssey, 1966). Ann Ridgeway, ed., *Selected Letters of Robinson Jeffers* (Baltimore: Johns Hopkins University Press, 1968), illustrated with portraits of Jeffers by Wiener. *How Do You Photograph People?* (New York: Viking Press, 1982).

Awards
Eddy (American Cinema Editors) for *A Slice of Sunday* (1965); Clio for ABC NCAA Football television commercial (1967); numerous New York Art Directors and Los Angeles Art Directors awards.

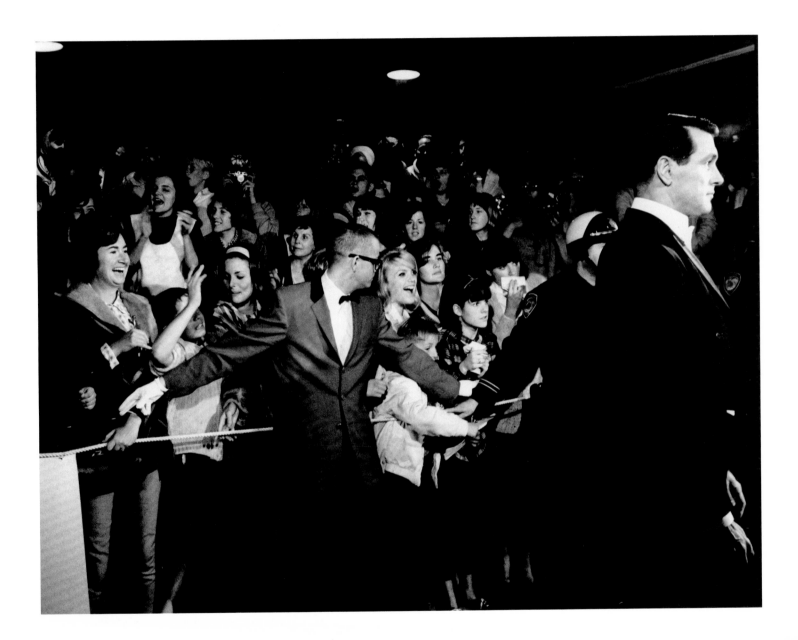

"Hollywood Rock"

Rock Hudson, 1964

Modern silver gelatin photograph

The perceptive photographer is required to see more than the ordinary person does in order to photograph not only the action but the reaction. This is nowhere truer than in Leigh Wiener's photograph of Simone Signoret at the Academy Awards ceremony in 1960.

"Life *magazine wanted photographs of all the Academy Award winners of 1960 and had about twelve photographers on the assignment. My responsibility was to photograph Simone Signoret, who was nominated as best actress for her role in* Room at the Top, *but the people in charge of the ceremony had decided that no photographers would be allowed in the theater. They would all be kept out in the lobby.*

"On the afternoon of the awards I went to the theater and located a fellow who was going to handle a spotlight on the audience. I asked him if for three bottles of scotch he would let me join him in the lighting booth. He said for three bottles of scotch he would let me join his wife. At 6 P.M. I returned with the scotch, and we fitted ourselves into the booth.*

"I was focused on Signoret when they read her nomination and then announced that she'd won. To truly appreciate this story you have to understand a little bit about the technical side of photography. I was using a reflex camera, which has a mirror in it that pops up when you press the shutter and blocks your view. You see it just before you click and just after the shutter closes, but the actual image that goes on the film remains a mystery until the film is developed.*

"The following Tuesday* Life *came out with its story on the Academy Awards. The lead photograph was a full page: Simone Signoret, eyes open and hands clutching her breasts. Several months later a letter arrived from Signoret, thanking me for the photograph. 'You know, Mr. Wiener,' she wrote, 'I guess your photograph just goes to prove that old adage that in times of crisis, we reach for those things we treasure the most.' "[32]*

"Room at the Top"

Simone Signoret, 1960

Modern silver gelatin photograph

15 ⁷⁄₁₆ x 19 ³⁄₁₆ in.

∎

Nancy Ellison (United States, 1936–)
Douglas Kirkland, 1986
Silver gelatin photograph
7 7⁄8 x 9 13⁄16 in.

■

DOUGLAS KIRKLAND

Canada, active in the United States, 1935–

Born in Toronto.

Early 1950s At Fort Erie Photo Studio, Niagara Falls, takes passport and wedding photographs. Staff photographer at *Times Review*, Fort Erie, New York. In Toronto briefly working as photographic assistant with commercial photographers.

About 1955 Returns to Niagara area, working as staff photographer at *Welland Evening Review*.

Late 1950s Photographic assistant in commercial studios in Buffalo, New York, Richmond, Virginia, and New York City. Assistant to *Vogue* photographer Irving Penn.

1961–72 Staff photographer at *Look*, later freelance at *Look* and other magazines, including *Life* (beginning 1971), *Paris Match*, *Stern*, and *Town and Country*, covering Hollywood, photographing celebrities, including Charlie

Chaplin, Audrey Hepburn, Sophia Loren, Marilyn Monroe, Peter O'Toole, and Elizabeth Taylor, and films, including *Ryan's Daughter* (1970) on location in Ireland and *The Boy Friend* (1971) in England.

1976–81 Working worldwide through Contact Press Images.

1981– Working in New York and Los Angeles through Sygma photo agency.

Publication
Passions (New York: Collins, forthcoming).

Vanessa Redgrave, 1967

Modern dye transfer photograph

$12^{11}/_{16} \times 8^{7}/_{8}$ in.

■

Jack Nicholson, 1973

Modern dye transfer photograph

12¾ x 8⁹/₁₆ in.

■

With singleness of purpose Douglas Kirkland effectively tells a story in one photograph: the spontaneity of Jack Nicholson "smoking" a match, the intensity of Dennis Hopper cutting a film. Kirkland furthers the sense of drama through the use of multiple pictorial devices, such as playing light against dark, manipulating bright colors, and bold graphic design.

Dennis Hopper, 1970

Modern dye transfer photograph

8¾ x 12¾ in.

∎

Notes

1. Harry Engleman, "I Was the Man Who Made the Starshine," *Los Angeles*, November 1983, 271.

2. George Hurrell and Whitney Stine, *The Hurrell Style* (New York: Day, 1976), 6.

3. Ibid.

4. Clarence Sinclair Bull and Raymond Lee, *The Faces of Hollywood* (South Brunswick, N.J.: Barnes, 1968), 7.

5. Ibid., 23, 31.

6. Laszlo Willinger, interview with the authors, Van Nuys, California, 25 August 1986.

7. Ibid.

8. Ibid.

9. Will Connell, *About Photography* (New York: Maloney, 1949), 6.

10. Edward Steichen, *A Life in Photography* (Garden City, N.Y.: Doubleday, 1963), unpaginated.

11. Vivian Cosby, "The Most Exciting Photos Ever Taken of Rita Hayworth," *Movieland* (November 1946), 38.

12. Peter Stackpole, interview with the authors, Oakland, California, 11 February 1987.

13. Stackpole, interview with the authors.

14. John Florea, interview with the authors, Los Angeles, California, 4 September 1986.

15. Ibid.

16. Richard Miller, interview with the authors, Los Angeles, California, 26 August 1986.

17. Ibid.

18. Ibid.

19. John Swope, manuscript, 1978.

20. Anonymous, introduction in John Swope, undated manuscript.

21. Swope, manuscript, 1978.

22. Ibid.

23. Harvey Fondiller, *The Best of Popular Photography* (New York: Ziff-Davis, 1976), 96.

24. Phil Stern, interview with the authors, Los Angeles, California, 12 April 1987.

25. Phil Stern, manuscript, 1987.

26. Norman Mailer, *Marilyn* (New York: Grosset & Dunlap, 1973), 57.

27. André de Dienes, *Marilyn Mon Amour* (New York: St. Martin's, 1985), 147.

28. Herve Guibert, *Le Monde*, 1979.

29. Ruth Orkin, *A Photo Journal* (New York: Viking, 1981), 49.

30. John Bryson, interview with the authors, Malibu, California, 7 April 1987.

31. Ibid.

32. Leigh Wiener to David Fahey, November 1985.

AFTERWORD

THE HOLLYWOOD PHOTOGRAPHERS ARCHIVES were founded by Sid Avery, Linda Rich, and David Fahey out of concern for the work of photographers who have practiced in Hollywood since the inception of the film industry. Collectively this work is an invaluable visual resource that has contributed substantially to American culture in the twentieth century, yet the glamour portraits, production stills, picture essays, and advertisements they created have not yet been researched seriously in terms of their specific contributions to the history of photography.

The primary concerns of the Hollywood Photographers Archives are research, collection, preservation, exhibition, and publication of the achievements and reminiscences of still photographers. Because of its geographic location and proximity to the best private collections, the archives are uniquely well suited to accomplish their major goal, the establishment of a permanent public cultural center with emphasis on Hollywood photography.

This work of Hollywood photographers has been too long neglected. Occasionally photographers themselves have been careless, storing negatives and prints unprotected from heat, humidity, and dust. Families of some deceased photographers have disposed of private archives, unaware of their historic value. Whatever the reason, the result is always the same: irreplaceable images perish. It is crucial to save this material now, before any more disappears. Some of the photographers are elderly; the opportunities to record their reminiscences, limited; their insights, in danger of being lost forever as well. For these reasons, this effort to rescue and preserve this heritage is urgent.

PHOTO SOURCES AND COPYRIGHTS

Ted Allan/the Kobal Collection: 2

Katherine Abbe: 12, 17b

Academy of Motion Picture Arts and Sciences: 13a, 17a, 35, 37, 40–41, 43–45, 75, 101

Sid and Diana Avery: 13b–c, 16b, 18–19a, 27, 32–33, 38–39, 57, 69, 71, 73, 81, 92–94, 97, 131–32, 251–55

The Kobal Collection: 16a, 48, 59, 63, 79, 98–99, 106–7, 109, 111–12

Peter Stackpole: 20

Robert Coburn: 21, 146–55, 169

Copyright © Time Inc.: 22–23, 264b

Peter Stackpole, copyright © Time Inc.: 24a, 170a, 171–77

Mrs. Marjory Engstead Richardson: 24b, 140–45

Hollywood Photographers Archives: 26, 85, 164–65, 181, 214–21, 279–81

John Swope estate: 26b, 206–13

Peggy Powolny: 30, 114

Academy of Motion Picture Arts and Sciences, copyright © Turner Entertainment Co.: 44–45

Washburn Gallery, New York: 46–47, 49–53

Manford E. Magnuson: 54–55, 60

Lois Flury, Flury & Co., Seattle, WA: 56

Collection of James Morgan Watters: 61, 77, 86–87, 115

Michael G. Wilson Collection, copyright © Mortensen Estate Collection, 1980: 62, 64

Deborah Irmas, copyright © Mortensen Estate Collection, 1980: 65–67

John and Susan Edwards Harvith: 72

David and Anne Fahey: 74

Barbara Kasten: 76, 88

Irving Lippman: 78, 82, 166–67

Louis F. D'Elia/Allpoints Collection: 83, 89, 91, 95

Earl and Joyce Witscher: 84, 105, 110, 135

Creative Art Images: 90

Jeff Spielberg: 96

Elliott Mittler: 100

Ted Allan: 102–3

■